THE BACKPACKER'S PHOTOGRAPHY HANDBOOK

CHARLES CAMPBELL

AMPHOTO
an imprint of Watson-Guptill Publications/New York

To Jennifer,
who shared the uphills and downhills, sun and rain,
and bugs and blisters of countless outdoor adventures.
I am thankful for her precious companionship and
indebted to her unwavering faith in my vision.

Edited by Robin Simmen
Designed by Bob Fillie, Graphiti Graphics
Graphic production by Ellen Greene

First published 1994 in New York by AMPHOTO, an imprint
of Watson-Guptill Publications, Inc., a division of BPI
Communications, Inc., 1515 Broadway, New York, NY 10036.

Library of Congress Cataloging-in-Publication Data
Campbell, Charles, 1951-
 The backpacker's photography handbook / by Charles
Campbell.
 Includes index.
 ISBN 0-8174-3609-X (pbk.)
 1. Outdoor photography. 2. Nature photography. 3. Back-
packing.
 I. Title.
 TR659.5.C36 1994
 778.7' 1—dc20 94-9027
 CIP

Manufactured in Singapore

2 3 4 5 6 7 8 9 /02 01 00 99 98 97 96 95

Title page:

ALPINE FLORA, Gore Range Mountains,
Colorado. 4 x 5 Linhof Master Technika
camera, 90mm lens (equivalent to 24mm in
35mm format), Bogen 3021 tripod with Foba
Super Ball head, Fujichrome Velvia.

Right:

COLORADO COLUMBINES AND QUAKING
ASPEN, Eagles Nest Wilderness, Colorado.
Nikon FM camera, 24mm f/2.8 lens, Bogen
3001 tripod with Linhof Profi II ball head,
Kodachrome 64.

Pages 4-5:

INDIAN PAINTBRUSH AGAINST A FALLEN
SUBALPINE FIR (charred black from lightning
strike), Weminuche Wilderness, Colorado. Nikon
8008 camera, 55mm f/2.8 macro lens, Bogen
3001 tripod with Linhof Profi II ball head,
Ektachrome Lumiere 100X.

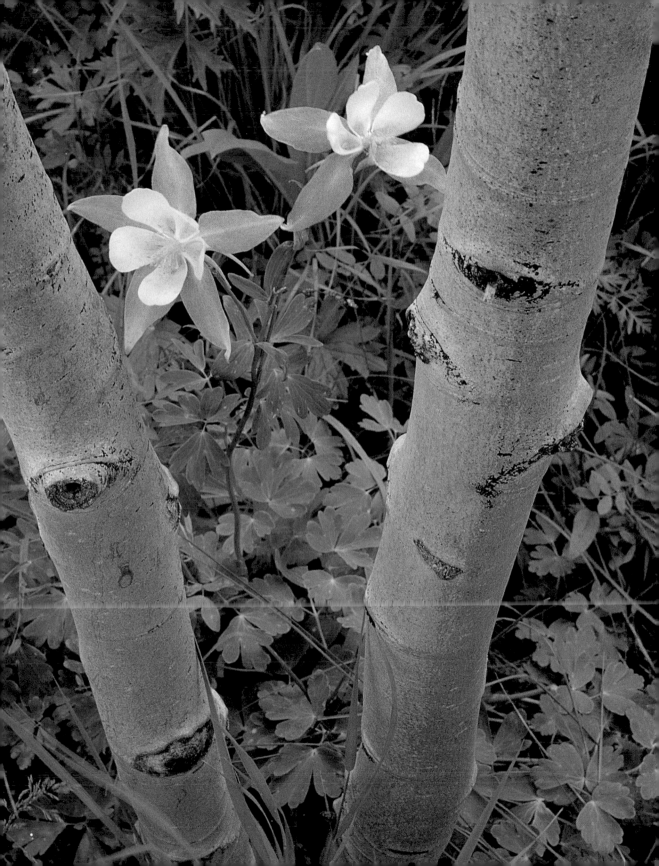

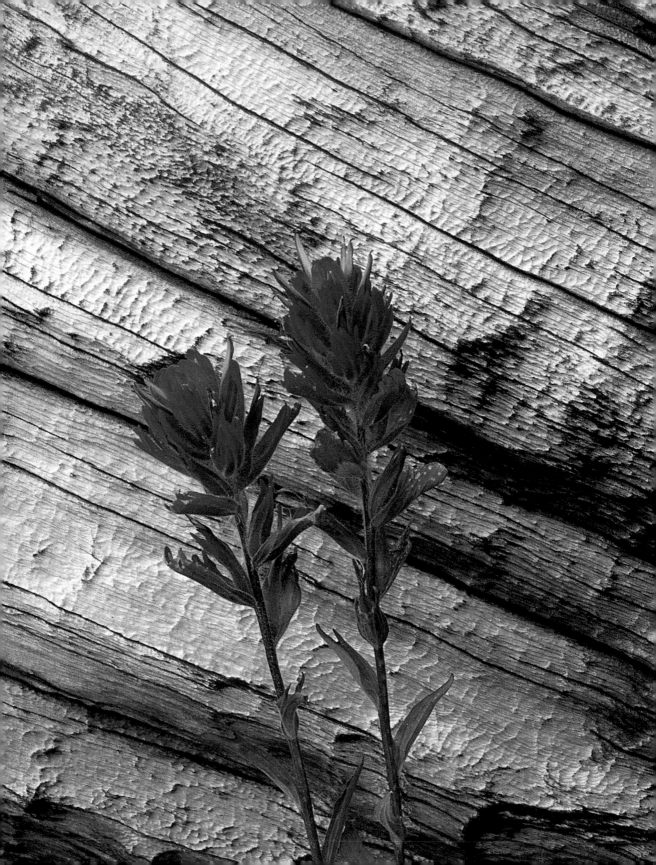

CONTENTS

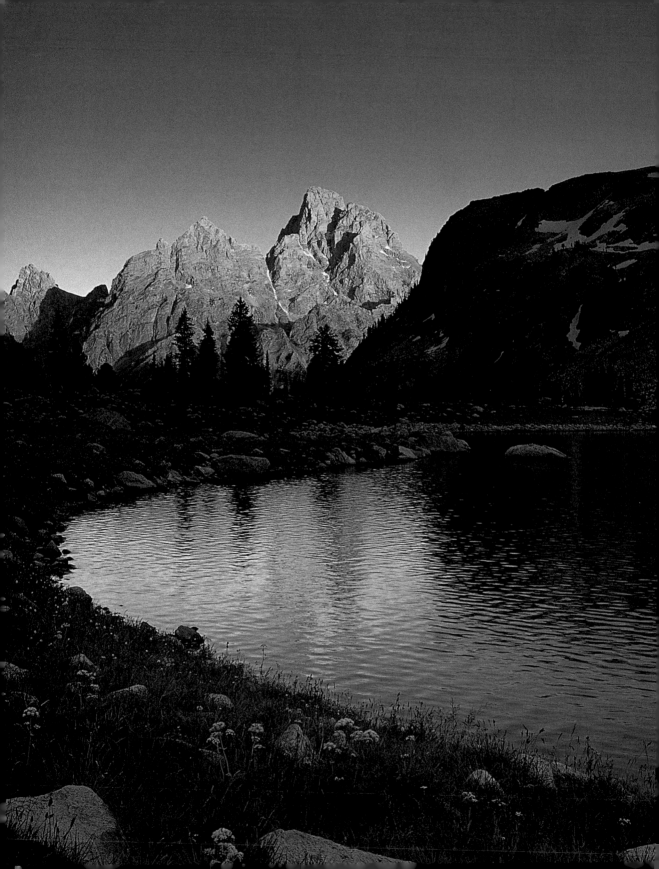

INTRODUCTION

*"In all things of nature, there is
something of the marvelous"*

— ARISTOTLE

I've been waiting all day for this moment. The mighty Grand Teton is bathed in perfect golden light as I check and recheck my exposure meter readings. The sun is setting, and soon another late-summer day on my seven-day solo traverse of the Teton Crest Trail in Wyoming's mountains will come to a close. I am high above timberline and completely alone here at the edge of Lake Solitude as I plead, "Please, just please, don't let me screw this one up!"

I pace back and forth, waiting anxiously for the perfect moment to photograph as the light turns richer and richer. Moments later, the light is at its best and I start shooting. I've got it! Suddenly, the magical light fades away as if this were a theatrical play and a stage hand is dimming the house lights. I feel like applauding. What an inspired performance!

The allure of photography for me is that with a camera and film, in a fraction of a second, I can record something from my experience with nature and pass it along for others to see. Even before I began photographing nature as a full-time pursuit, I understood how contact with the natural world rejuvenates human beings. Although my old Monday-through-Friday career felt like a tug of war, filled with misdirected priorities and superficiality, I found that I could cope with it as long as I returned to nature on the weekends. A simple hiking trip could restore my serenity.

For me, wilderness represents authenticity. My life in the city was increasingly an energy drain. One day, I finally succumbed to my innermost impulses and decided to make nature photography my career. But it took a set of extraordinary events to make me realize that nature photography was the number-one passion in my life and that I should make a total commitment to it.

My transformation began during the summer of 1979. I was leading a mountaineering expedition to the challenging West Ridge of the Moose's Tooth in Alaska (see cover photograph). My group was shuttled by a small single engine plane to a ski landing on the Ruth Glacier. Our bush pilot was Lowell Thomas, Jr., son of the world famous journalist. During the flight, vast glaciers and jagged mountains spread beneath us like a scene from a National Geographic television special. I remember quite clearly having a spirited conversation with Lowell about his passion—flying.

"I've been flying over these same mountains now for more than 25 years," he shouted over the noise of the Cessna's engine. "But I still get a bigger kick out of taking you boys on what's a routine flight for me over these mountains and to the Moose's Tooth, than I would in

LAKE SOLITUDE, Grand Teton National Park, Wyoming. Nikon N8008 camera, 35-135mm f/3.5-4.5 zoom lens, Bogen 3001 tripod with Linhof Profi II head, ND grad .6 filter, Fujichrome 50.

The Grand Teton is bathed in perfect golden light. I shot it across Lake Solitude during a seven-day solo traverse of the Teton mountain range.

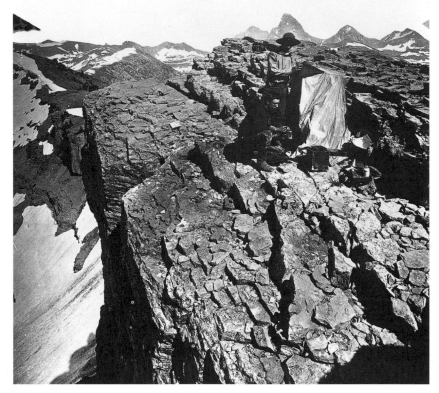

joining you on what will probably be the adventure of a lifetime!" His enthusiasm for flying was so genuine, and his zest for living was contagious. It dawned on this impressionable young adventurer that Lowell was one of the lucky few to be living out his fantasies *every day of his life*. A seed was planted; this is when "discovering your bliss," as the scholar Joseph Campbell so aptly described it, started to become a compelling personal goal.

Just three years later, I was once again climbing a mountain in Alaska. This time it was in a very remote glacial wilderness region bordering Alaska and Canada's Yukon Territory on a trip that changed my life. We were ascending 19,008-foot Mt. St. Elias when my companions and I heard what sounded like distant thunder. Suddenly, a massive snow avalanche appeared directly above us. Before we could react, it was upon us with the sudden fury of a tornado. Fortunately, two of my three climbing buddies

narrowly escaped the avalanche's path while the third was literally buried up to his neck. But I was in the wrong place at the wrong time and was entombed beneath 3-4 feet of snow.

I struggled violently against the weight of the snow, but it was useless—I couldn't budge. I tried to draw a deep breath, but I couldn't. I pictured my wife and her gentle face, thinking I would never see her again. Then I passed out. The cold snow rapidly refrigerated my body and plunged me into a deep hypothermic state. Ironically, the same frigid cold that threatened my life lowered my metabolism to the level of a hibernating bear and kept me in a state of suspended animation while my friends kept digging.

A faint "beep," "beep," "beep" from the avalanche transmitter I was wearing indicated where I was hidden under the avalanche debris. Precious seconds were ticking away as they dug frantically. Meanwhile, I was comforted by a

pair of angelic escorts who encouraged me to sprout wings and join them on a distant journey, when I was suddenly freed from my icy tomb. I wasn't breathing, but I still had a pulse.

My friends cleared my larynx, and a convulsive reflex caused me to cough up the ice that had been forcefully packed down my throat and into my lungs. At last, I was breathing again! But in my oxygen-deprived state, I was incoherent and argumentative for several minutes. They tried to reassure me, "Charley, you're going to be alright—you made it!" to which I kept saying "No, no, I'm dead!" They were talking to someone who had accepted his fate and thought he was still buried beneath the snow.

Within a few hours of the accident, I was resting and recovering at our glacier base camp. I was bruised from head-to-toe and I had a few scrapes, but I was feeling remarkably good considering what had happened. With a little Valium, I rested quietly and thought about what the accident meant to me. I had survived the avalanche by a very narrow margin. When you're young and brimming with adventure, you don't think that anything like that could happen to you. Accidents only happen to other people, right? So I concluded that this must be what some people call a "second chance"!

I'm not sure why it seems to take a close brush with death before we think seriously about our priorities. But that became all I could think about after the avalanche. What was I doing with my life? What changes did I need to make? How could I live more authentically?

Back then, I was working in a high-pressure sales-rep job in Colorado's skiing industry. I enjoyed an above-average income, and by all measures I had a successful career. But sales quotas and closing the deal didn't adequately define who I was. The accident made me realize that life is too precious to spend it doing something you don't enjoy. I had to make some changes. I could no longer tolerate doing something that I didn't believe in.

Some people dream of sailing a yacht around the world—my dream was to be a nature photographer. From that day forth, I began charting a course that would lead to a new career. I knew it would take a few years from the time I started calling myself a photographer to when I could actually produce an income as one. Sometimes that was pretty scary, because I walked away from the security of a job that I had built up over a decade and jumped headlong into the stormy seas of an uncertain photography career.

About two months into my fledgling new profession, I was reading the autobiography of pioneer landscape photographer, William Henry Jackson. *Time Exposure* is a fascinating account of a life that spanned the birth of landscape photography to the era of modern 35mm cameras. In his remarkable 99-year lifespan, Jackson traveled with the Hayden survey party in the 1870's and made many historic photographs, including the first pictures of the area we now know as Yellowstone National Park.

My all-time favorite Jackson photo is called "Photographing In High Places." It shows Jackson and his assistant standing on a high mountain promontory, preparing to take a photograph of the west side of the Teton Mountain Range. I had seen this photograph many times and enjoyed it because it was a rare photograph of Jackson at work with his legendary camera and equipment. In all the previous captions for this picture that I had seen, the identity of his assistant remained a mystery. But in his autobiographical account, I was amazed to read that the young man standing next to him in this 1871 photograph was someone named Charley Campbell! In my dream of dreams I would have loved to have been William Henry Jackson's assistant. Reincarnation, anyone?

You might say it was a circuitous route, but nature photography did eventually become the same powerful force in my life that Lowell found in flying. Now I can't imagine doing anything else with my life that could be more meaningful. When I'm hiking and taking pictures along a peaceful nature trail, I'm working at what I love. You know you have the right job when what you do on vacation is the same thing you do for a living. Whenever some setback makes me wonder if I made the right decision, I recall my conversation with Lowell and the grim lesson of the avalanche. Since then, I've discovered that outdoor photography enhances my backpacking adventures by sharpening my observation skills and opening my eyes to finer details that I would otherwise overlook. And the adventures have enhanced

my photography by leading me to the best locations for taking pictures—a perfect marriage of interests!

I wrote *The Backpacker's Photography Handbook* for all who love the rigors of the wild outdoors and share a passion for photography. I hope you'll benefit from my practical tips on how to take better pictures and travel safely through wilderness terrain. Some of you are already avid backpackers and want to savor your wilderness experiences by bringing back some of its wonder on a roll of film. If you haven't done much hiking or backpacking, you may suspect that backpackers are having all the fun. Well, you're right! And the sooner you get started, the sooner you'll find unique images by leaving the road, hiking up a trail in the Sierras, gracefully paddling a placid lake in the Adirondacks, or skiing virgin snow slopes in Colorado.

Either way, this book assumes that you have more than a casual interest in photography. If your concept of outdoor photography is shooting through the open window of a moving car, then you probably don't need this book or any other to help you. From inside a car, you'll never understand why so many of us willingly battle mosquitos and muddy trails only to return home with sore feet and aching backs (perhaps we do it because it feels so good when we stop). At any rate, nature photography can't be done without spending a great deal of time outdoors. This reminds me of an oft-quoted remark by Willy Sutton. When he was asked why he robbed banks, he replied "That's where the money is!" You and I have the perfect excuse to leave on another wilderness trip— that's where the photographs are!

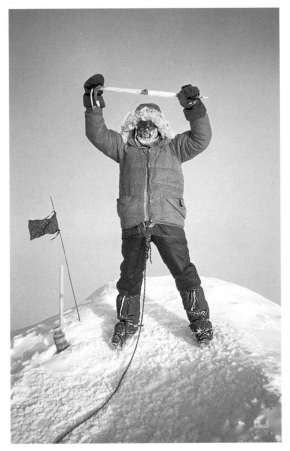

Here I am at 20,320 feet above sea level on the summit of Mt. McKinley, North America's highest mountain. For years I only grudgingly carried a camera with me while participating in many exciting adventures. Back then, I had a love/hate relationship with my camera—it was always in the way while I was skiing or climbing if I kept it handy enough to use. If it was safely tucked away in the pack, then it was less bothersome, but I missed out on a lot of good shots. Still, shots like this one kept me fascinated with outdoor photography.

THE WILDERNESS PHOTOGRAPHER

All of us who use cameras know the exhilarating experience of shooting a roll of film, followed by the wondrous anticipation of getting that first glimpse of the slides or prints when they come back from the photo lab. Even the most jaded, overworked professional photographers, who shoot thousands of images each year, anxiously fumble and tear at the boxes to see how their latest pictures came out. Capturing light on a piece of film is a magical experience for all of us. With each roll of film, we strive to make our images better and more consistent.

But photographers are also no strangers to disappointment. Remember how absolutely certain you were that your shot from a mountain's summit was the picture you always wanted for your living room? Why didn't the picture capture the same excitement you felt when you took it? What happened to the magic? The cold truth is that, unlike you, your camera shares no excitement about your subject. The camera

AUTUMN COLORS, Chequamegon National Forest, Wisconsin. Nikon F4s camera, 300mm f/4 lens, Bogen 3021 tripod with Foba Super Ball head, Fujichrome Velvia.

There is a rush of adrenaline as the idea for a photograph is born. Every time it happens, I feel privileged to experience that special moment and endeavor to capture it on film.

doesn't try to help you in any way. It sees what you point it at with absolute objectivity. While some things look better on film than they did in person, most things don't look as good. It takes experience to learn how to capture that magic on film.

The first test of a good photograph is whether it has any glaring technical flaws. Is it out of focus? Is the exposure bad? Is the horizon tilted? Any of these errors will immediately destroy an otherwise good shot. Then there are more subjective elements that cause us to react positively or negatively to an image. Was the composition good? Was the lighting the best

for this situation? Does the image show creativity? The third test is emotional reaction. What is the viewer's first response to the image? Is his or her reaction limited to an off-handed remark such as, "that's nice," or is it what we all want to hear: "Wow, how did you get that? Where was it taken?" If it is an exceptionally good shot, the viewer will want to linger over its qualities. The highest marks go to images that are powerful and thought provoking no matter how many times we see them.

Anyone can take a good picture now and then. When you learn how to capture the excitement of the moment with consistent results, then you are relying on skill instead of luck. The challenge is to use your camera and film so that they become a conduit for your personal vision.

One of the unexpected pleasures of outdoor photography is that it develops a keener vision that deepens our appreciation and understanding of the natural world. In fact, each of us has a unique and valid way of seeing the world. With this unique vision comes the opportunity

to make photographic images that bear our unique stamp as individuals. As we strive to see with greater awareness, taking pictures becomes part of a greater experience that fills our lives with joy and purpose.

We all have strengths and weaknesses that impact our photography as well as the rest of our lives. Achieving perfection is unrealistic, but challenging oneself to do better is something that every artist needs to do. Photographers should strive for improvement in five key areas of their work: passion, creativity, skill, time, and tenacity.

Passion. There is an icy coating of frost on your tent, and you're warmly snuggled in a down-filled sleeping bag. Will the reveille of a 4:30 AM travel alarm clock be sufficient persuasion to rouse you in the dark to photograph the sunrise? The answer is yes if you have an inner passion for photography and a deep appreciation of nature. At such times, I often think, "Sleeping and eating can be postponed, but events in nature won't wait for me!"

Creativity. Creative photographers have a way of photographing ordinary subjects to make

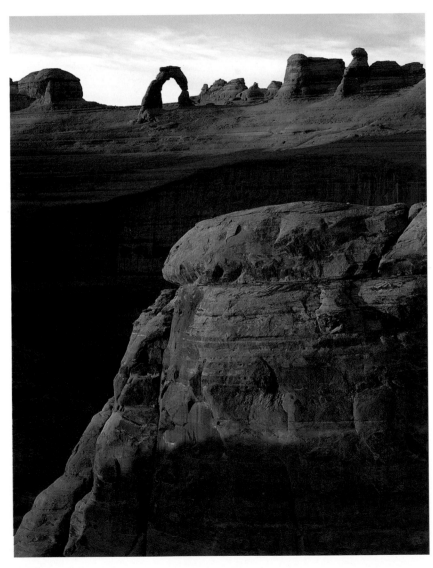

DELICATE ARCH, Arches National Park, Utah. 4 x 5 Linhof Master Technika camera, 300mm lens (equivalent to 100mm in 35mm format), polarizer, Bogen 3021 tripod with Foba Super Ball head, Fujichrome 100.

As I hiked up a ridge in Arches National Park to this viewpoint, I noticed in the foreground a monolithic rock, brilliantly lit by the setting sun. But instead of taking the picture at that point, I decided to hike farther until the edge of the rock aligned with the background to lead the viewer's eye up to the Delicate Arch. By paying closer attention to graphic lines and shapes that build strong pictures, I made a much better photograph.

extraordinary pictures. Isn't this precisely what excites us about photography? It refines and clarifies our everyday existence with visually stimulating moments. We reach photographic bliss whenever we manage to successfully communicate what we experience in nature. It is exciting to think that a particularly powerful, emotive photograph may achieve an immortality that outlasts its creator.

Skill. A recipe for taking good photographs could be expressed as blending 50 percent skillful seeing with 50 percent skillful shooting. Good images obviously have to be found before they can be photographed. This is where having a "good eye" for what constitutes a creative image comes in handy. Once the subject for an image is found, a skillful application of camera technique completes the task. When the light is fading fast and an ideal photo opportunity demands immediate action, you don't want to fumble with your equipment.

Time. Good photographs don't happen when you arrive at a place at high noon, the lighting is bad, and you have just 30 minutes available for photography. Nature doesn't revolve around your schedule. Fishing makes a good analogy—you have to keep the worm and hook in the water long enough to catch a fish. Too many people think that they can take good pictures on their timetables. They are wrong—you must be willing to work on nature's timetable.

To make best use of their time, many photographers develop expertise in such specialized fields as wildlife, landscapes, or closeups. Another good approach is to concentrate on a specific geographic region. This way you don't spread yourself too thin by trying to cover more area than you reasonably have time for exploring. Don't rush. Enjoy yourself as you hike and explore with a camera. Give yourself permission to relax and take pleasure in the process of photography as well as the end results.

Tenacity. At the beginning of a long photography trip, I'm usually brimming with enthusiasm and excitement. A few days later, I start to feel that I've blown it and can't remember how to take a decent picture. I frequently have to give myself a pep talk and resolve to work even

harder. I suppose there is just the right amount of cheerleader in me to keep going even when the wind is blowing, the light is all wrong, my back is sore and the mosquitos want to have me for lunch.

IN SYNC WITH NATURE

Every nature photographer needs to enjoy hiking because it takes a lot of hiking around to find good photographs. Good shots seldom just drop in my lap. I take my best photographs of a place after a day or two of shooting there. It takes time to uncover the secrets of a new area, and then synchronize my hiking and photography activities with the local natural rhythms.

A good way to start synchronizing yourself with nature is to plan your daily photographic schedule around the best light. I would rather have good lighting to work with than have a good subject and poor lighting. The warm, directional light of the early and late hours in a day are cherished for how they favorably record light on film, so reserve sunrise and sunset for photography. If you are on vacation with your husband or wife and kids, tell them that you'll be occupied around those hours, but the rest of the day can be spent freely with them. If you are climbing, backpacking, or river rafting, you'll need the greater portion of the day to get to the next destination anyway, so photography isn't likely to interfere with the group's plans during those hours.

My rule of thumb is to be on site and ready to take pictures half an hour before sunrise and an hour before sunset for the best light. I stay with the light and continue taking pictures until the light deteriorates. One of my top priorities on each new photography adventure is to determine an accurate time for sunrise and sunset, based on actual field observation. Next, I take an accurate compass reading of where the sun comes over the horizon at sunrise and another reading at sunset. With these simple compass bearings, I can then predict exactly where the sun will appear for the next couple of days, which lets me include the sun as an element in my images if I so desire. If you don't gather this information ahead of time, you may miss opportunities that can't be repeated.

Over the years, I've developed a sixth sense that constantly evaluates the environmental

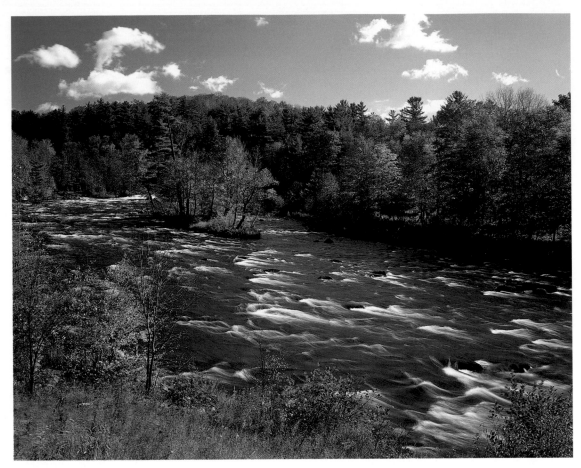

OSWAGATCHIE RIVER, Adirondack State Park, New York. 4 x 5 Linhof Master Technika camera, 180mm lens (equivalent to 50mm in 35mm format), polarizer, Bogen 3001 tripod with Linhof Profi II head, Fujichrome 100.

Every nature photographer should enjoy exploring on foot, because a lot of hiking goes into finding good shots. I walked for 3 miles along the Oswagatchie River until I found just the view I wanted.

factors affecting my photography. I especially watch for the quality of light: color, direction, contrast, and intensity. Any change in the weather can have an impact on my methods and activities as a nature photographer. I am constantly trying to second-guess what the weather will do next. For example, if the day is cloudy, I abandon taking scenic images and head into the woods where the soft light from

the clouds permits good images that aren't possible in more contrasty light. Eastward-facing terrain is generally best photographed in the morning hours, and westward-facing terrain is best seen in the afternoon. A steady, vexing wind is a photographer's worst enemy. You might as well forget about taking pictures in windy weather and resign yourself to just enjoying the hike.

Is your interest nature photography? Then it is vital to study nature as much as photography. I am a professional photographer, but I am an amateur naturalist, too. Combining knowledge in these areas is similar to being a surgeon who needs to know a great deal about anatomy as well as the techniques of surgery. You can't effectively photograph nature if you don't know something about it.

It is important to know when your subject will reach its peak form or when conditions are

most favorable for photography. For example, columbine wildflowers in the high alpine meadows of Colorado are usually at their peak bloom during the second week of July. It would be a mistake to take your annual vacation in June if you're looking for columbines. In the desert southwest, flash flooding and quicksand are more likely in the slot canyons of Arizona and Utah from July through September. Fall colors reach their peak in the Tetons during the last week of September. And polar bears congregate in Churchill, Manitoba from mid-October to early November. Knowing about your subject is as important as your skill with photography equipment.

Where to Go. I can't walk by a well-stocked magazine rack or calendar display without stopping to study the photographs. My favorite information sources for hiking and photography destinations are photography magazines, *National Geographic Traveller* and *Backpacker* magazines, coffee-table photography books on different regions, and Sierra Club and Audubon calendars. Another favorite resource is DeLorme Mapping, a company that sells a series of atlases that include the topographic maps for entire states. These atlases are loaded with information on public lands, back roads, trails, and geographic features that can help you plan a hiking, biking, or river trip. To organize this growing body of information, I maintain a database on my computer with tips on places to go for hiking and photography trips, and the optimal times to visit.

Some of the best places in the United States for nature photography are:

- National parks, monuments, and recreation areas
- State parks, forests, and recreation areas
- National forests
- Bureau of Land Management areas
- Wildlife refuges
- Nature preserves
- Botanical gardens
- Wilderness conservancy lands
- Wildflower and wildlife sanctuaries

America's great system of national parks and monuments are right at the top of the list for great photography trips. The parks are staffed

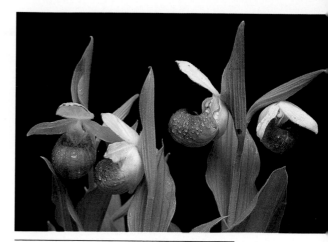

SHOWY LADYSLIPPER ORCHIDS, Wisconsin. Nikon N8008 camera, 55mm macro lens, Bogen 3021 tripod with Foba Super Ball head, Fujichrome 50.

These delicate flowers bloom very briefly in early June. I timed my trip to Wisconsin to capture them in peak form but had no assurance that I would find them in good condition. If they aren't quenched by rainfall every few days, they turn brown and wilt prematurely.

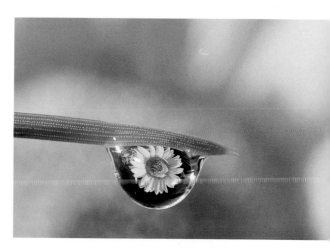

WATER DROPLET REFLECTING A FLOWER. Nikon F4s camera, reversed 24mm lens, SB-24 flash, Bogen 3021 tripod with Foba Super Ball head, B-15 macro focusing rail, Fujichrome Velvia.

Photographic opportunities exist close to home as well as faraway. I photographed this water droplet on a pine needle along a hiking trail near my house. The image was taken at 2X magnification, which is twice life-size.

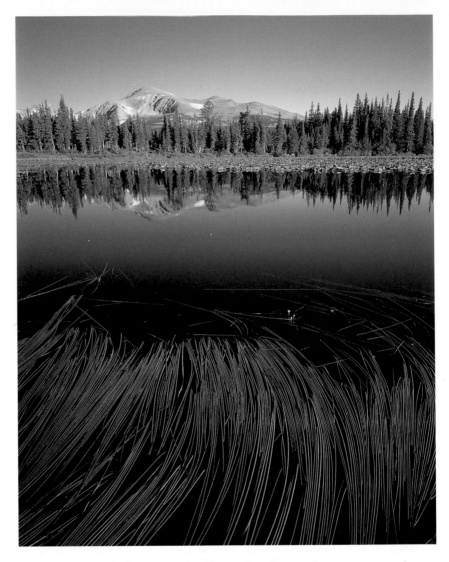

MT. AUDUBON, AND GRASSES FLOATING IN RED ROCK LAKE, Indian Peaks Wilderness, Colorado. 4 x 5 Linhof Master Technika camera, 120mm lens (equivalent to 35mm in 35mm format), Bogen 3021 tripod with Foba Super Ball head, Fujichrome 100.

Colorado's Indian Peaks Wilderness Area is only 30 minutes from metropolitan Denver and its sprawling population of almost 2 million people. But this designated wilderness is protected from development.

with willing and knowledgeable personnel who can help you put together a photography hike or backcountry trip. And you'll find superb bookstores at the visitor centers. These book stores often stock maps, trail guides, and flora and fauna identification books that can't be found anywhere else. The topographic maps they sell are almost indispensable for backcountry and wilderness travel. If there is a movie showing in a visitor center's auditorium, watch it to gain a general overview of the most unique aspects of the park.

Another tactic is to study postcards to uncover the best scenic viewpoints and natural land-marks of a region. Postcards can save you days and even weeks of research by revealing key geographic features and good viewpoints for photography. For example, a postcard photograph can reveal a lake or waterfall's photogenic potential in ways that a map can't, which will save you precious time. I don't advocate copying the shots, but use postcards as launching pads to stimulate your creative juices, and then try to capture your own unique images of an area.

Taking a fresh and original picture can sometimes be a challenge in popular places where photographers congregate. The most famous

landmarks in the national parks have been photographed endlessly by both amateurs and professionals. If you're somewhere such as Yosemite National Park, chances are that the best vantage points were photographed many years ago, making it difficult to find fresh perspectives of the major attractions. But there is nothing wrong with wanting to make your own photographs of these national icons. In fact, it is exhilarating to plant your tripod in the same spot where Ansel Adams or William Henry Jackson took their famous images.

Believe it or not, it is still possible to take unique photographs of even the most over-photographed scenes. Some strategies for fresh perspectives might be to try shooting with an unusual lens, such as a 20mm wide-angle; record such unique weather occurrences as lightning or fog; wait until dusk, and start a time exposure that records star trails; find a good foreground full of wildflowers; and use fill-flash technique at sunrise.

Some of the most useful tips on interesting areas come from casual conversations with local residents. Sometimes they're eager to show off their knowledge of favorite local places that are otherwise well-kept secrets. I once found the best map of southern Colorado mountain passes from a jeep rental dealer. That map led me to some spectacular high-altitude scenery. When I complimented the manager on a flower photograph he had taken and displayed on his office wall, he let me in on his secret spots for the best wildflowers then blooming.

Also, don't overlook what is in your own backyard. I used to believe that good photography only took place in distant and exotic locations. But next to my house is an open prairie with abundant wildflowers, birds, and prairie dogs. I've found that there are endless opportunities to photograph closeup subjects or to practice with new camera equipment.

From my travels around America, I've developed an emotional bond with some of my favorite photography locations. I sometimes wonder how events or conditions in these places are progressing, just as I wonder about old friends I haven't seen in a while. In Redwood National Park, for example, I love to photograph the rhododendron bloom at its peak around Memorial Day. Each Memorial day, no matter where I am, I wish I could be there to see if its a good bloom this year or how local weather patterns have affected it. I can actually see myself hiking up the foggy trail amongst the giant Redwoods. Or I might be shooting in Utah's Canyonlands when its silent, expansive beauty at sunrise triggers a distant memory of a special sunrise a few years earlier in Death Valley on the Mesquite Flat Dunes. In January while I'm sitting in front of my computer writing, my thoughts often drift to Teton Pass near Jackson, Wyoming, and the best day of back-country powder skiing I've ever had. Outdoor photography can enrich our lives in so many ways. It is hard to imagine a more worthwhile activity for a life of outdoor adventure.

Become a Friend of Wilderness. We are now witnessing the cumulative results of mankind's reckless treatment of the environment. National parks and monuments are sadly becoming the last places where we can get away from civilization. Outside of the national park system, the landscape has rapidly visually degraded. The evening sky is no longer dark enough to see the stars because of the glow of city lights. Roads and power lines crisscross the landscape like spider webs. I once counted 22 sets of ugly vapor trails from commercial airliners hanging in the sky over Monument Valley. Wilderness is shrinking, and our opportunities to return to nature are becoming more limited.

If you're a friend of wilderness, consider joining the legions of concerned citizens who belong to conservation groups like the Sierra Club and The Nature Conservancy. Working together, we can pool our voices collectively for greater political clout. It looks as if the 90's can be an exciting decade of new environmental awareness. People are waking up to the fact that we are dealing with limited resources, and that growing populations and industry have to co-exist with the environment. But we will always have to fight to save the remaining wilderness. They're not building anymore wilderness, only tearing it down. The camera can be a powerful political weapon in the battle. Through our photographs, we can extol the scenic and revitalizing virtues of a vanishing wilderness, and the dire need to save irreplaceable ecosystems.

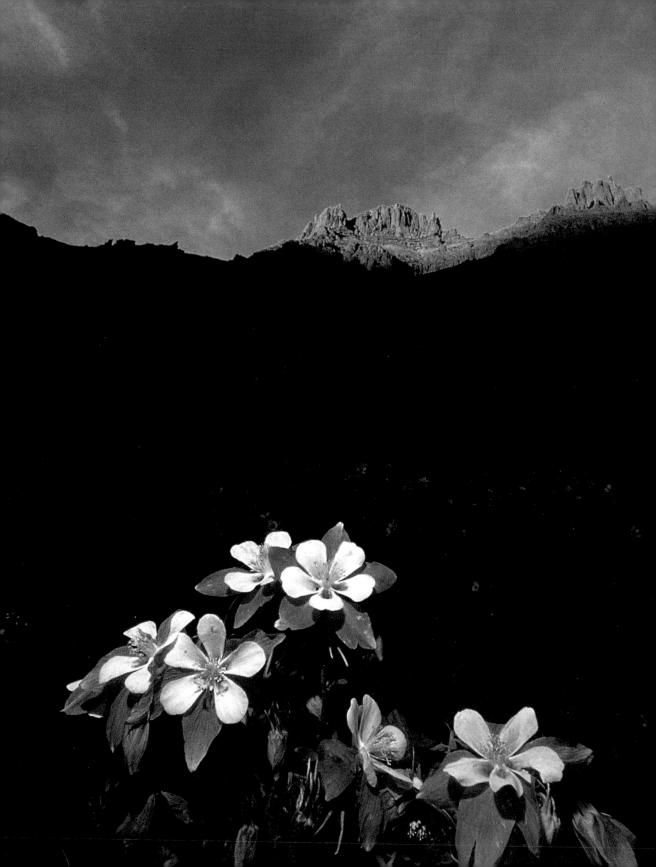

ANATOMY OF A PHOTOGRAPHIC SYSTEM

Your passport to adventure
is your camera and lens.

From a wilderness adventurer's perspective, camera equipment can be divided into three categories: heavy, heavier, heaviest! By the time you add up the weight of a tent, sleeping bag, stove, food, extra clothing, first-aid kit, and so on, it can seem as if you're carrying the equivalent of a house on your back. Sometimes, putting a camera on top of an otherwise hefty load seems like the proverbial straw that broke the camel's back. "No, no, no, please, I can't carry anymore *lightweight* gear!"

Wilderness photographers wear two hats: hiker and photographer. This dual role demands a constant compromise between what photography equipment we would ideally like to bring and our physical capability to carry it long distances. I've been known to sacrifice my personal comfort and mobility on hiking and backpacking trips so that I could carry a few more lenses and photography gadgets. Why? Because every time a "gear head" like me leaves something behind—a lens, a tripod, a

macro focusing rail, or even a small filter to save weight— that is the piece of equipment I seem to need over and over again on that trip. It never fails!

So how are you supposed to know in advance what kind of images you'll want to take and what gear you'll need? My answer is to fill my backpack with the camera gear first, then add the hiking and camping gear on top of it. If there is no room left for food and water, then so be it! It's a matter of priority. (I'm just kidding...sort of.)

If weight were our only concern in choosing camera equipment, then this would be a very brief book on how to use an automatic point-and-shoot camera. However, people who take photographs for a living own a great deal of equipment and use practically all of it on a consistent basis. Before every hike, I have to ask myself: How many items can I reasonably afford to leave out before my photography starts to suffer? In other words, when is more equipment better, and when is carrying less equipment a better strategy?

I use both 35mm and large-format camera equipment. I never carry both at the same time! That would require a sherpa or two to share the load. If I could, I would prefer to shoot with 35mm equipment full time, as it is more portable and versatile than using a view camera. But a view camera has certain advantages over 35mm or medium-format equipment. View cameras offer tremendous creative control over the final image through their tilt, shift, and

COLORADO COLUMBINES, Colorado. Nikon F4s camera, 20mm f/2.8 lens, SB-24 flash, Bogen 3021 tripod with Foba Super Ball head, Fujichrome 50.

These wildflowers were captured at sunset with a TTL flash by balancing the exposure of the distant peak with the flash exposure of the flowers. With the hyperfocal distance set for f/22, I took a spotmeter reading of the sunlit mountain, recomposed the image, and shot it at f/22 for 1 second with the flash set to "rear-curtain sync."

swing controls. And a large 4 x 5-inch transparency is capable of stunning clarity and detail.

Many of the images in this book were taken with a 4 x 5 view camera. I hike and backpack with this equipment despite the fact that it is tremendously heavy. My Linhof field camera, five lenses, film, tripod, and accessories weigh between 45 and 50 pounds in a padded photography backpack. At every opportunity, I like to ditch the heavy equipment in favor of moving light and fast through backcountry with a simple assortment of 35mm equipment. I call these fast-paced trips, usually around sunrise and sunset, "blitzkreigs" (see pages 52–54 for some of the options available for exploring the backcountry with different amounts of camera equipment).

Owning a lot of equipment has never been the ultimate solution to becoming a better photographer. I wish I could tell you exactly what equipment to buy and use. But I can only tell you what works for me and for others who use this equipment on a daily basis. Cameras, lenses, and films are nothing more than the tools you require to communicate your "personal vision."

35MM CAMERA SYSTEMS

Your current specialty might be wildlife photography, but a year from now you might be hooked on closeup work and suddenly need a specialized macro lens in order to photograph the proboscis on a mosquito's face! If you're serious about photography, it is prudent to invest in a camera brand that offers a line extensive enough for you to upgrade or add items as your future needs dictate. My work requires everything from a 6mm fish-eye lens to a monster telephoto. Also, I'm constantly upgrading items and adding accessories, so I find it imperative to buy within a camera system vast enough to match all my needs. Nikon is the largest integrated camera system available, and Canon is second largest. For this reason most professionals use one of these two systems.

Because photographers tend to place a great deal of emphasis on selecting a specific camera model, we sometimes forget that the camera body itself is basically a light-proof box that houses the film and an exposure meter. The technical quality of the image is more directly linked to the lens' ability to gather light and deliver a high-quality image to the film plane, so don't save your pennies to buy an expensive camera body and then go shopping for an "el cheapo" lens. Carefully consider the lens selection that a manufacturer can offer you.

Whichever camera you own, it is usually best to buy lenses made by that company. Camera manufacturers now design equipment so that the components operate as an integral system. The camera, lens, and flash are now designed to exchange important electronic information that makes exposure, focus, and special effects faster and more accurate. The system capabilities of camera equipment are a powerful incentive for staying with one brand, so that you can employ the system to optimum advantage.

The superb optics of the more than 70 Nikkor lenses are a good reason to buy a Nikon camera. I also appreciate the fact that Nikon designs their equipment with a minimum of obsolescence. A Nikkor lens made in 1959 still works on their latest, most sophisticated cameras. I have been a Nikon user for 19 years, so I am most familiar with the Nikon system. If you own another camera system, you can generally find suitable equivalents to the equipment I use and recommend in this book.

One of the best justifications for buying high-quality camera gear is that when you own the best, you have no one to credit or blame but yourself when the pictures turn out well or fail. As mentioned, the top contenders for extensive professional quality systems are Nikon and Canon. Clustered closely behind are four fine manufacturers: Contax, Minolta, Olympus, and Pentax. I wish I could choose the best cameras and lenses from each product line and combine them into my own customized super-duper system, but a Canon lens, for example, won't fit on a Nikon body. I wonder why!#*?

Camera makers wisely offer a line-up of camera bodies that allow you to go directly to the top-of-the-line model or start out lower and upgrade over time. Your first camera body should have certain features that won't restrict your ability to take pictures. I call these the "essential features," and they include:

Full Range of Shutter Speeds. Longer shutter speeds of 1-30 seconds are often necessary to

CHECKER-SPOT BUTTERFLY. Nikon F4s camera, 105mm f/2.8 macro lens, SB-24 flash, Stroboframe flash bracket, Fujichrome Velvia.

This butterfly was photographed with a handheld camera and a TTL flash. TTL flash units produce highly accurate exposures because they instantaneously measure light at the film plane and control the duration of the flash.

shoot in the dim light of sunrise and sunset with slow-speed films. Be sure your camera also features a "B" or "T" setting for low light and night photography, which will allow you to open the shutter for as long as the shutter release button is depressed or for as long as a cable release locks it open. Ultrafast shutter speeds over 1/1,000 sec. are rarely used by nature photographers.

Manual Metering. Yes, manual metering is still important. Some subjects are too light or too dark to give you correct exposure readings if you rely solely on auto-exposure. Also, having a choice of shutter speed and f-stop gives you creative control over how the subject records on film. Shutter speeds can freeze action or blur it. And f-stops control the zone of sharp focus called "depth of field."

Depth-of-Field Preview Button. Single-lens reflex (SLR) cameras are designed so that you can conveniently view the scene through the lens' widest, and thus brightest, aperture. When the picture is taken, the lens momentarily stops down to the aperture you have selected. To check the zone of sharp focus in your composition, you must be able to stop the lens aperture down and actually preview the depth of field before you take the shot. If your camera does-

n't have this feature, sell or trade it. You can't do nature photography without depth-of-field preview.

Metering Mode Options. Different metering modes can be useful for taking exposure readings. Among these are: matrix metering, which analyzes the exposure from a multisegmented image; center-weighted metering, in which 60-70 percent of the reading is concentrated in the center of the viewfinder; and spot metering, in which a small 2-percent area of the subject or scene can be analyzed for precise exposure calculation.

Motor Drive. This device automatically advances the film after the shutter-release button is pressed, so the photographer is always prepared for the next exposure. This feature is almost indispensable for wildlife and action/sports photography because the photographer can focus on the subject without looking up to cock a film-advance lever. Nature photographers seldomly use the rapid-fire capability of a high-speed motor drive in the way journalists do to cover a sports or news event.

ISO Adjustment. The film's sensitivity to light is called its ISO (International Standards Organization) rating, or film speed. The ISO number is

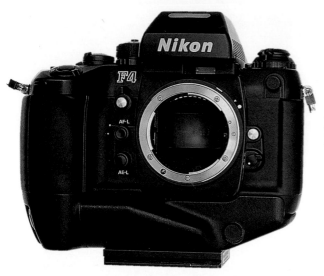

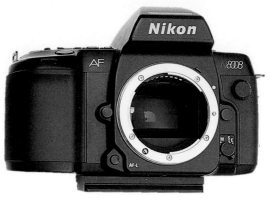

printed on the film box and film cannister. Generally, a camera should be set at the recommended ISO so that the camera's lightmeter is using the proper film speed in its calculations. But there are certain situations in which it is desirable to customize the ISO by setting it at something other than the recommended number. For example, you can push films by resetting the film speed.

Through-the-Lens (TTL) Flash. Most cameras are now made with this feature. TTL flash simplifies flash exposures in the field by measuring light at the film plane and controlling the flash duration. For closeup flash photography, TTL flash is a must feature. It is also great for fill-flash where you want to balance the flash exposure with the ambient lighting.

Cable-Release Capability. Be certain that the camera can use a cable release to trigger the shutter away from the camera. Some cameras use a simple manual cable release and others require an electronic cable release.

Interchangeable Focusing Screens. The focusing screen delivered as standard issue with your camera may not be your best choice for outdoor photography. What you need is a simple, bright focusing screen that doesn't require any focusing aids. Especially avoid screens with split-center prisms, as these sometimes partially "black out" with telephoto and closeup pho-

tography lenses. If your camera offers the option of replacing the screen, I suggest choosing a plain matte screen with an architectural grid. The architectural screen has a grid overlay with fine vertical and horizontal lines that are useful for composing the image and leveling the horizon.

In addition to the essential camera features listed above, here is a list of what I call professional SLR features. Most professional photographers would find them essential, but not everyone needs them:

Mirror Lock-Up. Few cameras have this great feature that eliminates camera vibration when the mirror snaps up during an exposure. Mirror lock-up is very useful with big telephoto lenses and in closeup photography when even the slightest vibration from the camera itself can blur the image. Shutter speeds between 1/4 and 1/30 sec. are especially prone to showing vibration when used with telephoto lenses 300mm or longer.

The reason this feature isn't commonly available in more cameras is that it requires an expensive modification to normal camera design. The problem is that once the mirror is locked up, light can leak past the shutter and fog the film. With the mirror in the normal down position, it isn't a problem, but with the mirror locked up, it is. The Nikon F4 has a second shutter that acts as a light-proof baffle, preventing such leakage.

100 Percent Viewfinder Coverage. With most cameras the viewfinder doesn't show the entire image area that will be recorded on film; you actually see only 92 percent. This is an industry-wide standard that is supposed to take into account how much of the final slide will appear when it is masked in a cardboard mount. In other words the camera records 100 percent, but you see a cropped version that is 92 percent of the image.

This is one of those concepts that seems like a good idea in theory. But in reality, the slide mount barely overlaps the image—maybe only 1 percent, which means that with 92 percent viewfinder coverage, you aren't seeing about 7 percent of the image that will appear on the final slide. This explains why so many surprises show up around the perimeter of your images even though you remember critically framing the edges of the image. The Nikon F4 is one of the only cameras that features 100 percent viewfinder accuracy, and it is a very handy feature for critical framing of the image.

Multifunction Control Back. Data backs, or multifunction control backs, add such useful capabilities to the camera as automatic bracketing, long time exposures, freeze focusing, and interval timing between shots.

Exposure Compensation. This feature allows you to set an intentional overexposure or underexposure in the appropriate situations by selecting a desired amount of exposure compensation, usually in 1/3-stop increments. Exposure compensation usually functions in aperture-priority or shutter-priority but not in manual mode.

Off-Camera Dedicated-TTL Flash. The ability to remove a flash unit from the camera hot shoe expands your creative possibilities. The flash remains connected to the camera with a special cord that facilitates TTL metering. Dedicated flash means that the flash and camera continue to operate as one unit even though the flash is being used on an extension cord.

Multiple Exposure. Interesting special effects can be created by making multiple exposures on the same frame of film.

Nikon's top-of-the-line F4 model has virtually every important feature discussed. Below the F4 there are the N90 and N8008 models that have most of the advanced features of the F4. Both of these are excellent alternatives to the more expensive F4. I generally use the F4 as my primary camera body and carry a N8008s body as a lighter backup. The F4 is my primary camera because it has such important features as mirror lock-up and 100-percent viewfinder accuracy, which many other cameras don't have. It is also more rugged and reliable than virtually any camera on the market and I can testify that it can take a beating and still keep going.

I use the N8008 when I need a lighter camera for longer hikes, climbs, or ski tours. I don't like the fact that the N8008 needs an electronic cable release instead of a simple plunger cable release. This means that I have to carry two types of cable releases. I also miss the fact that the viewfinder doesn't give me such information as the frame number and the aperture when I use manual focus lenses. I have to take my eye off the subject and look at the top panel of the camera to check this information. But the F4 has a less versatile shutter-speed range, only as long as 4 seconds in the manual exposure mode, while the N8008 has a more useful shutter-speed range of up to 30 seconds.

Point-and-Shoot Cameras. These cameras are remarkably sophisticated for their size. They use standard 35mm films and are so automated that they require little expertise to use. Their small size and agility have earned them the appropriate nickname of "point and shoot."

I mainly use these cameras in situations where I wouldn't want to expose more expensive equipment to risk. Weather-resistant and waterproof models are particularly well suited to raft trips and backcountry skiing where moisture, sand, and dust can be a problem for expensive equipment. They can fit in a coat pocket or a fanny pack where they are close at hand so you don't miss any of the action. There is no need to fuss with focusing or metering because everything is calculated automatically. The built-in flash units are ideal for candid portraits. These cameras are fun to use because they are so spontaneous. Look for useful features like weather resistance or waterproofness,

autofocus, autoexposure, zoom lenses, built-in electronic flash, self-timer, tripod socket, a wide range of film speeds, and the ability to screw filters into the lens.

Batteries. Today's sophisticated electronic camera equipment is highly dependant on battery power. With the equipment I generally use, the Nikon F4 camera body needs six AA batteries, the N8008 needs four, the SB-24 Flash needs four, and the SD-8 battery pack needs six more. In addition, I need about ten more AAs for backup. Whenever I go out on an important shoot, I like to replace all these batteries with fresh ones, even if they aren't dead yet. Eventually, the expense and environmental impact of frequently replacing all these batteries was enough to force me to search for a practical solution.

Several years ago, I started experimenting with rechargeable Ni-Cad batteries. They seemed like the perfect solution, but I was never quite happy with the results. The batteries went dead on me sooner than alkaline batteries. And they required 8-16 hours to recharge. So I gave up. Then in 1992, I discovered Millennium Ni-Cads. They're terrific! They have a lifetime warranty, they recharge in only one hour (using a Millennium charging unit), and they deliver 40-percent longer power than other rechargeables. They work better in cold weather than alkalines and shorten the recycling time of an electronic flash.

LENSES

The focal length you use determines how the image looks through the camera viewfinder. The narrow *angle of view* available from a telephoto lens makes a subject appear larger than the wider picture angle of a shorter focal length. The change in the size of the subject is due to the different angles of view that lenses have (see the box on the opposite page).

If you're using a 50mm lens and want to double the size of the subject, you would do so by doubling the focal length and using a 100mm lens. The subject is now twice as large without any change in your camera position. Moving in closer accomplishes the same thing, but this is often a difficult or impractical alternative to changing lenses.

Here is an example of how doubling the focal length works. Imagine that you spot a bald eagle sitting in a spruce tree. Using a 300mm telephoto lens, you discover that the eagle fills a quarter of the frame. But you want to feature the eagle more prominently in your composition. By switching to a 600mm lens, the eagle now fills half the frame. You can increase

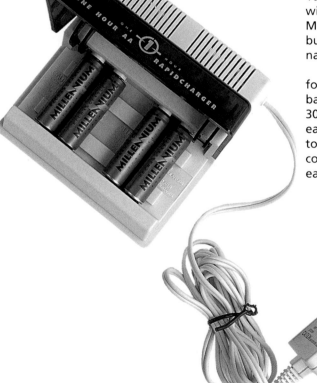

Among the longest-lasting and fastest-charging NiCad batteries are the Millennium Power Cells, shown here recharging in a CH4AAC1 Rapidcharger. These NiCads charge in only one hour and last 40 percent longer than other NiCad batteries.

or decrease the angle of view (and the size of the image) by increasing or decreasing the focal length of the lens. It doesn't matter whether your photographic subject is a tiny spider or Switzerland's Matterhorn.

Working distance is defined as the distance from the subject to the front of the lens. The longer the lens, the greater the working distance. While the advantages of greater working distance may be obvious in such situations as using a telephoto lens to maintain a safe working distance from a polar bear, it is also an important consideration in closeup photography. For example, if you are trying to maneuver a tripod close to a spider's web, a 60mm macro lens has only 4 inches of working distance when used at lifesize magnification. A 105mm macro lens would give you 8 inches. Using a 200mm lens would give you 16 inches to work with while maintaining the same magnification.

A lens selection from 24mm to 300mm is useful for general outdoor photography. This versatile range of focal lengths should work well for practically every subject you encounter. There are zoom lenses that practically cover this range with just one lens! But I find that the best way to have all these focal lengths is with a combination of zoom and fixed-focal-length lenses.

I like the way Nikon manufactures most of its lenses for two convenient filter sizes: 52mm and 62mm. Before you acquire a new lens, it is worthwhile to see if its filter size corresponds to the filters you already own. Otherwise, you may have the hassle of carrying duplicate filters in many sizes for different lenses.

Good-quality zooms are now equal in quality to fixed-focal-length lenses. Some of you may still be skeptical, but it is true. Today's zooms are so convenient and of such high quality that the only fixed-focal-length lenses worth using tend to be extreme focal lengths at both ends of the spectrum (for example, a 24mm wide-angle and a 300mm telephoto) or specialized lenses used for macro photography. Here are the lenses that I recommend using for outdoor photography:

Wide-Angle Lenses. These lenses have wide angles of view that can convey a lot of visual information. Wide angles tend to emphasize

ANGLES OF VIEW FOR 35MM-CAMERA LENSES		
Lens Category	Focal Length	Angle of View*
Wide-angle	20mm	94 degrees
	24mm	84 degrees
	28mm	74 degrees
	35mm	62 degrees
Normal	50mm	46 degrees
Telephoto	105mm	23 degrees
	135mm	18 degrees
	180mm	13 degrees
	200mm	12 degrees
	300mm	8 degrees
	400mm	6 degrees
	500mm	5 degrees
	600mm	4 degrees
	800mm	3 degrees

*At infnity focus.

the visual importance of objects close to the camera and decrease the importance of objects farther away, because they portray closer objects as larger than distant objects. Use these lenses carefully; they can easily include too much of a scene and reduce a towering mountain range into an insignificant bump in the distance. The most common wide-angle focal lengths are 20mm, 24mm, 28mm, and 35mm.

The most useful wide-angle lens for outdoor photography is probably the 24mm, commonly employed for the classic shot of a foreground of beautiful wildflowers with a towering snow covered mountain in the background. With a 24mm lens you can be within 12 inches of the flowers and still hold the mountain in focus. The 24mm's enormous depth of field or zone of sharp focus makes this lens indispensable for landscape work.

For the past few years I have been using a 20mm as much a 24mm. I like the way I can move very close to a subject and with a 20mm lens still include a lot of background. The 20mm has an angle of view of 94 degrees compared to the 24mm's 84 degrees. But the 20mm's ultrawide angle of view can distort images, so

without considerable practice, it can cause difficulties. I don't use a 28mm lens because I find the 24mm and 35mm are indispensable, and the 28mm falls awkwardly in between.

I strongly recommend that your 20mm and 24mm lenses be fixed focal lengths and not zooms. I don't like zooms in this range because the manufacturers delete the depth-of-field scales from them or the scales provided are almost impossible to use with precision. The depth-of-field scale is necessary to properly focus the lens to include an important foreground and background in sharp focus (see pages 78–79). Another reason to avoid wide-angle zooms is that they are very prone to *lens flare*, a problem when direct light from the sun

(Left) ALPINE WILDFLOWERS, Colorado. Nikon F4s camera, 20mm f/2.8 lens, Bogen 3021 tripod with Foba Super Ball head, ND grad .6 filter, Fujichrome Velvia.

Working with a 20mm lens lets me get close to important foreground subjects, such as these multihued Indian Paintbrush wildflowers, and still include some background, which helps instill a sense of where the photograph was taken.

(Right) CYPRESS SWAMP, North Carolina. Nikon F4s camera, 300mm f/4 ED-IF lens, Bogen 3021 tripod with Foba Super Ball head, Fujichrome Velvia.

Next to a 24mm lens, the 300mm is my favorite for landscapes because it lets me search for the photograph within the photograph by using its narrow angle of view to isolate interesting pockets of pattern, color, texture, and form.

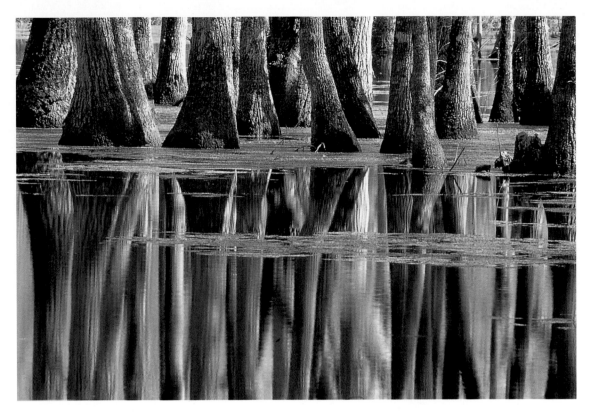

enters the front of the lens and ricochets off internal elements, which causes a glare of light to record on the film.

Telephoto lenses. Telephoto lenses compress perspective by decreasing the apparent distance between near and far objects. Landscape photographers generally use telephotos in the 100mm to 300mm range. In fact, next to a 24mm wide-angle lens, a 300mm lens is my favorite landscape lens. When I use the 300mm, I usually crop out the sky and try to isolate interesting pockets of patterns or colors in the landscape.

Wildlife photographers commonly shoot with 300mm to 600mm lenses to photograph small or distant subjects. To photograph birds and small mammals, you really need a telephoto longer than 300mm in order to fill the frame. Occasionally, even if you use a 500mm or 600mm lens, you may need to increase the focal length by adding a 1.4X or 2X teleconverter for even greater image magnification (see "Teleconverters" below). Around certain wild ani-

mals, such as grizzly bears and some African wildlife, you will probably need a 400mm or longer lens just to keep a safe distance from their sharp fangs and teeth.

My recommendation is to start with a 300mm telephoto such as the Nikkor 300mm *f*/4 ED-IF (*f*/4 is the lens' largest aperture). This is one of my favorite lenses because it is relatively compact and quite affordable compared to other telephotos. It focuses down to 9 feet, which is handy for photographing reptiles, snakes, small rodents, and flowers. It is an internal-focusing (IF) lens, which means it has an internal floating element that doesn't change the overall length of the lens as you focus between infinity and the minimum focusing distance. This speeds up focusing and prevents the loss of light due to extension. With a 1.4X teleconverter, this lens becomes a 420mm *f*/5.6, which extends its usefulness as telephoto.

Wide-Angle and Telephoto Zooms. A zoom lens simplifies precise cropping of the image without making you change the camera's position.

This can be crucial when you're working at the edge of a cliff, or the edge of a swamp or lake where your mobilitiy is restricted.

In wide-angle zooms longer than 35mm, I like the Nikkor 35-70mm *f/3.3-4.5*. The variable aperture design reduces the size and weight of the lens. It is an incredibly small, sharp lens and weighs only 8.5 ounces. A faster *f/2.8* fixed-aperture 35-70mm zoom is 15 ounces heavier and much bulkier.

In telephoto zooms, two very popular lenses are the 70-210mm *f/4-5.6* lens and the 80-200mm *f/2.8* ED. For backpacking, I prefer the 70-210mm because it is 21 ounces lighter (exactly half the weight). The *f/2.8* lens is easier to focus in dim light because its larger aperture gives you a brighter image in the viewfinder than the *f/4* zoom. Being faster, the *f/2.8* is a better lens for stopping action or for using in the early and late hours of the day when

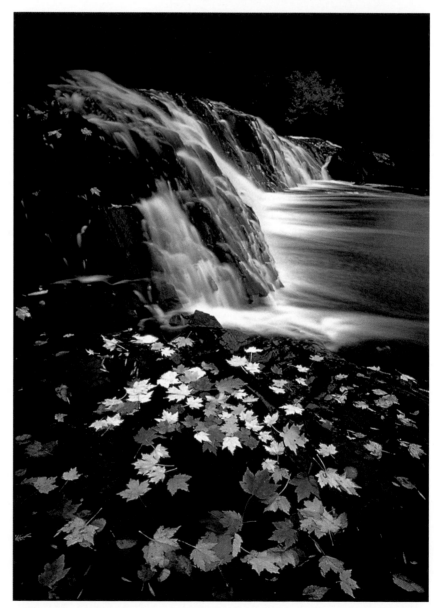

POTATO RIVER FALLS, Wisconsin. Nikon F4s camera, 35-70mm *f/3.3-4.5* zoom lens, Bogen 3021 tripod with Foba Super Ball head, polarizer, 81B filter, Fujichrome 100.

A 35-70mm lens facilitates precise cropping of the image without changing the camera's position. This photograph was taken at a 35mm focal length.

28

wildlife is most active. I also find that a 35-135mm f/3.5 4.5 zoom is nearly as versatile as carrying both the 35-70mm and 70-210mm zooms, and I can save weight and space in the pack. I seldom use the 200mm focal length of a 70-210mm zoom. I usually need at least a 300mm lens when I need to work with a telephoto, typically to get closeups of wary wildlife.

Teleconverters. These special lenses, which fit between the camera and regular lens, are primarily used to extend the magnifying capability of telephoto lenses. Teleconverters are available in two magnifications: 1.4X and 2X, or 1.4 and 2 times the image size. To calculate the effect of a teleconverter, simply multiply the teleconverter's power times the original lens' focal length: for example, 1.4 x 300mm = 420mm; and 2 x 300mm = 600mm. The teleconverter has the same effect on lens aperture: 1.4 x f/4 = f/5.6; and 2 x f/4 = f/8. Thus, by adding a 1.4X teleconverter to a 300mm f/4 lens, you increase your focal length to 420mm and decrease your maximum aperture to f/5.6; adding a 2X teleconverter to the same lens increases the focal length to 600mm and decreases the maximum aperture to f/8.

I always carry a 1.4X teleconverter to use with my 300mm lens. Because every ounce counts on backpacking trips, a lightweight teleconverter is a welcome way to reduce the equipment I have to carry on my back. While a 400mm lens weighs a hefty 99 ounces, at 47 ounces my 300mm lens with a 1.4X teleconverter is a much more reasonable choice.

Another benefit of teleconverters is that they increase magnification while still maintaining the minimum focusing distance of the lens. This means that a 300mm f/4 lens with a minimum focusing distance of 9 feet becomes a 420mm lens that still focuses down to 9 feet. This is a great way to maintain good working distance from small birds, mammals, and reptiles that are easily spooked.

Wildlife Photography. Wildlife photographers should bias their lens selection to faster and longer focal lengths. A versatile selection might include a 35-70mm f/2.8 zoom lens (24 ounces), 80-200mm f/2.8 ED zoom lens (42 ounces), and a 300mm f/2.8 lens (95 ounces). Most serious

HOW TELECONVERTERS AFFECT LONG FOCAL LENGTHS

Increase in Focal Length and Change in Maximum Aperture with Teleconverters

Lens	1.4X Teleconverter	2X Teleconverter
300mm f/4	420mm f/5.6	600mm f/8
300mm f/2.8	420mm f/4	600mm f/5.6
400mm f/4	560mm f/5.6	800mm f/8
500mm f/4	700mm f/5.6	1000mm f/8
600mm f/5.6	840mm f/8	1200mm f/11

wildlife photographers eventually acquire a 400mm f/3.5 (99 ounces) or 500mm f/4 (106 ounces) lens, too.

Choose big telephotos that have a relatively fast maximum aperture of no less than f/4. If you think a 500mm f/4 lens is in your future, then don't get a fast 300mm f/2.8 lens. At 95 ounces, it is too large and heavy to carry along with a hefty 500mm. A better choice is the 300 f/4 lens that only weighs 47 ounces. But if a $3,500 investment in a 500mm f/4 lens is too rich for your budget, then you might opt for the faster 300mm f/2.8 lens and use it with teleconverters to reach 400mm and longer focal lengths.

CLOSEUP PHOTOGRAPHY

If you like to take closeups of nature, sooner or later you're going to own several specialized lenses and accessories that make close-up shooting possible. Regular lenses just aren't capable of magnifying small subjects enough to fill the frame with their captivating details. There are several ways to reach greater magnification in photography.

The easiest, least expensive way to start taking closeups is with some of the new zoom lenses that have what is commonly called a "macro mode." Lenses with this feature have been designed to extend farther than normal (see the discussion on extension below) so they can focus on closer objects. The Nikkor 35-70mm f/3.3-4.5 zoom is such a lens. Its close-focusing function operates at any focal length. At 70mm it has a maximum magnifying capability of about 1/4 lifesize (1/4X), which is quite suitable

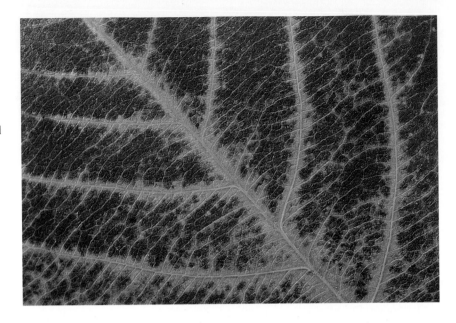

SUMAC LEAF. Nikon N8008 camera, 55mm f/2.8 macro lens, Bogen 3001 tripod with Linhof Profi II head, B-15 focusing rail, Fujichrome Velvia.

A 55mm macro is a good lens for closeups when a short working distance between the subject and the front of the lens isn't detrimental, but you might want a longer focal length when working with animate subjects that are easily spooked. This leaf was photographed with a 55mm lens at approximately 1/2 life-size.

for such closeup shots as frost-covered autumn leaves or small groups of wildflowers.

But the best way to shoot closeups is to use a true macro lens that is optically corrected for closeups and capable of life-size reproduction. Life-size means that if you hold a 35mm slide frame against the subject, you are photographing an area the size of the slide (1 x 1 1/2 inches). That is generally as much magnification as you'll ever need or want for most field work unless you become a highly specialized closeup photographer. Then you'd need to use extension tubes and closeup diopters for even greater magnification (see below).

Macro lenses (Nikon calls its "micro" lenses) are not available in all focal lengths. They generally come in three sizes: 55mm or 60mm, 105mm, and 200mm. The 55mm macro is a good lens, but it has very little working distance between the front of the lens and the subject, which can be a problem with live subjects. The 105mm has twice the working distance of the 55mm lens, and it is unbeatable when used with a TTL flash for handheld macro shots. The 200mm lens has the greatest working distance and a narrow angle of view that is useful for controlling distracting elements in the background.

Macro lenses also perform perfectly well as all-purpose lenses in their focal lengths. In other

words, if you have a 55mm macro, you don't need a standard 50mm lens, too. Therefore, they are worthwhile investments even if you don't specialize in closeup photography. As a nature photographer, I see absolutely no reason to own a standard 50mm lens. A far better choice is a 55mm or 60mm macro lens that can magnify closeup objects as well as function as a normal lens.

Extension Tubes. A lens becomes longer as it is focused from infinity to its minimum focusing distance. This is called extension. Regular lenses are designed for optimum performance at infinity and won't extend far enough to achieve the kind of magnification necessary for closeup photography. One of the easiest ways to increase the magnification of a lens is to use extension tubes.

Extension tubes are simply hollow, rigid spacers that fit between the camera and the lens, and add a fixed amount of extension. They are rugged, lightweight accessories that I consider among the most valuable items I own. They can be used separately or combined for even greater extension. Nikon makes a versatile set of extension tubes for Nikon lenses, but it is best to use extension tubes that are compatible with your specific brand of camera so that you retain normal TTL metering functions.

The effect that an extension tube has on magnification can be seen in this formula for magnification:

MAGNIFICATION = EXTENSION ÷ FOCAL LENGTH.

For example, if you were shooting with a 100mm lens, 1/4 life-size magnification could be achieved by using a 25mm extension tube; 1/4X = 25mm extension ÷ 100mm lens. Using the same formula, 1/2X = 50mm extension ÷ 100mm lens, and 1X = 100mm extension ÷ 100mm lens.

Extension tubes will make any lens focus closer. If you already own a 50mm, 100mm, or 200mm lens, you can add extension tubes. But you'll find that longer lenses require more extension. A 50mm extension tube will achieve 1X with a 50mm lens but only 1/4X with a 200mm lens. You can turn a standard 50mm lens into a fine macro lens by using a 25mm tube for 1/2X magnification and a 50mm tube for 1X.

High-magnification photography isn't the only application for extension tubes. They can also be added to telephoto lenses to improve their minimum focusing distance. If you attempt to photograph a marmot sitting on a sunny rock, you might use a 300mm f/4 lens that can focus down to 9 feet. But this may not be close enough to get a full-frame portrait. Adding just 14mm of extension with a Nikon PK-12 tube to a 300mm lens will let you move 4 feet closer and increase the telephoto's magnification enough to achieve a tight portrait and good working distance.

Closeup Diopters. Another great item for close-ups is called a closeup supplementary lens, or closeup diopter. It looks like a fat filter that screws into your lens and magnifies the focal length of the lens you are using. The ones I use are two-element Nikon diopters, designed to be used with fixed-focal-length lenses between 55mm and 200mm, or with zoom lenses.

The great thing about diopters is that they cost only about 50 dollars, they're lightweight, and they don't rob you of light the way extension tubes do. They are wonderful with zoom lenses because you can zoom with the diopter in place and the image stays relatively in focus. When I'm traveling light and don't want to carry the extra weight of a specialized macro

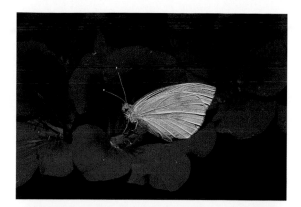

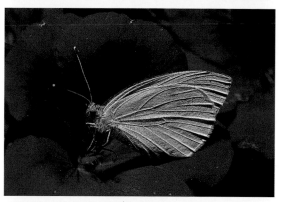

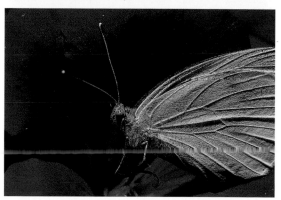

WOOD SATYR BUTTERFLY. Handheld Nikon F4s camera, 105mm f/2.8 macro lens, SB-24 flash, Fujichrome Velvia.

The top picture shows 1/3X magnification. The middle picture shows 1/2X magnification. The bottom picture shows 1X magnification, or a life-size rendition of the subject.

lens, I commonly use a 4T diopter on my 35-70mm zoom to boost the magnification from a maximum 1/4X without the diopter to 1/2X with the diopter. If you own a zoom lens, get a closeup diopter and experiment with it to see the great results it can provide.

I use diopters with macro lenses, too. The 4T can be combined with a 105mm f/2.8 macro lens to increase magnification from 1X to 1.6X without any additional light loss. The 200mm f/4 macro can be boosted from 1/2X to a little over 1X with the 4T. Many lens and diopter combinations are possible. You don't have to own a Nikon lens to use Nikon diopters. They can be used on any lens with either 52mm or 62mm filter threads or with filter adapter rings to fit other sizes.

TRIPODS

In some situations, you simply must use a tripod. For example, most landscapes are photographed around sunrise and sunset when the terrain is bathed in pleasant warm tones. During a typical sunrise, I may start shooting in dim light up to 30 minutes before the sun comes up. Then I carefully compose a 35mm shot on a tripod as if I was using a 4 x 5 view camera. I often use a 24mm wide-angle lens, stopped down to f/16 or f/22 for great depth of field. Using Fujichrome Velvia with an ISO 50 film

speed, the shutter speed might be as long as 30 full seconds before sunrise and then rapidly increase to 1/15 sec. when the sun first appears. If the wind cooperates, it is possible to take sharp photographs in the dimmest light as long as you have a tripod.

If you're using a telephoto lens or a zoom with longer focal lengths, then you should use a tripod to steady the lens. The longer the lens, the more critical the use of a tripod becomes. A valuable rule of thumb for steady handheld shots is to always use shutter speeds faster than 1/focal length. For example, you should generally never handhold your camera at less than 1/60 sec. with a 50mm lens or 1/250 sec. with a 300mm lens. Also, it is easier to use a telephoto when it is supported by a tripod; then both your hands are free to operate the camera and concentrate on framing and focusing the shot, instead of struggling to hold the setup steady.

Macro photography can involve such high image magnification that even the slightest movement of the camera or the subject can cause a blurred image. A good tripod that will set up close to the ground is an imperative. I rarely take a landscape or wildlife photograph without using a tripod. It has become a habit. Unfortunately, it is all too easy with autofocus, autoexposure, and a motor drive to shoot plenty of film without thinking first.

A tripod that can be lowered to the ground is a great asset for nature photography. I modified my favorite backpacking tripod, the Bogen 3001, so that it could rest on the ground. I carry a short centerpost for the ground position.

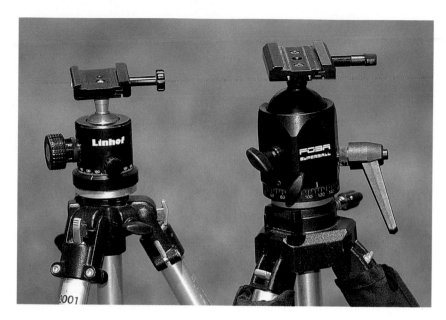

On the left is my backpacking tripod, a Bogen 3001 with a Linhof Profi II head (weighs 5 pounds total). On the right is an ideal all-purpose field tripod, a Bogen 3021 with a Foba Super Ball head (weighs 9 pounds total).

Experienced photographers understand the importance of sweating out all the details of each photograph and double checking their work. Working with a tripod forces you to think about what you're doing, get organized, and identify pitfalls before you shoot. And with most outdoor photography, you do have time to set up a tripod and study the subject first. At photography workshops, I encourage students to bring a small portfolio of their 20 best photographs. About a quarter of their shots aren't critically sharp when studied with a magnifying loupe. Most of these fuzzy images could have been prevented by using a tripod.

Even if the action is fast paced, you can use a tripod to support a telephoto lens and pan with the subject's action. For example, if you are shooting a whitewater raft from a high vantage point, try to anticipate where the peak action will occur, then follow the action by panning with the camera and using your motor drive to advance the film while you keep firing. Using the tripod will help you save on film costs because you'll end up with more keepers.

Tripod Features. Choosing a tripod means deciding how it will be used and what equipment it will hold. A lightweight tripod is suitable for a small camera and lens combination. But a fairly hefty tripod is needed to steady a larger camera with a 500mm telephoto lens. If I never had to carry my tripod very far, I would own just one heavy tripod for all the photography I do. Bigger is almost always better when it comes to stability. But there are limits to what I am able or willing to carry on top of all the other gear necessary for traveling into the heart of wilderness. Therefore, buying a tripod almost always involves some compromise between stability and how how strong your back is.

You should own at least two tripods. One should be your everyday workhorse with maximum stability; the other should be an ultralight model for backpacking, canoe trips or carried to base camp on mountaineering expeditions. Check the height of any tripod without its centerpost extended. The top should come close to eye level without extending the centerpost at all. A short tripod with its centerpost fully extended is an unstable three-legged monopod, not a tripod.

It is amazing how many subjects can't be photographed because they are too close to the ground for a standard tripod to reach. Some tripods, including my favorite Bogen 3021, have reversable center posts that can suspend the camera upside down under the tripod. If you are shooting straight downward, this can be a useful technique. But most subjects look better when they are photographed from a vantage

HOW MUCH DO TRIPODS WEIGH?	
BACKPACKING Tripods	**Weight**
Cullman 2101	1.5 lbs
Gitzo 001	1.5 lbs
Gitzo 026	2.5 lbs
Bogen 3001	3.0 lbs
FIELD Tripods	**Weight**
Gitzo 224	5.0 lbs
Bogen 3021	5.7 lbs
Gitzo 341	7.0 lbs
Gitzo 410R	9.0 lbs

point parallel to the ground instead of from directly above. And with the center post reversed, it is awkward for the photographer to fit between the tripod legs to see through the camera. A better solution is a tripod that can rest on the ground.

All-Purpose Field Tripods. My favorite tripod for everday use is the Bogen 3021. I had it modified by Kirk Enterprises so that the legs can be spread out parallel to the ground. A standard tripod center post is too long to use when the legs are splayed parallel to the ground, so to get those "grounder" shots, you have to carry an extra centerpost that has been cut down to a shorter length.

Another excellent tripod is the Gitzo 224. Gitzos are expensive, but they are very well made and come with a lifetime warranty that makes them worthwhile investments. I like the fact that the 224's legs can be spread parallel to the ground. But I don't use my Gitzo 224 very much anymore because the telescoping legs tighten with a collar that is slow and clumsy to adjust. By contrast, Bogen tripods have easy-to-use locking levers that make adjusting the tripod height a breeze. I like to maneuver a tripod into different positions to get the best camera angles; with the Gitzo, it is a struggle to change positions. And in winter, the Gitzo collars tend to ice up and are hard to twist when you're wearing gloves.

The Bogen 3021 is a little lightweight for rock-steady shots with big telephotos in the 400mm to 600mm range. If you use big lenses frequently, you have no choice but to use a heavier tripod like the Gitzo 341 or 410. But I wouldn't want to carry these tripods very far on a hike.

If I'm not hiking at higher elevations or on steep terrain, I usually prefer to take my everday workhorse Bogen 3021 tripod. But for backpacking trips, I find it is too heavy, so I bring the Bogen 3001 instead. A great backpacking tripod, it is reliable with lenses up to 200mm or even 300mm long if it isn't windy. This tripod is too short to be considered an all-purpose field tripod. Also, I sometimes use a Cullman 2101 ultralight tripod when I am travelling light and fast. Backpackers will appreciate that the Cullman is half the weight of the Bogen 3021 and is extremely compact.

Tripod Heads. You don't have to use the tripod head—the platform that attaches to the camera—supplied by the tripod manufacturer. In fact, it is a good idea to choose the tripod head separately so that you get exactly what you need. There are basically two types of tripod heads: pan-and-tilt heads and ball heads.

I've finally given up on pan-and-tilt heads because they are just too slow to adjust. Every time you pan to the left or the right, you have to readjust both the horizon placement and the vertical placement of the camera by fiddling with three different knobs. By the time you make all the adjustments, you've missed the sunset. Following action by panning with a pan-and-tilt head is nearly impossible. And for backpacking, the head's handles stick out and grab every tree branch.

I recommend that you use a ball head, which, in comparison to a pan-and-tilt head, is a joy to use. You simply loosen an adjustment knob, and the ball is free to move the camera into any position. Then tighten the knob, and you're ready to shoot. Ball heads are great for locking heavy cameras and lenses rigidly into place, plus you can easily loosen the ball and follow a moving subject that requires simultaneous panning and tilting. The best-made ball heads have a friction-control feature that lets you alter the camera's position for precision framing while still holding the basic overall position with some tension.

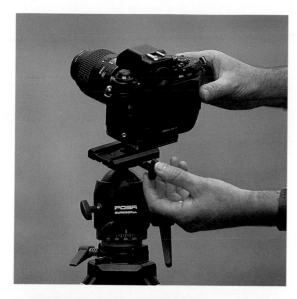

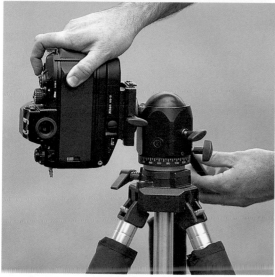

Custom-fitted quick-release plates are great for setting up the camera fast and for locking it solidly in place on the tripod. The camera can be moved quickly into any position merely by loosening the large handle.

The Foba Super Ball head is a top performer. I use it on my Bogen 3021 field tripod. The Foba can easily handle the heaviest cameras and lenses, and it is a precision-crafted piece of equipment that is a pleasure to use. For backpacking, I like the smaller Linhof Profi II ball head on a lighter Bogen 3001 tripod. The Linhof Profi II has astonishing holding power and smooth movements for such a small ball head. I highly recommend it.

Professional-grade ball heads are terribly expensive (they cost about 350 dollars), but worth the money. In addition to Foba, you might investigate the following brands: the Arca Swiss B1, Linhof Profi III, or the Studio Ball. For beginning photographers, I can recommend a few less expensive ball heads that work satisfactorily: the Slik Pro, the Bogen 3055 Heavy Duty Ball Head, and the Bogen 3038 Super Ball Head (it is particularly sturdy).

Quick-Release Plates. Sometimes you need to scramble as fast as a short-order cook to get the camera onto the tripod, or you'll miss the shot. The perfect solution is installing a quick-release system between the camera and tripod head. The camera is fitted with a customized base plate made for your particular model of camera body. The camera base plate then locks securely into a clamp on the tripod head.

Quick-release plates are not only a solution for fast release, they also prevent the camera from twisting loose. Have you ever flopped the camera to one side for vertical framing, and then the camera started to rotate until it pointed at the ground? A quick-release plate is designed to hold the camera in place. I've outfitted all of my camera bodies and also all my telephoto lenses that have tripod collars with custom-fitted quick-release plates made by Really Right Stuff (RRS). Do yourself a favor and get the quick-release system from RRS (see the Resource Guide on page 142). You'll say goodbye forever to annoying camera wobbles!

Padding the Tripod Legs. Tripods take a real beating outdoors. For about 5 dollars, you can insulate and protect your tripod legs. Go to a hardware store, and buy some foam-pipe insulation and duct tape. Cut the foam to fit the upper sections on the tripod legs; then tape the

Essential filters, pictured from left to right, are a UV filter, the 81A and 81B filters, and a polarizing filter.

The Tiffen .3 and .6 ND grad filters are shown above a Cokin filter holder. My first set of ND grads were Cokin filters. But Cokin's grays are not precisely neutral and add a gray tint to pictures. My favorites are Tiffen glass filters, which can be used in the Cokin holder.

foam pieces into place. For a few bucks more, you can buy fancier protectors from Laird Photo Accessories or Op-Tech that are designed to fit your tripod. Either way, you'll appreciate the padding when you carry the tripod over your shoulder. And in cold conditions, the insulation will protect your hands from the tripod's freezing metal parts.

FILTERS

I believe that filters should be used sparingly in outdoor photography. Nature usually doesn't need any improvement from a filter; but in some situations a filter can improve a photograph by bridging the gap between what you see and what the film will record. My rule of thumb is, if the viewer can tell that you used a filter, then it was overused. Shooting with filters is like being a fashion model; you learn from experience how to apply enough lipstick and makeup to bring out natural, not artificial, beauty—a little bit of makeup works better than too much. Here are the filters I always carry with me into the field:

- ultraviolet (UV) filters
- 81A filters
- polarizing filters
- graduated neutral-density filters (grades .3 and .6)

Ultraviolet Filters. UV filters have the appearance of clear optical glass. They filter out ultraviolet light that is invisible to the human eye but not to film. A stronger UV filter is the skylight filter (1A) that is tinted slightly pink to correct for the extra blue found in snow scenes and at higher altitudes. Both versions of UV filter are suitable for everday photography, and their use protects the lens from dust and scratches.

Color-Correction and Color-Enhancement Filters. Daylight film is color balanced to render colors accurately in midday light. If the lighting is cooler or warmer than white midday light, then all the colors recorded by daylight-balanced film will be affected. At sunrise and sunset, a warmer bias is generally preferred, and no color correction is needed. But in open shade with a blue sky overhead, you may want to use a warming filter, such as an amber 81A or a

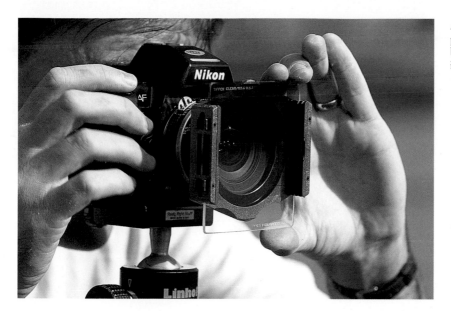

An ND grad filter is positioned over a scene by sliding it up or down in a filter holder.

slightly stronger 81B filter, to warm up the blue light. Viewers generally prefer an image with a warmer bias to a cooler one.

Color-correction filters can be used to boost a slightly dull sunrise or sunset. Try a filter with a slight amount of red or magenta to add color; for example, a Tiffen CC10R (red) or CC10M (magenta) filter. But I wouldn't use these colored filters unless there is some sunrise or sunset color already present in the sky. The idea isn't to create colors, just to give them a slight boost. Remember, you can almost always tell when someone has overused a filter.

Polarizing Filters. Light normally moves in a randomly scattered fashion. However, when light reflects off such shiny surfaces as leaves, rocks, sand, and water, it becomes concentrated (polarized) onto one plane, which intensifies the light into reflective glare.

Linear polarizing filters act like venetian window blinds by blocking polarized light waves yet permitting other light waves to pass through. This improves the final photograph because when glare is removed from shiny surfaces, the result is more saturated colors. Polarizers can also be used to darken the sky to accentuate puffy white clouds.

To judge its affect on a scene, hold the filter up to your eye and rotate it until you see the desired amount of polarization. A polarizer

works best when pointed at objects that are 90 degrees to the sun. When you have the results you want, add the filter to the lens (remember to remove your UV filter first if it is on the lens) and start shooting.

Use polarizers judiciously. Overpolarization can eliminate a rainbow because it is a polarized reflection. It can destroy a pleasant mirror reflection in a lake. And it can turn a natural-looking royal-blue sky into a stark, navy blue. To ensure a natural look, back off the polarizer's effect just slightly from its maximum strength. Also, with 20mm and 24mm wide-angle lenses, a polarizing filter may polarize the blue sky more at one end of the image than at the other. The result is an uneven looking sky that looks light blue at one end and considerably darker at the other. In that case, don't use the polarizer at full strength.

Neutral-Density (ND) Filters. ND filters are designed to add density (photography jargon for "to make darker") and reduce the amount of light reaching the film. They are neutral in color and don't affect color transmission. ND filters are commonly used in bright sunlight when a slow shutter speed is desired for special effects.

A special type of ND filter is called a neutral-density graduated filter (ND grad). ND grads are dark neutral gray at one end with the color

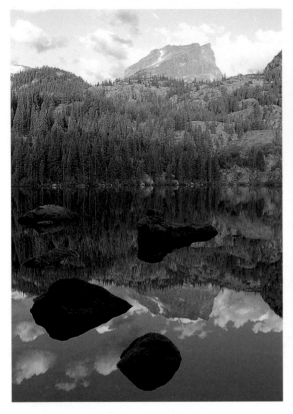

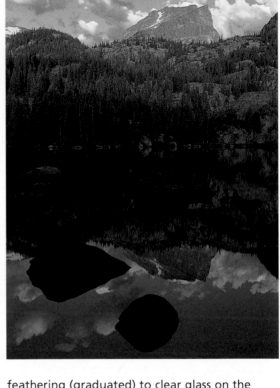

HALLET PEAK AND BEAR LAKE, Rocky Mountain
National Park, Colorado. Nikon F4s camera,
35-70mm f/3.3-4.5 zoom lens, Bogen 3021
tripod with Foba Super Ball head, Tiffen ND
grad .6 filter, Fujichrome Velvia.

No filter was used to expose the two photographs
on this page. In the left picture, the exposure
was based on the foreground, so the background
was washed out. In the middle picture, the
exposure was based on the brighter background,
so the foreground was underexposed. In the picture
on the far right, a 2-stop .6 ND grad filter was used
to balance the exposure between the brighter
background and the darker foreground. The
result is a photograph that matches what I
saw when I was at Bear Lake.

feathering (graduated) to clear glass on the
other half. ND grads are almost indispensible to
outdoor photographers for balancing the light-
ing ratio in scenes that contain both highlights
and shadow areas. The filters are available in .3,
.6, and .9 densities that correspond to a 1-stop,
2-stop, and 3-stop variance between the dark
and clear half. The .6 density is the most useful.
A 1-stop .3 ND grad usually isn't dark enough,
but a .6 ND grad is ideal. In the most extreme
cases, I will combine the .3 and .6 filters to cre-
ate a 3-stop .9 ND grad.

To use an ND grad, place the dark half over
a brightly illuminated area, such as a back-
ground of brilliant white snow-capped moun-
tains, and place the clear half so that it overlaps
a darker foreground, such as your campsite in
the shade. The darker part of the filter adjusts
the brightness ratio of the image so that the
film can record both highlights and shadow
areas. Without the ND grad, if you exposed for
the snow-capped mountains, the foreground
would be grossly underexposed. Conversely,

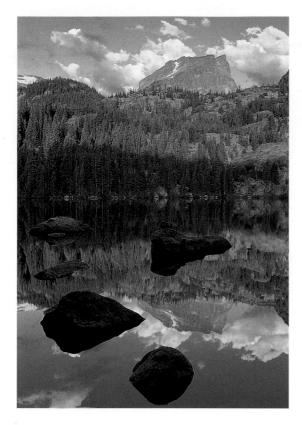

exposing for the shaded foreground would wash out detail in the brighter background.

ND grads take some practice to use effectively. My basic technique is to do a selective spot-meter reading of the foreground and of the background to check the lighting ratio. If the difference in exposure is greater than 2 stops, then I use a .6 ND grad to balance the lighting. To determine the correct shutter speed and *f*-stop, I use a meter reading of a neutral area in the foreground as the basis for the exposure. Then I carefully align the dark half of a 2-stop ND grad over the bright half of the scene. You can see the effect of the filter most accurately by stopping down the depth-of-field preview button. Smaller apertures will accentuate the effect the graduated filter has on the scene. Colors in the scene are unaffected, and because the gradation is feathered, the filter's usage goes undetected by the viewer.

ND grads are available either as round filters or as rectangular shapes. Stay away from the round ones; the rectangular versions are better

for precisely positioning the filter for the desired affect. Rectangular ND grads are used in specially designed filter holders that screw into the lens' filter threads. I use Tiffen ND grads that fit into a Cokin "P series" holder.

Filter Accessories. When you own lenses that require different filter sizes, you can reduce duplicating filters in all those sizes by using step-up rings. For example, a 52-62mm step-up ring is an adapter that makes a 62mm filter usable on a 52mm threaded lens. I prefer to use a full set of 52mm and 62mm filters for the common types of filters such as polarizing and the 81 series. But for filters that aren't used very often, I usually buy just the 62mm size and use step-up rings to fit my 52mm lenses.

The best way to carry filters around is in a lens pouch, or filter file. These soft pouches have compartments that hold your filters to protect them from damage and keep them clean. I recommend pouches with a white backing that allows the color of the filter to be easily visible.

As lens cleaners, I like to use premoistened towelettes that are safe for camera optics and come in individual foil wrappers (be sure to dispose of discarded wrappers properly). They are

CHARACTERISTICS OF POPULAR SLIDE FILMS			
	Film Speed	Grain	Resolving Power
KODAK FILM			
Kodachrome 25	25	9	100
Ektachrome Elite 50	50	9	125
Ektachrome Lumiere 50X*	50	9	unavailable
Kodachrome 64	64	10	100
Ektachrome 64	64	12	125
Ektachrome Elite 100	100	9	100
Ektachrome Lumiere 100X*	100	9	unavailable
Ektachrome Pro Plus 100*	100	11	100
Ektachrome Elite 200	200	19	125
Kodachrome 200	200	16	100
FUJI FILM			
Fujichrome RVP Velvia*	50	9	160
Fujichrome RF 50	50	11	125
Fujichrome RFP 50D*	50	11	125
Fujichrome RD 100	100	11	125
Fujichrome RDP 100D*	100	11	125

*Professional Films

quicker to use and take up less space than a bottle of lens cleaner and lens-cleaning tissues. The towelettes are lint-free, and because they are premoistened, they don't apply too much lens cleaner that can leave streaks. Another handy cleaning item is a reuseable Luminex lens cloth. This ultrasoft cloth for cleaning optical surfaces works by wiping the glass clean after you've fogged it with your breath.

FILM

Slide films are identified by the word "chrome" in their name, such as Kodachrome or Fujichrome. Slide films are also called transparency or color-reversal films. Print films are called color negative and have the word "color" in their name, such as Kodacolor or Fujicolor. All serious amateur and professional nature photographers prefer to shoot slide film for its accuracy and rich colors, and because book and magazine publishers work from slides. If you need a print, you can always make a high-quality print from a good slide.

As already mentioned, films are assigned ISO numbers that rate their sensitivity to light. The higher the ISO number, the greater the film's

sensitivity to light. The most common ISO ratings are: 25, 50, 64, 100, 200, and 400. The camera needs to know the film speed so that its exposure meter can function accurately. The canister housing the film has a bar-code identification called DX Coding. That code instructs your camera to automatically adjust its metering to the film's ISO rating. If you have an older camera that doesn't read bar codes, you must manually set the film speed on the camera body when you switch to a film with a different ISO rating.

Most photographers in the United States use either Kodak or Fuji films. For decades, Kodak was king of the mountain, but in the past few years, Fuji has introduced some very impressive films that have converted many loyal Kodak shooters. Now there are new films being introduced each year, and photographers are benefiting from the competition between these two giants of the film industry.

Every color-slide film on the market has its own personality. Films are described with such terms as grain, sharpness, color saturation, exposure latitude, color balance, color bias, and contrast. Most of these are subjective evaluations based on experience with different films in different conditions. But two of the most important characteristics—grain and resolution—can be scientifically measured and thus evaluated.

I've compiled a comparative list of the most popular slide films, rated from ISO 25 to 200, to aid your evaluation of what film you want to shoot (see the box above). The numbers don't tell all, for there is no substitute for individual experience with these films in different situations. A lower "rms" grain number means finer, less-noticeable grain. There is a direct correlation between grain size and film speed. The slowest films typically exhibit the finest grain. In general, the more a slide is magnified or a print is enlarged, the more pronounced the grain becomes. A high resolving power indicates a film's superior ability to discern detail. Grain and resolving power work together in the film

to create an overall impression of sharpness.

When you buy film from the local supermarket, drug store, or discount department store, you are getting an amateur-designated film made for sale to general consumers. As long as amateur films are used before their expiration dates, they are suitable for general use and don't require refrigeration. Without refrigeration, a film's color balance and speed change ever so slightly. Because film is often part of a retailer's inventory for several weeks before it is actually exposed, the manufacturers send film to the retailer with the idea that it will age a while before being used.

A professional photographer uses a lot more film than the average amateur. When a professional needs a roll of film, it must be as close to perfect as possible. Therefore, professional films are manufactured to very tight tolerances that assure greater accuracy with respect to film speed and color consistency. While amateur films have an ISO tolerance of plus or minus 1/3 stop, professional films have a very tight tolerance of plus or minus 1/8 stop. Even the emulsions are different from those designated for amateurs, with slightly different color palettes. In order to retain their accuracy, professional films should be refrigerated until they are used. I recommend using professional films if your shooting has reached the level where these refinements could make a difference to your work. Otherwise, the less-expensive amateur films are fine.

Choosing the Right Film. Film choice essentially boils down to individual taste and preference. Although it is fun to try different films, I believe you should eventually settle into working with one film that you can depend on for most situations. Once you get to know your film, you can practically determine the right exposure based on experience. If you're constantly changing films and film speeds, you're not going to develop that kind of familiarity, which is invaluable in the field. For the best results, always use the slowest (i.e., finest-grained) film that works for the type of photography you do. Generally speaking, faster films are grainier, less sharp, and have less saturated colors.

The most versatile film for nature photography is a slide film with an ISO 100 rating. I esti-

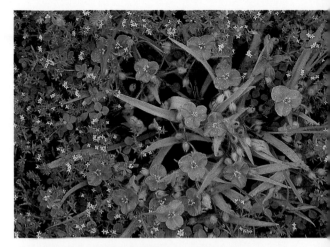

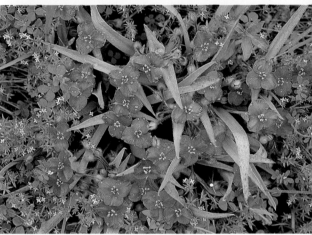

SPIDERWORT PRAIRIE WILDFLOWERS, Texas.
Nikon N8008, 55mm f/2.8 macro lens,
Bogen 3001 tripod with Linhof Profi II head,
RRS B-15 focusing rail.

The top picture was made with Kodachrome 64 film; the bottom one was made with Fujichrome Velvia. Which color palette do you prefer?

mate that my productivity with an ISO 100 film is about 25 percent greater than when I use a slower ISO 50 film! That is right—a film that is one stop faster makes that much difference. Wind and subject movement are the culprits that faster films eliminate. The dilemma is that film technology hasn't evolved to the point where you can use an ISO 200 or 400 film speed without sacrificing quality. The good news is

that there is a negligible difference between ISO 50 and 100 speed films. When my productivity is at risk, I feel that ISO 100 is the better choice.

My standard film for the past several years has been Fujichrome RDP 100. It is a wonderful all-purpose film, with rich colors and fine grain for an ISO 100 film. I also keep a second camera body loaded with Fujichrome Velvia. For a long time, I was reluctant to use Velvia because it is a slow ISO 50 film. But it was the sharpest E-6 film available, and the rich, saturated colors are the best available for outdoor photography.

Eventually, I switched completely over to Velvia. The vivid colors are unbeatable, and the film has the longest tonality of any film I've tested. By long tonality, I mean the wide range of subtle hues and tones that seem to give Velvia photographs a depth unlike any other film. Fuji scientists call this *enhanced spacial reality*. I am also getting saturated blue skies that can't be matched with other films. Another factor that confirmed my loyalty to Velvia was its astounding resolving power of 160 lines per mm. It even records individual blades of grass in a broad scenic image. The next closest films have a maximum of only 125 lines per mm! Now I am comfortable making print enlargements up to 16 x 20 inches that retain the sharpness of the original 35mm slides.

Velvia isn't a true ISO 50 film and should be rated at an exposure index (EI) of 40. The exposure index is any speed at which you rate the film other than its designated ISO number. When I need a faster film, I sometimes "push" Velvia one stop by doubling its EI to 80 (see "How to Push Film" below) without the film showing even the slightest increase in grain and only a slight increase in contrast.

In the quest to improve the relationship between film speed, grain, and sharpness, Kodak has recently introduced a new class of ISO 50 and 100 Ektachrome films for amateur and professional photographers. The new Ektachrome films have extremely fine grain, very high resolving power, and excellent color saturation. Ektachrome Elite is the designation for the amateur version of the film, and Ektachrome Lumiere is the professional film. In addition, Lumiere X in both ISO 50 and 100 has a warmer color balance than either Elite or Lumiere and is ideal for outdoor photography.

I'm testing Ektachrome Lumiere 100X, and it could very well be the film I've always wanted in the ISO 100 class. Lumiere 100X is a technological breakthrough from the standpoint that it is the only film faster than ISO 50 with a rms grain rating of 9. By comparison, Fujichrome 100 has a rms grain rating of 11. Lumiere 100X is a major improvement over Fujichrome 100's color and sharpness. I will continue to test Lumiere, but so far, I prefer the enhanced colors of Velvia.

How to "Push" Film. To push a film one stop, load the film as usual; then, using the above example of Velvia, adjust the camera's ISO dial to 80 instead of 40. Shoot the entire roll of film at EI 80. Now that the whole role is underexposed by one stop, you must ask your film lab to "push process" the development of the film by one stop. Pushing film usually costs a few dollars more.

If you find that you consistently have to push an ISO 50 film to EI 100, you may as well switch to an ISO 100 film. Then if you need more speed, you can also push ISO 100 films to EI 200 with good results. I actually prefer the look of Fujichrome 100 pushed one stop to the grainier look of Kodachrome 200. The grain of Fujichrome 100 remains close to rms 11 even when pushed, whereas Kodachrome 200 has a grain rating of rms 16.

(Top) SHOWY GOLDENEYE, Eagle County, Colorado. Nikon F4s camera, 35-70mm f/3.3-4.5 lens at 35mm setting, Bogen 3021 tripod with Foba Super Ball head, Ektachrome Lumiere 100X.

The new Kodak Lumiere 100X film has suprisingly minimal grain and warm saturated colors for an ISO 100 film.

(Bottom) PAPER BIRCH TREE TRUNKS, Bayfield, Wisconsin.Nikon N8008, 180mm f/2.8 ED-IF lens, Bogen 3021 tripod with Foba Super Ball head, Scotchchrome 1,000 film exposed at EI 2,000 and push-processed 1 stop for extra grain.

Push processing Scotchchrome 1,000 to create maximum grain provided an artistic representation that I couldn't have wrestled from a lower-speed film.

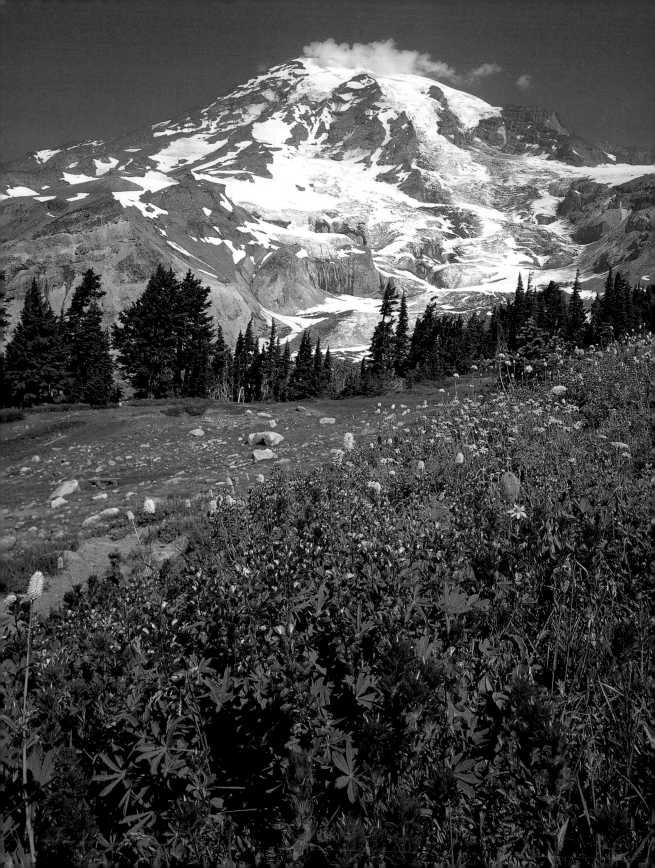

HIKING AND BACKPACKING STRATEGIES FOR PHOTOGRAPHERS

*An adventurer is someone
who invents their own life.*

One of my favorite photography trips is a 2-mile hike to Mills Lake in Rocky Mountain National Park. I time my trips to the lake so that I can stop and photograph Alberta Falls along the way and arrive at the lake in time to photograph another beautiful sunset. I usually take all of my 35mm or 4 x 5 equipment with me because it is a relatively short hike. I don't mind carrying that much equipment a reasonable distance.

At the other end of the spectrum, one of my favorite week-long backpacking expeditions is the 100-mile loop called the Wonderland Trail around snow-clad Mt. Rainier in Washington State. On such a long and strenuous trip, I have to make some hard choices regarding which photographic and camping items I carry.

While some people hike *to* take photographs, other people hike *and* take photographs. Because the goals of these two groups are so different, their camera equipment requirements vary greatly. Over the years I've developed four strategies for exploring

scenic locations, which you can use in planning your own individual outdoor adventures.

First, there is what I call *photo-naturalist exploration*. Nature photography is the top priority on these hikes, which are generally short-distance trips with ample time scheduled for photography. Having a complete selection of camera equipment with you is generally desirable on these trips.

Then there are *photo day hikes*. The main purpose of day hikes is to enjoy being outdoors. Photography is a lower priority, so your camera items should be carefully chosen for minimum weight and maximum versatility. *Photo backpacking* is a third option and involves multi-day outings with lots of camera equipment and camping gear.

Finally, there is what I call the *golden hour blitzkrieg*. A prime time for photography is the hour before sunset or after sunrise. The blitzkrieg is an expeditious strategy for reaching a special destination for a splendid hour of golden-light photography. A half-day blitzkrieg to a prescouted location can enable you to produce wonderful pictures without taking two or three days to backpack the same distance.

Travel Safely. When planning any type of trip, be sure to tell a friend or relative where you will be each day and who to alert if you don't return as scheduled. Don't forget to tell the appropriate people when you return so that they don't initiate an unneccesary search and

MT. RAINIER AND ALPINE FLOWERS,
Washington State. 4 x 5 Linhof Master Technika, 90mm lens (equivalent to 24mm in 35mm format), Bogen 3001 Tripod with Linhof Profi II head, polarizer, Fujichrome 100.

Red Indian Paintbrush, Lupine, Bistort, and other wildflowers are rich rewards awaiting hikers along Mt. Rainier's 100-mile Wonderland Trail.

rescue. If the trip will be strenuous, begin exercising at least one month in advance to prepare for it. Being fit will add to your enjoyment and reduce the likelihood of injury in the field.

An efficient hiking technique for traveling on steep terrain is to maintain the same pace or rhythm as you would use on flat ground, but adjust your stride to shorter steps. Hiking is less fatiguing when you stay below a level of exertion that makes you huff and puff out of breath. When mountaineers carry heavy packs up steep slopes, they use a "rest step" technique: You take a step, pause long enough to deeply inhale and exhale, then take the next step. This hiking technique is slow but effective. The only way to reach high summits is by pac-

ing yourself. A slow but steady pace saves you time in the long haul because you end up taking fewer long rests.

PHOTO-NATURALIST EXPLORATION

These are my favorite outings because they are oriented exclusively around nature photography. Unlike a typical day hike, the distance traveled doesn't matter. In fact, I may start out with a destination in mind, but as long as I find photo opportunities along the way, I don't care whether I reach my destination or not. Sometimes I don't wander very far from my car before I find plenty to photograph. Other times, I might hike all day before I reach a good area for photography. About 90 percent of my

FAVORITE PHOTOGRAPHY EQUIPMENT FOR PHOTO-NATURALIST EXPLORATION

I use Nikon equipment, described below, but owners of other cameras should be able to substitute equivalent equipment. The weight of each item is given here to help you decide how much you might want to carry. I prefer carrying a lightweight pack as much as anybody, but I hate to miss a good shot just because I don't have what I need with me. So here is a comprehensive summary of my ready-to-go-anywhere, photograph-anything-in-nature equipment list (you'll find a complete description of most pieces in the previous chapter):

ESSENTIAL GEAR
- Nikon F4 camera (3 pounds with batteries) with a tripod quick-release base plate from Really Right Stuff (RRS)
- Nikon N8008s backup camera (2 pounds with batteries)
- Nikkor 24mm f/2.8 lens (9 ounces); my primary wide-angle landscape lens
- Nikkor AF 35-70mm f/3.3-4.5 zoom lens with macro mode (8.5 ounces)
- Nikkor AF 105mm f/2.8 macro lens (20 ounces)
- Nikkor 200mm f/4 IF macro lens (28 ounces)
- Nikkor AF 300mm f/4 ED-IF internal focusing lens (47 ounces)
- Nikon TC-14B 1.4X teleconverter (6 ounces)
- Nikon SB-24 Flash (1 pound with batteries) with SC-17 remote cord (4.5 ounces) for off-camera dedicated-flash capability.

- Nikon closeup extension tubes: PN-11 (8 ounces), PK-12 (2.5 ounces), and PK-13 (3.5 ounces)
- Nikon 4T closeup diopter (1.5 ounces)
- Bogen 3021 Tripod with Foba Super Ball head and RRS quick- release clamp (9 pounds)

USEFUL OPTIONS
- Nikkor 20mm f/2.8 lens (9 ounces)
- Nikkor AF 80-200mm f/2.8 zoom (42 ounces); a possible substitute for carrying a 105mm macro and a 200mm macro lens)
- Nikon TC-301 2X teleconverter (12 ounces)
- Macro focusing rail (9.5 ounces)
- Stroboframe macro flash bracket (14 ounces)
- Nikon SD-8, AA battery power pack (10.5 ounces with batteries) for reserve flash power and fast recycling)

PHOTO ACCESSORIES
- 10 rolls of ISO 50 or 100 slide film (1 ounce each)
- Filters: 81A, 81B, circular polarizing, Tiffen .6 ND grad and holder (5 ounces total)
- Gray card (1 ounce)
- Cable release (.5 ounce)
- Chroma-Zone reference cards (2 ounces)
- 22-inch Photoflex reflector (1 pound)
- 22-inch Photoflex diffuser (1 pound)
- Luminex lens cloth
- Waterproof backpack raincover (2.5 ounces)
- Backup AA batteries

GRIZZLY BEAR WITH THREE CUBS, McNeil River, Alaska. Nikon F4s camera, 300mm f/4 ED-IF lens, Bogen 3021 tripod with Foba Super Ball head, Kodachrome 64.

During one of my photo naturalist explorations in Alaska, I photographed these bears from a safe distance with a telephoto lens, which is the best way to approach wary wildlife — especially mother bears with cubs.

best work results from using the photo-naturalist exploration strategy.

You can ruin a friendship or spousal relationship if your companion isn't thoroughly briefed in advance that you might hike for five miles or for five minutes before you stop to take pictures. This understandably drives other people crazy. My wife is very understanding about such matters and brings along a wildflower guidebook or a paperback novel to entertain herself while I burn up film. As sympathetic as she is, I prefer to do these trips solo, because then I don't feel guilty holding up the pace of the hike when I stop to shoot.

The hallmark of photo-naturalist exploration is equipment versatility. My equipment selection is based on a simple parameter: I must be prepared for any subject matter I find, from animals, to landscapes, to intimate closeup portraits of minute subjects. For this reason, I rarely scale down the general photography kit I always bring with me in the car, which means I carry a pretty large backpack. But it also means I'm prepared to photograph anything from a square mile to a square inch.

I fondly remember a hike in Alaska's Denali National Park that began with my shooting early-morning ice patterns on the frost-covered tundra. I took pictures of the fascinating patterns on my hands and knees with a macro lens for almost an hour. Shortly thereafter, I spotted a group of Dall sheep traversing a ledge on a precarious rock cliff. I would have pulled out my hair if I had left my longest telephoto lens in the car, but I had it with me. Occurrences like this are not far fetched. In fact, they happen all the time and confirm my belief that luck belongs to those who are prepared.

I carry all of my 35mm camera equipment in a large, specialized photography backpack called the Lowepro Super Trekker (9 pounds). It has a spacious main compartment (14.5" x 6.75" x 26.5") with padded compartment modules. It opens with a large, zippered, panel for quick, easy access to the contents. Each camera, lens, filter, and accessory has an assigned spot in the pack so that I can find it even in the dark. Velcro strips make it possible to customize the compartment dividers so that each valuable item is padded and held securely in place.

For additional protection, I put each item in a nylon stuff sack for extra protection from damaging sand, dust, or moisture when the pack is open. On one occasion at Great Sand Dunes National Monument in Colorado, a sudden gust of wind filled my photography backpack with fine-grained sand. Since then, I've used stuff sacks as an extra precaution. The Super Trekker is so huge that I think of it as a camera store with shoulder straps. The shoulder and hip-belt suspension can comfortably suspend as much weight as I am willing to carry.

For my 4 x 5 equipment, I prefer to use a Tenba model PBA pack (4 pounds, 5 ounces). The deep dimensions of the PBA (L16" X H21" X D7") works best for large-format equipment, but it is ideal for any camera format. The Tenba PBA pack is unique in that it can be carried by its own shoulder and hip suspension system. With a brilliant innovation, this pack is also designed to fit to a Kelty pack frame for extra support and comfort. Grommet holes in the pack match the holes in the Kelty frame. Then simple clevis pins hold the Tenba PBA pack securely onto the frame. With the frame in place, there is ample room to lash on a tent, sleeping bag, and other camping items for backpacking trips. There is simply no better system on the market for photography hiking and backpacking with a large load.

My experience has been that very few good photographs happen so spontaneously that it is worth the trouble to keep a camera around my neck while I am exploring. Besides, it is unlikely

Traveling with the Lowe Super Trekker backpack is like bringing a camera store with you on shoulder straps. One of the best features of the Lowe Super Trekker is that it is the only backpack designed to accommodate carrying a tripod.

that you'll have the right lens on the camera if a coyote suddenly scampers across the trail or you spot a beautiful wild orchid growing next to the trail. A better technique is to stop when you spot an interesting subject, remove your pack, and take out the equipment you need. If you like to grab shots on the go, you could keep a camera and zoom handy accessible in a fanny pack. I wear one on the front when I'm backpacking with fewer camera items, but not when I am on a photo-naturalist exploration.

If you find a gorgeous alpine meadow filled with wildflowers, the best approach is to "work the area" in a radius from wherever you leave the photography backpack, using a camera and a macro lens on a tripod. If you've interrupted your hike because you spotted an interesting animal, then prepare a camera and telephoto lens, mounted on the tripod, and get ready for action. As you're exploring, you can get quick wildlife shots by using the tripod as a stable monopod.

If you walk more than a short distance with the camera on the tripod, always remove the cable release. Cable releases are easily lost, and they have a knack for catching on things and tearing apart the camera. When carrying the tripod and camera over your shoulder, protect the camera and lens by aiming the lens behind your head. When you resume hiking, it is best to put everything back into the photography backpack where it is safe and the load is properly balanced for hiking. Your tripod can be fastened to the outside of the pack or carried by hand.

PHOTO DAY HIKES

Day hikes differ from photo-naturalist explorations in that the main intent shifts from photography to hiking. Most day hikes are goal oriented around reaching a destination: a lake, a mountain summit, or a scenic overlook. These trips are possible in any season and can include cross-country skiing as well as summer hiking and mountain climbing. With fewer stops for photography, it is wise to travel much lighter and enjoy the trail. My best results on day hikes have been with photographing action, for there isn't time enough or enough equipment to do more detailed nature photography.

FAVORITE PHOTOGRAPHY EQUIPMENT FOR PHOTO DAY HIKES

ESSENTIAL GEAR
- Nikon N8008s camera (2 pounds with batteries)
- Nikkor 24mm F2.8 lens (9 ounces)
- Nikkor 35-135mm F3.5-4.5 zoom lens (21 ounces)
- 5 rolls of ISO 50 or 100 film (1 ounce each)
- Filters: 81A, circular polarizing, .6 ND grad and holder (5 ounces total)
- Gray card (1 ounce)
- Luminex lens cloth
- Cable release (.5 ounce)

USEFUL OPTIONS
- Nikon SB-24 Flash (1 pound) or SB-28 flash (8 ounces)
- Cullman 2101 ultralight tripod (1.5 pounds)
- Nikon PK-12 extension tube (2.5 ounces)
- Nikon 4T closeup diopter (1.5 ounces)
- Chroma-Zone reference cards (2 ounces)

PHOTOGRAPHY BACKPACK
- Lowepro Orion AW fanny pack (2 pounds)

Photography Backpacks. On day hikes, I use a Lowepro Orion AW fanny pack that has room enough for an SLR, up to five lenses, film, filters, and accessories. I usually take a camera, a 24mm lens, and a 35-135mm zoom lens. The Orion has a cleverly designed separate day pack that attaches to the top of the fanny pack, which creates extra room for food, water, a Gore-Tex parka, and other hiking essentials. This setup is ideal because the heavier photography items are carried comfortably low on the hips. Fanny packs have a tendency to bounce up and down when they are fully loaded. But with the Orion's day pack attached to the top of the fanny pack, the shoulder straps add a stability that I haven't found in other fanny packs. I especially appreciate this when it is necessary to jump a stream, hop a boulder, or ski off a mogul. You can even run with this pack and it won't bounce! The day pack adds so much stability that I am tempted to keep it in place even when I don't need it for extra storage capacity.

The day pack stows away in the front pocket of the fanny pack, and there is a built-in weather cover. When I bring my ultralight Cullman tripod, it fits inside the day pack and carries more comfortably that way than using the lashing straps underneath the fanny pack. When the Orion is used without the day pack it can be rotated around to the front and the lid opens away from your body allowing quick access to the contents. Worn to the front it provides a convenient waist-level platform during lens changes and film reloading (especially handy on climbs and ski tours). It is a joy to travel fast and light, unhindered by excessive equipment.

I recently had the opportunity to test quite a few fanny packs from different manufacturers, and I uncovered a real gem that stood out from the crowd: the Ergo 460 Tundra Ruff Pack. This

TELEMARK SKIER, Colorado backcountry. Nikon N8008, 24mm f/2.8 lens, 1A skylight filter, Fujichrome 50.

During a day of skiing, I set up this shot after noticing my telemark skiing partner's elongated shadow. I pointed my 24mm f/2.8 lens straight into the sun and, using a small f/16 aperture, created a sunburst effect. I knew from experience that the highly reflective snow slope would provide fill light on the strongly backlit skier.

pack is really comfortable! A padded waistbelt, made of neoprene, conforms to your body shape for a customlike fit. Neoprene, which is the material used in wet suits, prevents the pack from slipping, and it flexes with your movements. In addition, two lateral stabilizing straps on each side adhere the pack snugly to the waistbelt. The pack has a very spacious main compartment with fully adjustable dividers. There is enough room in this fanny pack for several camera items, a lightweight parka, trail snacks, and a water bottle.

I sometimes run short of enough space for everything to fit into a fanny pack. Then I carry a Lowepro Photo Trekker day pack. This pack has more room for such items as a water bottle, water-purification pump, shell parka, an electronic flash, and a lunch. I can fasten my Bogen 3001 tripod on the Photo Trekker, a tripod that is too heavy for the Orion fanny pack.

PHOTO BACKPACKING

People flock from all over the world to experience our uniquely American landscapes. The United States and Canadian national park systems are the envy of the world. Just think of the endless opportunity we have to experience the wild outdoors: mountains, coastlines, deserts, rivers, forests, swamps, tundras, canyons, grasslands, and glaciers. We are blessed with so much variety and pristine natural beauty on this continent.

Even a brief overnight wilderness trip can have a profound effect on us. We can't explain it, but somehow it just feels right. Suddenly we are dealing with the basic necessities of survival: food, water, shelter, and personal safety. As soon as we leave the car and the telephone behind, the sun and weather begin to regulate all of our activities. The sudden change from city to wilderness and back again is thoroughly invigorating.

My favorite backpacking trips are several days long. Shorter weekend trips sometimes consume limited time with a long hike in and then back out, while a longer trip has the advantage of more time for photography. Extending a weekend trip by three or four days only involves carrying more food; the rest of your equipment needs (sleeping bag, tent, and clothing, for example) remain the same. Your

odds of getting good weather, a variety of lighting conditions, and spotting wildlife increase on longer trips.

The problem with photo backpacking is that packs are heavy enough with camping gear without the extra weight of camera equipment. For this reason, every item must be chosen with careful consideration as to how much it weighs. Each trip is a little different from the last one in terms of the distances covered, the terrain, the climate, the time of year, and last but not least, your fitness level. Making a checklist is useful for determining which items should go and which items should stay. The biggest mistake most people make is that they take too much, and the weight becomes overwhelming.

On the trail, I carry all my 35mm camera equipment (except the tripod) in a padded fanny pack, worn on the front so that it is accessible and acts as a counterbalance to the weight of the backpack. Camera equipment can also be carried inside the backpack, near the top. I use a Kelty frame pack or a Mountainsmith internal frame pack to hold my camping gear, food, and clothing.

FAVORITE PHOTOGRAPHY EQUIPMENT FOR PHOTO BACKPACKING

ESSENTIAL GEAR
- Nikon N8008s camera (2 pounds with batteries)
- Nikkor 24mm F2.8 lens (9 ounces)
- Nikkor 35-70mm F3.3-4.5 lens (8.5 ounces)
- Nikkor 75-300mm F4.5-5.6 zoom lens (30 ounces)
- 10 rolls of film per weekend (10 ounces; 2-3 rolls per day on extended trips)
- Filters: 81A, circular polarizing, .6 ND grad and holder (5 ounces total)
- Gray card (1 ounce)
- Luminex lens cloth
- Cable release (.5 ounce)
- Bogen 3001 tripod with Linhof Profi II ball head and RRS quick-release clamp (5 pounds)
- Nikon 4T closeup diopter (1.5 ounce)
- Waterproof raincover for backpack (2.5 ounces)
- Chroma-Zone Reference Cards (2 ounces)

Storing the camera gear separately makes it easy to leave basecamp and explore with the camera. I like to carry the tripod at the top of the backpack so that it can be reached quickly. Or I lash it vertically alongside the pack to keep it from catching tree branches along the trail.

When I'm backpacking with 4 x 5 camera equipment, I simply attach the Tenba PBA photography pack to a Kelty backpack frame. I try to eliminate as much weight as I can, but a 4 x 5 system is always a heavy load. The frame provides handy lashing points for a sleeping bag and foam pad. Another practical way to carry 4 x 5 gear is to put the camera equipment in a photography day pack—for example, the Lowepro Photo Trekker described above—and just slide the day pack into the main compartment of a frame pack.

The best policy is to travel as lightly as possible. A light load, carried in a comfortably designed backpack, is a crucial factor in making your backpacking trips a pleasure. The only way to cut down the weight of your pack is by saving a few ounces here and there on each item (clothing and camping gear are covered in the next chapter). Look for the lightest equipment that will suit your purposes. A major area to consider are camping items that have the greatest overall impact on total weight: the tent, the sleeping bag, and the camp stove.

THE GOLDEN HOUR BLITZKRIEG

There are times when fast travel with minimal equipment is the most reasonable way to reach good backcountry scenery. If you're in excellent physical shape, you can blitz into remote locations for a golden hour of photography at sunrise or sunset, without taking two or more days to backpack there carrying a huge overnight backpack.

The general strategy of a sunrise photography blitzkrieg is to start before dawn and move very quickly along the trail using a flashlight or, better yet, REI's lightweight climber's headlamp that leaves both hands free. I usually jog on the low-angle and flat sections of the trail, and walk the steeper parts. If jogging is too strenuous for you, then allow yourself more time and walk at a fast pace. I time my departure so that I reach a specific destination—for example, timberline, a lake, or a scenic vista—just before

sunrise. Eastward-facing terrain is best photographed at dawn, and westward-facing terrain should be photographed at sunset.

On sunset blitzkriegs, you don't have to burn up the trail on the way to your subject. Take your time on the way in; it is a good idea to save your energy for the fast trip out in the fading light. The point of the blitzkrieg isn't to set speed records but to access scenic locations for the best period of golden light. Not having to set up a tent and cook dinner means more time for your photography.

You must exercise more caution on a blitzkrieg than you would on a backpacking adventure. Rain and snow storms can attack you with sudden fury; in these conditions, you should seek natural shelter or turn around and get out of there. You don't have enough extra clothing and equipment to continue in foul weather. I want to emphasize that it would be irresponsible to put yourself in a situation where you might get hurt or lost and require rescue assistance. Blitzkriegs are strenuous, so be sure to pace yourself and watch your step. Don't attempt a blitzkrieg unless you train beforehand with an aerobic exercise regime, such as running up stairs or hills.

Going as lightly as you possibly can will add immeasurably to your comfort. Wear comfortable shorts or lycra tights that offer more leg protection from the early morning chill and biting insects. Avoid cotton T-shirts that become drenched with perspiration and remain wet the entire day. I like to wear a Thermax short-sleeved shirt that dries quickly. I use jackets with long zippers that open up for ventilation.

SUNRISE ON LONGS PEAK, ACROSS CHASM LAKE, Rocky Mountain National Park, Colorado. 4 x 5 Linhof Master Technika camera, 75mm lens (equivalent to 20mm in 35mm format), Bogen 3001 tripod with Linhof Profi II head, Tiffen ND grad .6 filter, Fujichrome 100.

The park service doesn't permit overnight camping at Chasm Lake, so I used the golden-hour blitzkreig strategy to access this stunning location. In order to capture this golden light on the East Face of 14,256-foot Longs Peak, I had to hike 4.5 miles to timberline in the dark, using the light of my head lamp. My strategy was literally a success when this image was published as a postcard.

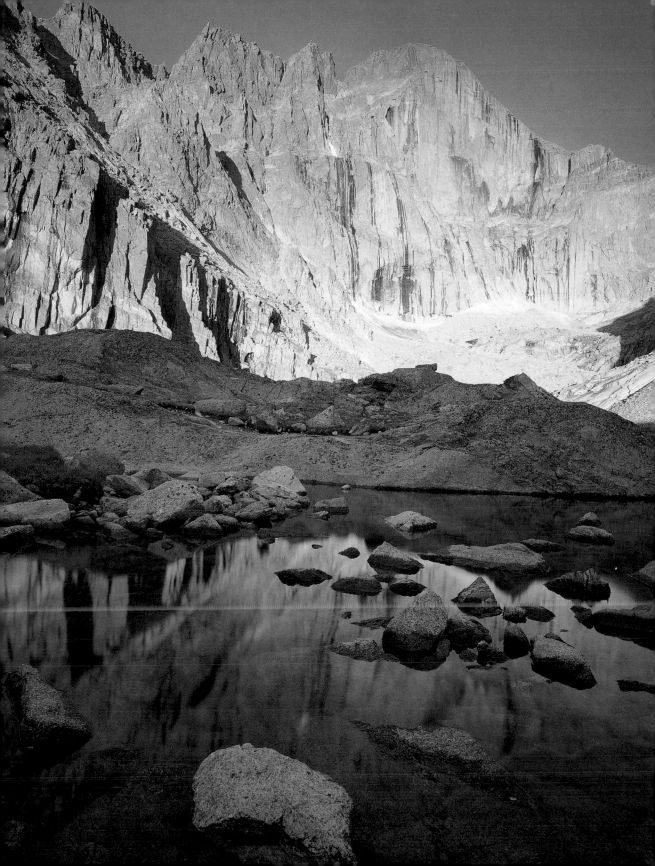

My windpants have full-length zippers so they can be removed or added without my taking off skis, snowshoes, and climbing crampons.

On blitzkriegs, my most important piece of clothing is my Gore-Tex shell parka. Gore-Tex is both windproof and waterproof, yet it breathes so that condensation is minimized. I bring a second long-sleeved Thermax shirt so I have something dry to put on when I stop for photographs. In bad weather, I wear both shirts together for extra warmth. I put on spare clothing items as soon as I cool down at rest stops. In mountainous higher elevations I always take a lightweight warm hat and a pair of thin silk gloves.

Low-cut trail boots or rugged running shoes are essential for light and fast travel. Be sure that your footwear is broken in and won't give you blisters. I prefer low-cut trail boots for their greater traction, stability, and protection, even though they are clumsier than running shoes. Slow down on rough or slippery sections so that you don't risk a bad fall or twist an ankle.

I carry a 1-quart water bottle, although I don't always fill it up because a full quart weighs 2 hefty pounds. I like to rely on back-country water sources for refills along the way. I always carry water-purification tablets or a water-purification pump. The best snack food I've found is the PowerBar (2.25 ounces each). When eaten with a few gulps of water, Power-Bars provide almost instant energy. Unlike sugary candy bars or granola bars that are loaded with sugar and oils, PowerBars give you an easily digested energy boost. I carry enough Power-Bars to provide a snack every 45 minutes on the trail. I usually take three to five bars depending on the hike.

The best photography pack for blitzkriegs is the Lowepro Orion AW fanny pack, described above. The heaviest items carry low on the hips, and adding the day pack is perfect for the non-photographic essentials (see "Favorite Paraphernalia" on page 64). I always carry a tripod because I know I will be taking long exposures in the low light of sunrise or sunset. Before I leave, I always check that my camera and flash batteries are fresh, so that I don't have to carry backups.

ON THE WATER
Boat and raft trips are popular with photographers for a good reason—they are loaded with fun and adventure, and they offer unique opportunities to reach places that are otherwise inaccessible. I used to worry all the time about the safety of my photography equipment when it was around water. But I've learned that it is not difficult to protect valuable equipment if I take a few precautions.

When I photograph around water, I load my standard photography backpack with cameras and lenses, double wrap the pack in plastic garbage bags, and then place it in a special waterproof duffel called a "dry bag." Kayakers, canoeists, and rafters use these durable, watertight dry bags to protect all their gear. If you anticipate navigating through white water or if you might capsize the boat, then use two dry bags just to be sure. Once you are on land, you can pull out your photography backpack and be free to roam around and find interesting subjects to photograph.

KAYAKER ON SOUTH CANYON RAPIDS, Colorado River. Nikon F4s camera, 300mm f/4 ED-IF lens, polarizer, Kodachrome 64.

I observed this kayaker surfing and decided to take advantage of the overcast lighting. I blurred the kayaker's action by using a slow 1/2 sec. shutter speed and a small *f/22* aperture.

Some photographers protect their gear with shockproof and waterproof camera cases, made of space-age plastic. A couple of the best-known brands are Pelican and Tundra. These cases are waterproof down to 10 feet underwater. An old trick of experienced river rats is to get a 20mm ammunition box from an army surplus store and pad the interior with close celled ensolite foam. You can paint the case white so that it reflects sunlight and keeps its precious cargo cooler. Hiking with a couple of ammo cans is ridiculous, so when you're back on terra firma, put your gear back into your photography backpack, making it easier to wander around and take pictures.

Action shots from the inside of a boat or raft can capture some very exciting moments. Most shooting from within the boat doesn't require a fancy, full-featured 35mm SLR. But it is a good idea to use a waterproof or weather-resistant point-and-shoot camera. The camera's controls are automatic, so it is easy to take spontaneous shots of the action from the watercraft. If the camera gets sandy or muddy, it can be rinsed in water and dried with a cotton bandana. A few good cameras in this category are the Canon Aqua Snappy, Olympus Infinity Twin, and Nikon Sport-Touch.

It is very risky to use a standard 35mm SLR camera on a boat. If the camera drowns, you can't give it mouth-to-mouth resuscitation! If you must use your regular SLR, put it in an underwater camera housing such as the EWA-Marine bag, which is basically a vinyl bag with a glove to access the camera controls. The advantage of using your regular camera is your access to its interchangeable lenses. Another alternative is to use a professional underwater 35mm camera, such as the Nikonos RS.

Salt water presents special problems. The corrosiveness of salt spray and salt water will wreak havoc on cameras, lenses, and even tripods. I've found that spraying a fine film of WD-40 (a lubricant and anticorrosive spray for metal) on your equipment does an excellent job of protecting it. After I've used my equipment around salt water, I use a cotton cloth and some WD-40 to clean all exterior surfaces of the camera and lenses, except the glass optics. Then I give the equipment a final wipe down with a clean cloth to remove the excess WD-40. The tripod should be flushed with fresh water, then wiped dry before getting the same WD-40 treatment.

CLIMBING WITH CAMERAS

When you take a camera on a technical rock climb or ice climb, your main consideration should be weight. Every ounce counts when you are fighting gravity. A lightweight 35mm point-and-shoot automatic camera with a wide-angle lens or a zoom lens is ideal. The camera should fit into a fanny pack or inside the hauling sack. When you're hanging on with just one hand, cameras with autofocus, autoexposure, autowind, and autoflash are handy. If the climb isn't technical, I carry a more versatile but heavier 35mm SLR and a 35-135mm zoom lens.

Big mountaineering expeditions sometimes last weeks or months. With so much gear to

CLIMBERS ON MT. HUNTER, Alaska. Nikon FM camera, 35-135mm f/3.5-4.5 zoom lens, Kodachrome 64.

A 35-135mm zoom is the ideal lens for climbing because it lets you zoom in and out of the scene. For example, these two pictures were taken minutes apart from the same camera position.

carry, the extra weight of camera equipment is less critical than when you're doing a lightweight alpine-style ascent. My most trustworthy camera for cold weather and high altitude is my Nikon FM (only 19 ounces) and my trusty 35-135mm zoom lens.

I'm not a fan of camera harnesses that hold the camera against the chest in a padded case. Wearing one, I can't see my feet, and the added pressure from the chest harness and camera make it difficult to breathe at higher elevations. This is when the temptation is to put the camera back inside the pack. But too many photos will be missed with the camera stashed away. As an alternative, try sliding a small, padded, camera pouch onto the pack's waistbelt. Use a camera pouch that zips shut so that the camera can't fall out and so that snow will stay out. This is the best system I've been able to devise for having access to the camera while climbing or skiing without interference from a camera chest harness.

The best photographs of rock climbing or ice climbing are usually staged. The photographer rappels down to where the climbers are surmounting a particularly steep, intimidating section. Shots from the side of, or slightly above, the climber show verticality better than looking straight up at the climbers. Using a camera with a motor drive and autofocus will simplify your shooting. And the camera and lenses can be protected in a fanny pack while you're on rappel. You'll want to be right next to the climbers so that you can easily communicate with them. A wide-angle lens, such as a 24 or 35mm, is ideal for working close enough to direct the action sequences and control the poses.

Although it can be tempting, be careful not to tilt the camera to create artificial steepness. The slides will usually reveal some detail that shows that the angle wasn't for real. Finally, the camera should be tethered to you in some way, in case your sweaty hands lose their grip and the camera flies away.

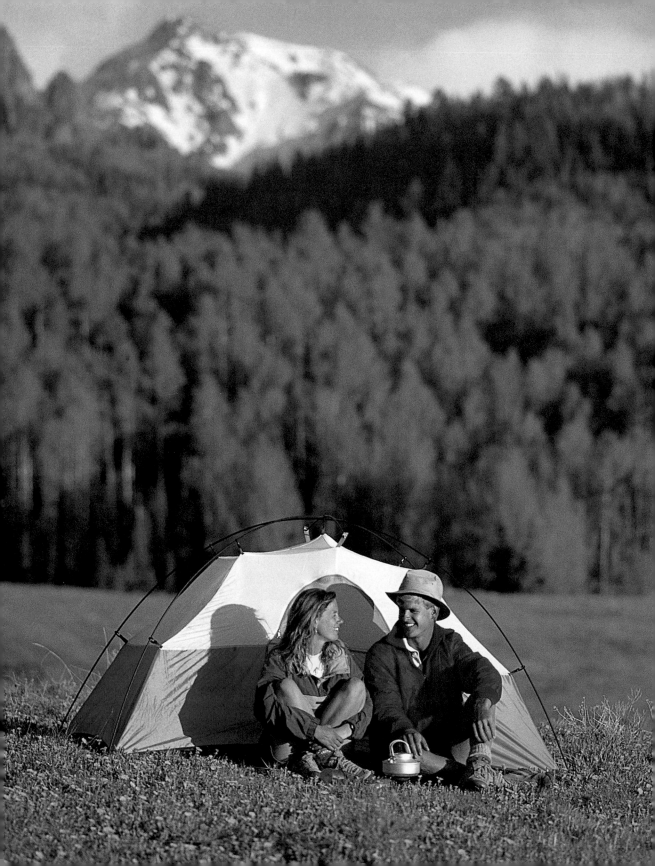

GEARING UP FOR WILDERNESS

Dress properly, stay dry, and be alert to changes in the weather.

From snowmelt to snowfall, I am outdoors a lot. I depend on my equipment to take me through the worst weather so that I can capture the best pictures. And since traveling light is important to every wilderness photographer, I am always interested in hearing about equipment that is both lightweight and rugged. Although I should know better, I often treat my equipment as if it is indestructible. You might say I am the ideal testing machine for everything from boots to backpacks. Give me a piece of equipment for six months, and I'll give it the equivalent of two years of normal use.

When it comes to dressing comfortably in the outdoors, the cardinal rule is to stay dry, because staying dry means staying warm. The way to stay dry is by knowing how to dress properly and by remaining alert to changes in the weather and your exertion level. At the very least, wet clothing can cause minor physical discomfort, and at the very worst it can lead to deadly hypothermia (sometimes called "exposure").

HAPPY CAMPERS, Sunshine Plateau, Telluride, Colorado. Nikon 8008 camera, 200mm f/4 macro IF lens, Bogen 3001 tripod with Linhof Profi II ball head, Fujichrome 50.

We mountain-biked up a 4-wheel-drive route to reach this scenic meadow. I wanted the space-compressing perspective of a 200mm telephoto lens and chose a large f/4 aperture to soften the background while sharply focusing on the campers.

Multiple layers of clothing, or layering, can make it easier to react to these changes. The first layer is the one worn next to the skin, ideally to wick away perspiration. It should be covered by an insulation layer, and this in turn should be encased in a final, weather-protective outer layer. These three layers work together to manage moisture generated from within (sweat) or from external sources (the weather).

As you begin to exercise, you start to perspire—yes, even in winter! Just ask any downhill skier if they sweat from exertion when they ski through moguls. The worst thing an active outdoorsperson can do is to wear cotton underwear because once it gets wet, it takes forever to dry out, and a wet layer of clothing next to the skin steals precious body heat. The answer is to wear synthetic long underwear, such as polypropylene, Thermax, or Capilene. These fabrics pull perspiration off your body and then wick the moisture into outer clothing layers so that it evaporates without chilling you in the process. Before these synthetics were invented, wool was considered the best fabric for making underwear.

The next layer of clothing is the thermal, or insulation, layer. Various combinations of clothing are useful here. The thermal layer often consists of several mini-layers, such as a turtleneck shirt, a wool or fleece sweater, a down vest, and finally a warm down jacket.

The outside layer may have to combat wind, rain, or snow while you are busy backpacking, skiing, or climbing. This is why I believe it is

wise to wear an uninsulated Gore-Tex parka as the outer layer. Gore-Tex is a material that provides waterproof protection, yet it breathes by letting water vapor, and hence perspiration, escape.

CLIMATE CONTROL FOR HOMO SAPIENS

During exercise, you should take off a layer of clothing or increase ventilation to the inside layers at the first sign of perspiration. As you slow down and cool off, you can add layers to keep warm. The point is to be able to maintain a relatively stable body temperature, which is why it is better to wear several flexible layers rather than a single heavy coat.

Contrary to popular belief, the most dangerous weather is not a winter snowstorm but a combination of rain and wind. Once you are wet, you are vulnerable to the heat-draining effect of the wind. Soon your body temperture starts to drop. A drop of only a few degrees in the body-core temperature can affect your mental ability to properly evaluate the danger the heat loss poses. If your temperature continues to drop, you may reach a critical point.

Cases of fatal hypothermia almost always result from not reacting to the situation early enough. In winter, we generally have the sense to dress properly because we expect very cold conditions, and it is fairly easy to remain dry when it is very cold. But in summer, a sudden rainstorm can catch us unprepared. I can vividly recall many experiences in the mountains when I needed every item of high-tech clothing with me, and the bad weather made me glad I had brought them.

One such experience occurred during an April ascent of Mt. Rainier in Washington State. Our climbing party began the climb in a thick fog and a light drizzle. Higher on the mountain, the conditions turned severe. It was around 35°F, and a steady wind was driving snow and rain. I had to wear my ski goggles just to see; the rain was so bad that I wished they were equipped with windshield wipers! We were carrying huge packs loaded with climbing gear, camping equipment, and alpine touring skis for the glacier. The steep ascent and heavy load caused me to perspire profusely despite the cold wind and rain.

The solution lay in how we were dressed. I wore thin polypropylene long-underwear tops and bottoms underneath a head-to-toe mantle of waterproof-breathable Gore-Tex. I knew that I would be soaked in perspiration within this shell. But I was able to remain reasonably comfortable because Gore-Tex so effectively blocks wind and cold rain. After three hours of stew-

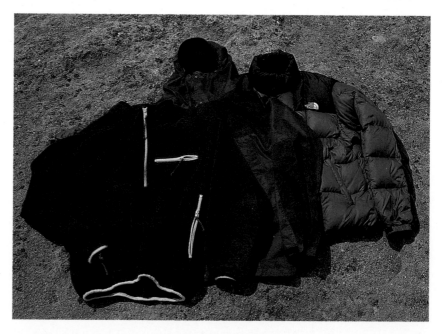

Part of a good layering system for the upper body might include a fleece jacket (left) worn with a Gore-Tex parka (middle) in dreary wet weather. In mid-winter, when the mercury plummets below zero, conditions are cold but dryer. This is when a fleece jacket can be worn with a warm down jacket (right).

ing in my own juices, we finally arrived at our 10,000-foot campsite on the mountain. At this point, I knew that I had to put on some dry clothing right away. I hastened to remove the damp polypropylene underwear and replaced it with a fresh, dry pair. I added a layer of dry insulation with my fleece jacket and then put the Gore-Tex back on. Suddenly I was warm and comfortable again.

We moved into our tents, and the weather continued to pound us for two more days. On the third day, the low-pressure system moved out and, wearing Marmot's Stormlight Parka made of Gore-Tex, windpants, and a layer of fleece, we climbed the mountain in clear, cold conditions. On the windy summit, I added my lightweight North Face Nuptse goose-down jacket for the -10°F summit celebration. This climb was a classic example of knowing how to dress in severe weather. A less-prepared climbing party would have been forced to give up and head for home.

It isn't often that I find a piece of equipment so well designed and lightweight that I would nearly pay any price for it. Marmot's Stormlight Parka is one of those rare finds. Marmot has designed more functional features into this

lightweight jacket than any other jacket I've used. The parka is unlined so that the Gore-Tex fabric can breathe at its intended transmission rate (the linings of other parkas are there strictly for cosmetic puposes). The lightweight fabric is strategically reinforced at the shoulders and elbows. And the feature I really like is that the spacious front pockets are above where the waistbelt of my pack fits me. Plus the underarm ventilation zippers perfectly align with the zippers of a fleece jacket that can be worn underneath the parka. And all of this weighs a total of 19 ounces.

In summer, when the conditions are generally mild, I recommend a ridiculously simple solution for rainstorms: an umbrella that costs 5 dollars at discount department stores. I like to use this small umbrella on summer hikes because then I don't have to take the time to stop and put on a rain jacket, and it helps me react quickly to short bursts of rain that hardly merit donning full foul-weather storm gear. Best of all, with an umbrella I can protect my camera and any other equipment from the rain, too.

Footwear. The old rule of thumb for backpacking footwear was "the heavier the pack, the heavier the boots should be." But clunky leather hiking boots are drifting into obsolescence as bootmakers create new ways of incorporating running-shoe technology into their designs. The newer boots improve shock absorption and reduce overall weight while still maintaining support. Old hiking lore states that every extra pound on the feet is equivalent to four or five pounds on your back. The point is well taken. It is less fatiguing to hike with lighter footwear.

A below-the-ankle trail boot is adequate for short hikes primarily on established trails. I want such boots to have running-shoe comfort and the traction of a hiking boot. To reduce weight they are sometimes made with a combination of leather and fabric. My biggest gripe with low-cut boots is that they get wet very easily. Look for models that can be waterproofed to some extent, or you'll get wet feet from even a short walk in dew-covered grass. I like Merrell's WTC™ Torrent Hiking Shoes for their unique Weather Tight Construction.

Clockwise from the left: The Merrell WTC (weather tight construction) Torrent hiking shoe for day hiking, Vasque's Clarion Superlite for general backpacking, Vasque's Trailwalk Gore-Tex for general backpacking and wet conditions, and Merrell's Guide Boot for heavy backpacking and moderate mountaineering.

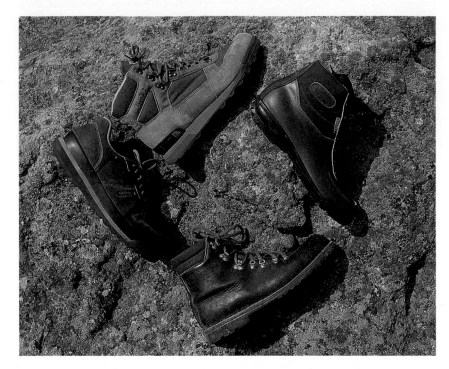

As the backpack grows in size and weight, a corresponding compensation in support for the foot is prudent. With a heavier pack, the likelihood of spraining an ankle or taking an unexpected tumble becomes amplified. For overnight backpacking trips, a boot with ankle support is advisable. I have a pair of Vasque Clarion Gore-Tex boots that are lightweight, waterproof, and so comfortable that they require almost no time to break-in. By the way, these boots really are waterproof!

In the states with major mountain ranges such as Washington, Oregon, California, Wyoming and Colorado, a backpacking trip often includes some mountaineering. In this case you should wear a light mountaineering boot that can be used with ice-climbing crampons (long, sharp spikes that fasten onto boots for gripping snow and ice). Another Merrell boot, called the "Guide," is a prime example of a rugged boot made with weight-saving technology. It has a one-piece full-grain leather upper and a cushioned EVA midsole, and the inside is lined with a quick-drying synthetic fabric that conforms to the foot to reduce blisters.

Waterproof your boots before and after each trip. The boot manufacturer can recommend the best waterproofing material for you to use with the specific materials in your boot. In addition to waterproofing, the leather needs the reconditioning benefits of the waterproofing agent to keep the leather from rotting or drying out.

Have your boots fitted while you're wearing the same pair of socks and sock liners you intend to use. Thermax sock liners with a medium-weight wool sock make a good combination. If you've used your boots extensively, consider replacing the inside footbed (insole) with a new one that hasn't had the foam padding pounded out of it. It will feel as if you're wearing new boots.

In snow country it is wise to wear 16-inch knee-high gaiters over your lower legs to keep snow from sneaking into your boots and soaking your socks. In summer, a short pair of 8-inch gaiters will keep pebbles, sand, and ticks from infiltrating your boots. Gaiters should have full-length zippers or should seal with Velcro, so that you can access your boot laces or put the gaiters on without taking off your boots. Higher gaiters are best when constructed with uppers of Gore-Tex. Shorter gaiters should be made from breathable uncoated packcloth.

BACKPACKING PARAPHENALIA

Deciding what personal items to bring is important from many standpoints, such as the comfort, safety, and weight they provide. Here are some fundamental items no backpacker should do without. Be sure to bring these with you on every trip outdoors, whether you're going for a day hike or a two-week expedition.

Sunglasses. Long before modern sunglasses were invented, American Indians protected their eyes by wearing small strips of tree bark with narrow slits cut into them. With all the crazy styles of sunglasses there are today, who knows? Maybe tree bark will make a fashion comeback. For now, put aside the subject of style, and consider the importance of protecting your eyes from the damaging effects of bright sunlight.

The safest tactic is to use sunglasses that filter out 100 percent of harmful ultraviolet (UV) as well as some infrared (IR) wavelengths. Sunglasses don't have to be expensive to perform this function. Look for the percentage figures in the information supplied by the manufacturer. If the manufacturer doesn't specify exact figures, then look for the FDA's rating: Special Purpose. This means that the sunglasses are rated for maximum filtration of harmful wavelengths in harsh sunlight.

Sunglasses can be made of glass or polycarbonates (a type of plastic). Glass lenses are more likely to be optically perfect, which means they've been ground and polished to eliminate distortion that can cause eye fatigue and headaches. Polycarbonate lenses are more durable than glass, but they are more easily scratched. Polycarbonates are popular because they are lighter, less expensive, and less prone to fogging.

Although sunglasses come in different shades of brown, amber, and rose, the best color for photographers is gray. You need a high-quality neutral gray that will transmit colors very accurately. UV wavelengths penetrate cloud cover, so don't get dark glacier glasses that block so much visible light that you can't see anything on overcast days. A good accessory is a sunglass keeper to hold your "shades" around your neck while you're taking pictures.

First-Aid Kit. Your first-aid kit should be compact and lightweight. Bigger kits tend to be left behind when the pack starts to fill up with heavy equipment. A basic kit should include: Extra Strength Tylenol or aspirin, adhesive bandages, butterfly adhesive bandages, roller gauze, gauze pads, tape, triangular bandages, elastic bandages, safety pins, antiseptic towelettes, moleskin, a needle, tweezers, salt tablets,

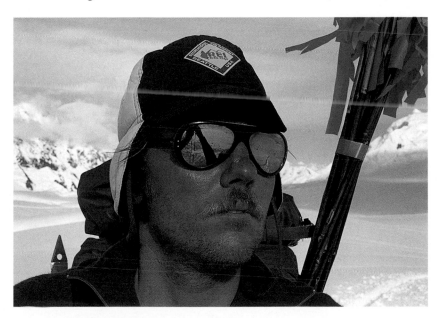

Here I am the day before I was buried in an avalanche on Mt. St. Elias in Alaska. Wearing good sunglasses, sunscreen, and a cap with a visor is critical in bright alpine environments where sunburns are the norm.

antacid tablets, antibiotic ointment, and personal medications (for example, allergy and prescription medicines).

In snake country, a good first-aid item to have with you is the Sawyer Extractor. This pocket-sized, powerful vacuum pump has enough suction to extract snake venom. I was once struck in the leg by a rattlesnake while I was walking through tall prarie grass. I had the Extractor back in my car just a few minutes away. Fortunately, the bite was a "dry hit" because the snake hadn't injected his venom into me. My heart skipped a few beats, but I was uninjured. I learned later that snakes use their venom only to kill their prey. When they strike either in fear or self-defense, they usually don't inject venom. But I wouldn't want to rely on that possibility without having the Extractor with me!

Sunscreen. Your first line of defense from the sun is a good hat or visor and protective clothing. Be particularly cautious about sun exposure between 10 AM and 2 PM. Time of year, latitude, sand and snow terrain, and altitude are other factors that contribute to the intensity of cancer-causing ultraviolet (UV) radiation. Climbers and backpackers at high elevations are exposed to extreme levels of UV. For every 1,000 feet of elevation gain, the intensity of UV light increases by 4 percent. On a mountaintop at 14,000 feet in Colorado, there is at least 50 percent more UV light than at sea level! It is good to be conservative in matters of sun exposure because its cancer-causing effects are cumulative.

The Skin Cancer Foundation recommends using a sunscreen with a SPF rating from 15 to 30. But I've found that sunscreens vary greatly in their effectiveness. The main reason is that they can rub off or sweat off, leaving you vulnerable to sunburn. In a recent study conducted by the environmental dermatology center of Columbia-Presbyterian Medical Center in New York City, Neutrogena Sunblock SPF 30 was rated the most resistant to the effects of sweat and water. In fact, its patented rubproof/waterproof formula protects against sunburn until you wash it off with soap and water.

If your hair is thinning or gone, a good product is Dermatone's Topcoat Aerosol SPF 20. It is waterproof and comes in an easy-to-use pump-

spray bottle. The closest thing to a total sunblock is that nasty white stuff, zinc oxide. If you're around snow all day long for an extended period, you might want the total protection of zinc oxide on your nose and lips.

Insect Repellant. Nothing seems to tantalize mosquitos and biting flies more than the sight of a photographer looking through his camera. Photographers need even better protection from insects than average backpackers because photographers are often stationary while they set up to take pictures. I don't believe in anything less than the best protection when it comes to insect repellant. There are over 2,000 species of mosquitos in the world and I think I've met every one of them. Repellants containing the active ingredient DEET work the best. Most extra-strength insect repellants are formulated with up to 40 percent DEET. But in heavy mosquito country, I use Jungle Juice 100, available from REI (see the Resource Guide on page 142), which is 100 percent DEET.

Map and Compass. An experienced orienteer can study a topographic map and tell a great deal about a place before he or she even sets foot there. Elevations, distances, and place names are the most obvious benefits of reading a "topo." A good map will indicate where to find waterfalls and high passes that provide scenic vistas. A topo can also tell you where to camp near water or where you might find a flat, level spot for setting up the tent. A photographer who can read a topo map can predict with reasonable accuracy where the best sunrise and sunset vantage points might be.

Inexperienced hikers usually want to know how far it is from Point A to Point B. A much more meaningful question is, how long will it take? To understand this, you need to read the elevation contours that point out the ups and downs of the terrain. On average, it requires twice as much time to hike a given distance going uphill than it does going downhill.

A map can be oriented in the field by identifying geographic landmarks or by orienting the compass to magnetic north and adjusting for magnetic declination. If you're lost, you can perform a map-and-compass triangulation to find out where you are.

My favorite compass is the Silva Ranger 15CL (it weighs 3 ounces). It has a folding, hard-shell, protective cover and is filled with a nonfreezing liquid that dampens needle vibration. My most frequent use of a compass is to determine

Some of the personal essentials I usually bring include, from left to right: (top row) travel alarm clock, PowerBar trail snack, ultra sweatproof Neutrogena Sunblock SPF 30, and a compass; (bottom row) premoistened towelette and a small Swiss Army knife.

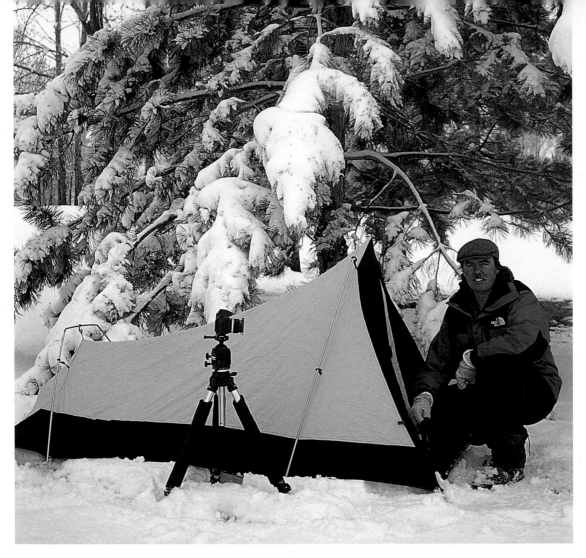

where the sun will rise and set. This is very easy to do and provides valuable information that a landscape photographer can use. At the beginning of a trip, note what time the sun rises and sets, and take a compass bearing on where it appears on the horizon. As long as you don't drive 500 miles away, the sun generally reappears in the same place at the same time for the next couple of days.

CAMPING GEAR

If you plan to spend the night, certain life-support equipment is essential. At the very least, you'll need a tent, sleeping bag, foam pad, camp stove, cookware, water purifiers, and food. Some of my recommendations follow. (Consult the Resource Guide on page 142 for information on where to obtain the equipment described below.)

Backpacking Tents. Your choice of tent should depend on such variables as season, climate, altitude, and the size of your party. Backpacking stores generally sell tents for three-season or four-season use. Three-season tents are adequate for all conditions except high winds encountered above timberline or snow conditions. Choose a tent by studying several product catalogs to find the lightest tent that will work for the conditions you are likely to encounter. A tent is one of the most important items you'll need, and it is one of the heaviest ones, too. So it is wise to use a lightweight tent constructed of very high-quality materials.

I use a Sierra Designs
Flash Magic Tent for
camping in the desert or
on the snow. Weighing
only 2 pounds, 15 ounces,
it makes an ideal shelter
for wilderness
photographers.

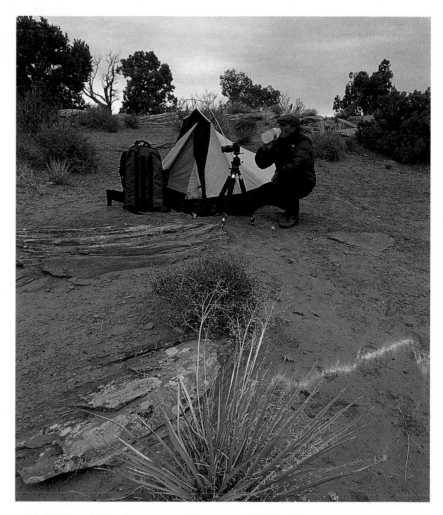

The first consideration should be tent capacity. A solo tent or two-person bivouac tent will be tight fitting in order to save weight. A two-person tent makes a spacious shelter for one person, with extra room to stretch and store equipment. Similarly, a three-person tent is roomier for two people, but the additional weight may be excessive. Your budget and personal preferences will play a large role in how large a tent to purchase. Some of the three-season tent features you should look for include:

● It should be easy to set up. Free-standing designs are popular because they are quick to set up and require fewer tent pegs.
● Seams should be double-stitched. Stress points should be reinforced with bar tacks.

● Look for tent floors with the extra protection of a "bath tub" design that extends the waterproof floor partway up the sidewalls of the tent. Whenever possible, the floor should be made from a single piece of waterproof nylon or offer a minimum of seams that can leak. Floors should have double- or triple-urethane waterproof coating.
● A rainfly should fit snugly over the tent and maintain about 1.5 inches of space for ventilation between the fly and inner wall.
● Be sure there is adequate ventilation and good no-see-em bug netting.
● Look for handy storage side pockets for sunglasses, flashlight, and contact lenses.
● Poles should be shock corded.
● Check for adequate floor space for sleeping.

● The packed length of the tent (especially the poles) shouldn't exceed the width of your backpack.

Check the tent stakes to see if they are sturdy enough to withstand repeated pounding into hard ground. Most tent manufacturers package inferior tent stakes with new tents so that the tent's weight looks low in the catalog. But don't base your decision to buy a tent on the quality of its tent stakes. Most of them should be immediately thrown away and replaced with better ones.

You might want to use a plastic ground sheet to protect and extend the life of the tent floor. Also, tents are frequently damp or wet from condensation between the tent floor and the ground. Be sure to thoroughly dry the tent before storing it away unless you like jungle mildew.

A lightweight shelter worthy of consideration is the three-person Megamid from Black Diamond. It isn't a full-featured tent at all but a teepee-shaped rainfly with a center pole. Without a tent floor, it is an exceedingly light (3 pounds, 6 ounces) and spacious option for backpackers. The center pole is adjustable in height so you can raise it for increased air circulation or lower it to ground level to seal out inclement weather. It pitches very quickly to provide shelter in sudden thunderstorms that are encountered along the hiking trail. Normally, you wouldn't bother with the hassle of pitching a tent for a 30-minute rain squall, but the

FAVORITE CAMPING EQUIPMENT

There are many excellent tents, sleeping bags, and camp stoves on the market. Here is a short list of those that I've tested and found dependable:

● Sierra Designs Flash Magic Tent for 2 people (2 pounds, 15 ounces)
● Marmot Nighthawk goose-down sleeping bag with Gore-Tex shell (2 pounds, 9 ounces)
● Thermarest Ultralight sleeping pad (17 ounces)
● Peak 1 Apex II camp stove (18.6 ounces)
● 2 Cookware pots (1 pound, 6 ounces)

Megamid can be set up on rocky or uneven surfaces with an ease impossible with a traditional backpacking tent.

Another tent design that caters to lightweight afficianados is Sierra Designs' Flash Magic tent. This bivouac tent for two people weighs in at an incredibly light 2 pounds, 15 ounces. Come on, a quart of water weighs 2 pounds. How do they do it? The tent is made from waterproof nylon, thereby eliminating the extra weight of a rainfly. To reduce condensation, there are front and rear vents with weather-flapped covers. This is my favorite lightweight tent.

For winter trips and camping above timberline, you'll need a four-season tent that can withstand high winds and pressure from heavy snow build-up. If your trip will be long, consider taking a tent with extra capacity so that you can bring backpacks inside, out of the snow, and minimize claustrophobia from longer tent-bound stretches of bad weather.

Digging a snow cave is an excellent alternative to carrying a tent. If you haven't tried camping in a snow cave, it can be a fun experience. I've spent quite a bit of time in snow caves and igloos, and I have a tremendous appreciation for them as winter shelters. In tempest winds and frigid sub-zero temperatures, they are more dependable and considerably warmer than tents.

You'll need to take along at least two large shovels to dig a snow cave, and for an igloo you'll need a snow saw. You'll also need a snow drift 5-6 feet deep to make a good cave for two or more people. Digging a snow cave is time consuming, and you can get quite wet from lying in the snow during the excavation. Snow caves are an attractive option when the party stays in one area and can use the cave more that one night. Otherwise, I think that carrying the extra weight of a tent compensates for two or more hours of digging, and possibly getting wet and cold.

Sleeping Bags. When I was a mountain guide on Mt. McKinley, I used to preach that a sleeping bag was a high-altitude climber's most valuable possession. If you've been injured and can't walk back to civilization, your best bet is to get into your sleeping bag and wait for rescue. And

if you're climbing and become disoriented or lost, you can sit out the night comfortably if you have your sleeping bag with you. In less dire situations, a sleeping bag can make the difference between a peaceful night or a sleepless struggle with cold.

A sleeping bag must be sufficiently warm to protect you through the coldest conditions you'll encounter. In mountain terrain you can experience snowfall even in the summer. It is advisable to use a good three-season sleeping bag rated down to about 15°F. For winter, you'll want to use the warmest bag you can put your hands on. It should be rated to -30°F.

In a pinch, you can wear extra clothing and even a parka inside the sleeping bag to stay warmer. But as a rule, the less you wear, the more comfortable you'll be inside your sleeping bag. If you wear heavy clothing inside, it will retain moisture that will feel damp and clammy after you get up. By overdressing, you also risk actually insulating yourself from your sleeping bag, and cold will gradually creep into the bag and chill you. However, wearing a hat is a good idea. A Polartec fleece hat is dependable headwear protection during the day and is great to sleep in because it doesn't itch.

A synthetic-filled sleeping bag will keep you as warm as a down-filled one so long as they have the same temperature rating. Warmth depends mostly on the loft (thickness) of the bag. As long the loft is dry, you'll stay warm. High quality down insulation is superior to synthetic fill in its warmth to weight ratio, and it is more compressible. A down-filled bag with an integral Gore-Tex shell is even better because it adds overall warmth and keeps the down dry without adding weight. Synthetic-filled bags are less expensive and dry more quickly than down insulation. But synthetics are bulkier and have to be replaced every few years because they lose their loft sooner.

After scrutinizing a dozen top-of-the line sleeping bags, I bought a Marmot Nighthawk bag. It has an integral Gore-Tex outer shell and is insulated with 650 fill-power goose down, the lightest, most efficient insulation available anywhere. The Nighthawk weighs only 2 pounds, 9 ounces and is rated as warm to 15°F. It is a good example of a lightweight three-season sleeping bag for backpackers.

Sleeping-bag manufacturers are usually conservative in the ratings they assign their products, but ultimately, these ratings are only broad guidelines to how warm you'll stay at night. Other factors that detrimentally affect your comfort are: altitude, exhaustion, dehydration, inadequate caloric intake, damp clothes, and a drafty tent. Some people have higher metabolisms and better circulation to their extremities, and they subsequently sleep warmer than others.

A three-season sleeping bag with a 15°F rating sounds like overkill for warmer climates. But that sleeping bag can be opened and used as a quilt in these conditions. Desert evenings start out warm but quickly drop in temperature. The bag can be zipped up as the temperature drops, one of the reasons a good three-season bag is so versatile.

A compression stuff sack is a great space-saving item to buy for your sleeping bag. Replace your regular stuff sack with one that has compression straps. When you pull the straps tight, it will compress the sleeping bag to half its normal size.

Sleeping Pads. A good foam pad is important for comfort and insulation. I slept for years on an inexpensive, 3/8-inch thick, closed-cell ensolite foam pad. It offered adequate insulation from the ground, but I could feel every rock and twig beneath me.

Since then, I've been spoiled by a Thermarest sleeping pad. Basically, it is a thin air mattress with open-celled foam inside. You can sleep on top of rocks and not feel a thing! I like the lightweight, 3/4-length Ultra Lite model for three-season camping trips. For winter, the 6-foot, standard model offers better protection.

Old-fashioned air mattresses can be used in summer conditions, but they tend to be either too heavy or too flimsy and prone to flats. For snow camping, an air mattress is absolutely worthless insulation. The cold air continually circulates inside the mattress, and you can really feel the cold next to your back.

Backpacking Stoves and Cookware. Campfires are great for roasting marshmallows and telling tall stories well into the night. But the days of cooking over a backcountry wood fire are

The Peak 1 Apex II (top right) is among the best lightweight stoves for four-season use (shown with its windscreen, top left, and a lightweight pan). Specialized freeze-dried foods are lightweight and make food preparation fast and easy.

almost over, because it is ecologically unsound to strip the forests for campfire wood at frequently used campsites. And a carelessly placed fire made outside an established fire pit can denude the ground of organic matter for decades afterwards. For this reason, most of the national parks have outlawed cooking over wood fires at backcountry camping sites. Besides that, a small campstove is much more efficient and saves time preparing meals. Campgrounds still permit small campfires, but the wood is either provided or sold to the campers in order to save the surrounding timber from certain destruction.

Backpacking stoves rely on either white gas or propane for fuel. I've always preferred backpacking stoves that use white gas. They are cheaper to operate, and you don't have to carry backup propane canisters. If you don't own a good stove, I recommend the MSR Whisperlite. It weighs 16.7 ounces and has performed flawlessly for me in both summer and winter. The Whisperlite saves space and weight because the fuel bottle serves as the fuel tank. You can use a liter bottle or half a liter, depending on what you need. When one fuel bottle runs dry, you simply unscrew the pump from the empty fuel bottle and reconnect the pump to a full bottle. This way, there is no spilling of fuel. Unlike pressurized propane bottles, you carry just the

amount of fuel you think that you'll need for the duration of your trip.

MSR stoves use lightweight aluminum foil windscreens that reduce heat loss from wind and reflect heat to the cookware. This greatly increases the stove's efficiency. The windscreen fits around the burner and the cooking pot but not the fuel source. These windscreens can't be used with traditional camp stoves, designed so that the burner sits on top of the fuel, because the increased efficiency would retain too much heat and explode the fuel tank.

You can carry a small spare-parts kit on long trips to replace or repair just about anything on the stove that fails. The Whisperlite's low profile reduces the likelihood that it will topple over, and the stove and fuel bottle form an "L" configuration that is very stable. My only complaint is that it doesn't simmer as well as it works on higher settings.

When my Whisperlite finally reached retirement age, I decided to try a new stove called the Peak 1 Apex II that weighs 18.6 ounces. The Apex has a design similar to the Whisperlite but offers such improvements as easier starting and built-in windguards that make an additional aluminum screen unnecessary. It seems to have a better simmer control than the Whisperlite, so I am rapidly becoming sold on the performance and reliability of this new stove.

You can use this all-inclusive checklist to help you prepare for a backpacking trip.

CLOTHING
- [] Gore-Tex shell parka
- [] Bandana
- [] Hiking boots
- [] Wind or rain pants
- [] Underwear
- [] Down vest or jacket
- [] Shirt
- [] Fleece sweater
- [] Gloves
- [] Hiking shorts & long pants
- [] Socks
- [] Clothing stuff sacks
- [] Stocking cap
- [] Gaiters
- [] Cap or sunvisor

PERSONAL ITEMS
- [] Travel alarm clock
- [] Vitamins
- [] Personal medications
- [] Premoistened towelettes
- [] Ear plugs (snoring tent mates)
- [] Toothbrush & toothpaste
- [] Sunscreen
- [] Insect repellant
- [] Biodegradable soap & towel
- [] Lip balm with sunscreen
- [] Paperback novel
- [] Emergency money
- [] Car keys
- [] Sunglasses, case, neck cord
- [] Toilet paper
- [] Miniature sewing-repair kit

CAMPING GEAR
- [] Backpack or photo backpack
- [] Spare clevis pins for frame pack
- [] Pack raincover
- [] Tent
- [] Tent ground cloth
- [] Foam pad
- [] Sleeping bag

GENERAL GEAR
- [] Two 1-quart water bottles
- [] Swiss Army knife
- [] Umbrella
- [] Water filter pump
- [] Pencil and 3x5 index cards
- [] Headlamp or flashlight
- [] Plastic trowel to bury excrement
- [] Water purification tablets
- [] Maps
- [] Emergency signaling whistle
- [] Warning bell (wear in bear country)
- [] First-aid kit
- [] Compass
- [] Nylon cord for suspending food in trees
- [] Guidebook

COOKING
- [] Stove and fuel bottle
- [] Butane lighter
- [] Pot scrubber, dishwashing soap
- [] Nesting cookware (pots & pans)
- [] Plastic measuring cup
 (doubles as a drinking cup)
- [] Eating utensils
- [] Ziploc bags & garbage bag
- [] High energy trail snacks
- [] Powdered drink mixes
- [] Food for: breakfast, lunch, dinner
- [] Spices

REMEMBER BEFORE YOU LEAVE TO CHECK:
- [] Tent for parts and needed repairs
- [] Contents of first-aid kit and restock if necessary
- [] Hiking boots for waterproofing
- [] Hiking boot laces for signs of wear
- [] Water bottles for leaking caps
- [] Sleeping pad for air leaks
- [] Blades of Swiss Army knife and sharpen if necessary
- [] Stove performance
- [] Fuel bottle for leaks
- [] Flashlight and headlamp batteries
- [] Campsite regulations and get wilderness camping permits
- [] Your itinerary and give a copy to a friend or family

One of the reasons I like using a water filter to purify water, rather than boiling it or treating it chemically, is that filtered water usually tastes better. Here is the Basic Designs Ceramic Water Filter Pump I use, along with a Nalgene wide-mouth water bottle, and a package of Kool-Aid.

Pots and pans made of stainless steel are slightly heavier than aluminum, but they have several advantages. Stainless steel is a better heat conductor, more durable, and foods won't pick up metal particles as they do with softer aluminum pots. Cooking sets with two pots and pans that nestle together take up little space and protect both pots from damage. Sometimes a camp stove will fit inside the cooking set to save valuable space.

Always pack food items above the stove and fuel bottle in your backpack. This way, if you develop a fuel leak, it won't ruin the food. I put the fuel bottle in a side pocket of the pack to keep it separate from the food and where I can immediately detect a leak by the smell of the fumes alone.

Drinking Water. Most backcountry water from lakes and streams can't be trusted for drinking. The water must be either boiled, treated with chemical tablets, or purified with a specialized filter. A common hidden culprit in water is a microscopic parasite called *giardia*. The water can look, smell, and taste perfectly good, but you still can't trust it. *Giardia* sickness usually occurs a few days after ingesting the parasite. The symptoms include stomach cramps and diarrhea that can last for weeks or months.

I prefer using a water filter to boiling water or treating it with chemicals. Using a filter is faster, and the water usually tastes better. Filters also save fuel that would be used to boil water. Best of all, as long as there are water sources, the pack remains lighter because you only have to carry enough water for short-term requirements. The main drawbacks to using water filters are that they are somewhat fragile, they eventually clog, and they take up valuable space in the pack. Numerous filters are available. I use the lightweight Basic Designs Ceramic Water Filter Pump that weighs 6 ounces and filters *giardia*, tapeworms, bacteria, and other harmful pathogens.

Water bottles are generally superior to canteens. They are lighter and take up less space in the pack. A good general-purpose water bottle is the Nalgene wide mouth. Its rigid high-density polyethylene doesn't taint the flavor of the contents with a plastic taste. The wide mouth is better than a narrow opening for adding powdered drink mixes, and in winter, a wide-mouth bottle is less likely to freeze shut. Wide-mouth bottles are also easier to fill in streams. The only better bottle is an imported one called the Hunersdorf. Its specially designed cap is threaded to seal against leaks at three different points. It is absolutely leak proof! Also, its softer

plastic is more durable and won't crack when the contents freeze. The Hunersdorf bottle is difficult to find but more dependable than any other water bottle.

I carry two 1-quart water bottles on backpacking trips. Two bottles are better than one on long, waterless stretches of trail. Otherwise, I fill just one bottle to save weight. Having a second bottle comes in handy around meal time when more water is needed for cooking.

What's Cooking? A strenuous hiking or backpacking trip is not the time to go on a crash diet. Our caloric intake increases to 4,000-5,000 calories per day while we are exercising. Foods should be chosen for their caloric content, weight, taste, and ease of preparation. Some backpackers are gourmets and demonstrate quite a creative flair for meal preparation, while others just want something that is easy to prepare and easy to clean up. I've been through both stages.

On mountaineering expeditions, I've found that high altitudes can affect the appetite, so it is imporant to bring foods that are appealing to eat. If you hand me a breakfast bowl of instant cream of wheat at 18,000 feet, I might turn my nose up at it. But a freeze-dried spanish omelet is scrumptious enough to rouse me from my sleeping bag. On the other hand, during a weeklong solo backpacking traverse of the Teton mountain range, I took nothing but PowerBar snacks and gorp (a trail mix of nuts, fruit, and candy—see below) to eat! My 4 x 5 photography equipment was so heavy that I couldn't afford the added weight of a stove, fuel, and cooking pot.

I suggest that you consult one of the menu books that have been written for backcountry food preparation, such as *The Backpacker's Food Book*, by Hasse Bunnelle and the editors of *Backpacker Magazine*, (Simon and Schuster, 1981). On weekend winter camping trips you can eat like a king by preparing a hot meal—for example, spaghetti with marinara sauce—

before you leave and freezing it overnight in a Seal-A-Meal Bag. Later at camp, you just heat the bag in boiling water for a delightful hot meal with no mess to clean up.

You might want to avoid coffee and tea with caffeine. Caffeine is a diuretic and will contribute to dehydration. Substitute decaffinated coffee or herbal teas. A great hot drink can be made with Jello. Be sure to drink enough fluids every day—at least 2 quarts. Dark-colored urine is a sign that you need to increase your fluid intake.

A favorite trail food is something called "gorp." A gorp mixture typically starts with a Ziploc bag filled with a combination of raisins, mixed nuts, and M&M candies. To that I've seen people add such ingredients as pretzels, candy corns, sesame sticks, banana chips, and so forth. Believe me, the combination of salted nuts and sweet candy can propel you to the summit of Mt. Everest.

Here are a few bits of advice about camp food that I've picked up over the years:

- Remove all excess packaging from foods to reduce bulk and weight.
- Be sure to include cooking instructions if you repackage foods in plastic bags.
- Use powdered drink mixes to hide the taste of water- treatment tablets.
- Create a spice kit to add some "zip" to freeze-dried foods. Empty film cannisters are great spice containers.
- Some freeze-dried dinners are hard to digest, so bring along antacid tablets.
- Freeze-dried meals are quite expensive, so search your grocer's shelves for less expensive packaged foods that are lightweight and don't have to cook very long.
- Eat high-energy trail snacks and drink small amounts of water every 45 to 60 minutes on the trail to maintain energy and prevent dehyration.
- Hard candies that slowly dissolve in the mouth are good for dusty trails.

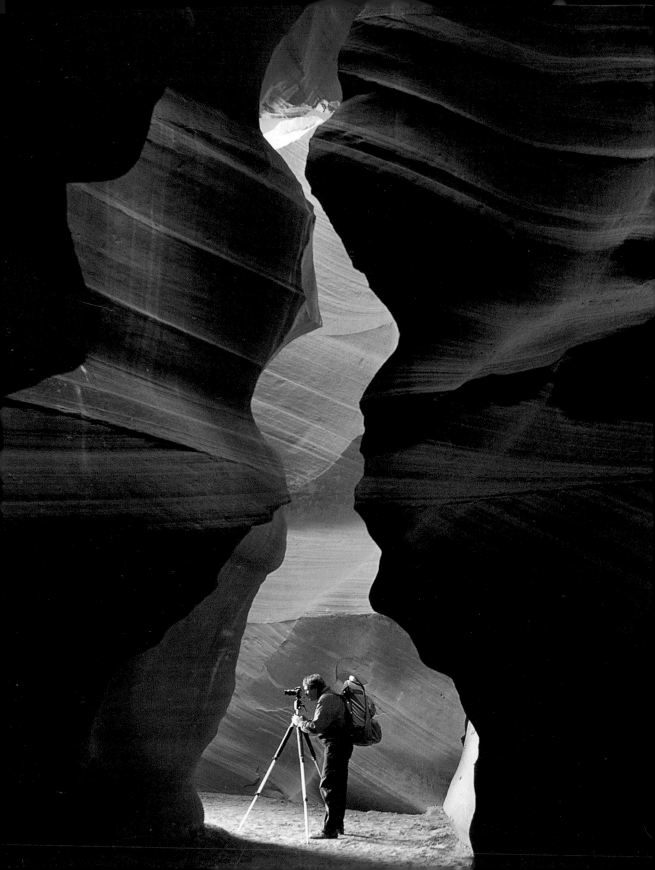

CHROMA-ZONE EXPOSURE

Learning how to manage light
is the key to making
great photographs in the field.

Like most people, you probably don't relish the thought of having to sit down and spend your valuable time studying a topic as tedious as "exposure calculation." Going out with your camera and lenses to take pictures is much more fun. Believe me, I understand; as a nature photographer, spending time outdoors is my top priority. But you're probably reading this because you've been down that road before, and by now you're sick and tired of that dark cloud of uncertainty following you around as you struggle with everyday exposure decisions.

So your pictures don't always come out as you expected. In fact, you've frequently had high hopes of taking a special photograph, but the results didn't match your expectations. You're losing confidence in your camera's auto-exposure capabilities. You're not sure how to deal with such tricky conditions as snow, fog, and closeup subjects. You're wasting a tremendous amount of film by bracketing (shooting extra frames above and below your determined "proper" exposures to safeguard against mistaken calculations). And you hear conflicting points of view on how to take properly exposed photographs.

PHOTOGRAPHER AT WORK, Slot Canyon, Arizona. Nikon F4s camera, 24mm f/2.8 lens, Bogen 3001 tripod with Linhof Profi II ball head, Fujichrome Velvia.

The fundamentals of photography—light, time, optics, and how they affect film—are eternal. To make great photographs, you must understand how these elements work together, even with today's sophisticated equipment.

Well, I've been in your shoes. Before I figured out how to meter the light and arrive at the proper exposure, I bracketed enough film to keep Kodak and Fuji very happy. And I know I wasn't alone. Exposing images properly is one of the most fundamental tasks in photography, yet for many outdoor photographers, it continues to be one of the most frustrating and mysterious aspects of trying to take good pictures. Where can a photographer turn for help?

Camera manuals give woefully inadequate space to explaining how exposure meters work and how to make exposure decisions because they want their products to seem as user friendly as possible. Can you imagine a manual as extensive as this chapter supplied with every new camera? No way—too intimidating for the buyer! To the rescue comes autoexposure, but this technology unintentionally exacerbates the situation as photographers surrender more and more control over to their cameras. I'm not satisfied with that. For me, photography is art, and I always want to maintain creative control.

The bottom line is that I'm strictly interested in results. I really don't care how I arrive at the proper exposure, as long as I can do it quickly and maintain close to 100 percent accuracy. Like every photographer, I've learned that camera manufacturers' advertising hype doesn't match reality, and even the most advanced cameras can't be trusted to determine automatically the right exposure for every situation. My desire to be completely in control of my picture taking has led me to study the topic thoroughly, refine my technique, and learn from my mistakes.

LEAVES FLOATING ON MABEL LAKE, Vilas County, Wisconsin. 4 x 5 Linhof Master Technika camera, 180mm lens (equivalent to 50mm in 35mm format), polarizer, Fujichrome 100.

The leaves floating on the surface of this pond are all in one subject plane, so the depth-of-field necessary for complete image sharpness is easily met with a medium *f*/11 lens aperture.

Eventually, I put together the Chroma-Zone Exposure System™, which works for all my outdoor photography, from wildlife and wildflowers to wild scenery. Before I teach you how to use it, you need to understand some basic concepts regarding light and time, and how they affect the image recorded on film.

THE FUNDAMENTALS OF EXPOSURE
The amount of light that reaches a piece of film is controlled by the camera shutter speed and the lens aperture, so it helps to think of them as managers of light. It is very important that you grasp how shutter speed and lens aperture work together to control exposure. In addition, shutter speeds can be used to freeze action or blur it to show motion. Meanwhile, lens apertures affect the depth of field, or the area of sharp focus, in an image. Photographers use aperture and shutter speed together to maintain creative control over the final image.

Shutter Speeds and Apertures. Exposure length is controlled by the camera shutter speed. A standard range of shutter speeds is 4 seconds to 1/1000 of a second. Some cameras offer a wider range.

Each interval between shutter speeds is known as one "stop," and each stop represents a change in the amount of light reaching the film by a factor of two. For example, a one stop change from 1/60 sec. to 1/30 sec. doubles the

length of the exposure. Each successively faster shutter speed cuts the light by one half, such as going from 1 second to 1/2 sec. Standard camera shutter speeds are (slower to faster): 4 seconds, 2 seconds, 1 second, 1/2 sec., 1/4 sec., 1/8 sec., 1/15 sec., 1/30 sec., 1/60 sec., 1/125 sec., 1/250 sec., 1/500 sec., 1/1,000 sec.

Lens apertures also work in "stops." Every size opening of the lens aperture is designated as an "*f*-stop." You can adjust the aperture in whole *f*-stops, or you can make aperture adjustments as small as one-third of a stop. Something that surprises people is that the higher aperture numbers, such as *f*/22 and *f*/32, represent the smallest openings. It is important to remember this fact because it goes against common sense to have a high number represent a small aperture.

A change of one *f*-stop smaller—for example, from *f*/8 to *f*/11—decreases the amount of light passing through the lens by one half. Going in the other direction—for example, from *f*/8 to *f*/5.6—doubles the amount of light admitted by the lens. Standard aperture openings are (larger to smaller): *f*/1, *f*/1.4, *f*/2, *f*/2.8, *f*/4, *f*/5.6, *f*/8, *f*/11, *f*/16, *f*/22, and *f*/32.

Think of Exposure in Stops. A "stop" is a standard measuring unit of light used in photography. Because f/stops and shutter speeds equally measure light, a change in one affects an equal but opposite change in the other. This is known as *the law of reciprocity*, and it is common sense; if you increase the size of the aperture (allowing more light to pass through the lens), then you have to decrease the shutter speed (allowing light less time to pass through the lens) to achieve the same exposure on film. Conversely, if you decrease the aperture (allowing less light to pass through a smaller hole in the lens), then you have to increase the shutter speed (allowing more time for light to pass through the lens).

If you are using the camera's manual exposure mode, it is easy to calculate a change in exposure by counting the number of stops. This is really handy when you want to make a change in the *f*-stop or shutter speed and you need to know how altering one will affect the other. For example, imagine that your exposure meter indicates a proper exposure reading of

1/60 sec. at *f*/22. But you need a faster shutter speed, such as 1/500 sec., to freeze your subject's movement. In the manual exposure mode, you simply turn the shutter-speed control and count the number of stops from 1/60 to 1/500 sec., a three-stop change.

1/60 sec. 1/125 sec. 1/250 sec. **1/500 sec.**
⎯⎯⎯⎯⎯⎯⎯⎯⎯⎯⎯⎯⎯⎯⎯⎯⎯▶
3 stop change

At 1/500 sec. you are using a faster shutter speed, so you need to make a reciprocal change in the aperture to allow more light to pass

ROCKY MOUNTAIN IRIS, Colorado. Nikon N8008 camera, 105mm *f*/2.8 macro, tripod with Linhof Profi II ball head, Fujichrome 50.

Depth of field controls how the background is portrayed. In the picture on top, I stopped down to *f*/16 in an effort to hold more of the flower in focus; in so doing, the background became a jumble of confusion. In the bottom picture, I changed to a wide *f*/2.8 aperture to focus on one petal and soften the background.

TIGER SWALLOWTAIL BUTTERFLY, Littleton, Colorado. Nikon F4s camera, 105mm f/2.8 macro lens, SB-24 flash on a Stroboframe flash bracket, Fujichrome Velvia.

As magnification increases, depth of field decreases. So when you photograph closeup subjects, it is important to use small apertures to keep the subject in sharp focus. This butterfly was photographed with a handheld camera and TTL flash. I used f/22 to keep its entire wing span in focus.

through the lens. The solution is to open the aperture by three stops.

f/5.6 **f/8** f/11 f/16 **f/22** f/32

← 3 stop change

Original Exposure = 1/60 sec. at f/22
Modified Exposure = 1/500 sec. at f/8

The modified exposure is now 1/500 sec. at f/8. The exposure remains the same because stops allow you to move around to any combination of aperture and shutter speed once you have your initial reading from the exposure meter. Later I'll discuss how to use stops to calculate the correct exposure.

Film speed also works in stops. The following sequence of film speeds represent a change of one stop between each: ISO 25, 50, 100, 200, 400. As you can see, the ISO numbers arithmetically double for each change in stop. There is a four-stop difference between ISO 25 and ISO 400. This means that if you changed from Kodachrome 25 film to Fujichrome 400, the exposure meter readings would be affected by four stops. For example, a meter reading of 1/30 sec. at f/5.6 for Kodachrome 25 would become 1/500 sec. at f/22 using Fujichrome 400 film. (Kodachrome 64 is kind of an odd ball because its ISO 64 rating is one-third faster than ISO 50, not twice as fast.)

DEPTH OF FIELD

Another way that shutter speeds and apertures affect the image is by affecting its depth of field, defined as the zone of acceptably sharp focus that extends in front and behind the subject. Smaller apertures produce greater depth of field, and larger apertures produce shallower zones of sharp focus. This is one of the most important principles in photography.

In most images, having everything in focus, from foreground to background, is a good idea. Areas that aren't in focus can be distracting and spoil the image. But there are times when it is preferable to use a shallow depth of field to focus the viewer's attention on the subject only. This is known as "selective focus," as it reduces the zone of sharp focus in the image.

Depth of field is also directly influenced by the camera-to-subject distance. The closer you get to the subject, the harder it is to keep everything in focus. Limited depth of field is one of the challenges of photographing subjects at high magnification. For example, a 105mm macro lens has 48 inches of depth of field when it is 10 feet from the subject. When you move up to 1 foot away, the depth of field at f/22 is reduced to only 1/8 inch!

Focal length has a direct influence on depth of field, too. Wide-angle lenses have tremendous depth of field, and telephoto lenses have extremely limited depth of field. For example,

compare the depth of field of a 24mm lens to a 180mm lens when both are focused on a subject 5 feet away, using the same aperture of f/8. The 24mm lens has a depth of field of 11 feet, and the 180mm telephoto lens has a depth of field of only 1 foot.

Hyperfocal Distance. To obtain maximum foreground-to-infinity zone of sharpness in an image, you should use the depth-of-field scale on your lens to find the hyperfocal distance. Focusing at the hyperfocal distance will yield more depth of field than focusing on infinity and stopping down to the smallest lens aperture. When hyperfocal distance is used with wide-angle lenses, you can achieve remarkable depth of field that extends from a few inches in front of the lens to infinity. The wider the lens, the closer you can focus on foreground elements in the picture.

Here is how to set your lens quickly at the hyperfocal distance. First rotate the lens' focusing barrel until the infinity symbol on the lens' distance scale is opposite the *f*-stop on the depth-of-field scale (it identifies all the lens' *f*-stops in different colors for easy recognition). The maximum depth of field will result from using the smallest *f*-stop on the lens, usually

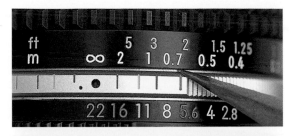

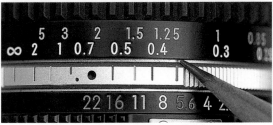

In the top picture, a lens is focused on infinity and the aperture is set to *f*/22. The depth-of-field scale indicates that the zone of sharp focus extends from approximately 2 feet to infinity. In the bottom picture, the lens is set to its hyperfocal distance. The depth of field now extends from just under 1.25 feet to infinity. Another foot of sharp focus was gained by using the hyperfocal distance.

f/22. So line up the infinity symbol with the f/22 index mark on the depth-of-field scale. The other end of the scale will indicate closest distance from the camera where the depth of field begins.

The strange thing about using the hyperfocal distance setting is that the scene won't appear to be in focus when you look through the viewfinder. To see the effect of focusing at the hyperfocal distance, you have to press the depth-of-field preview button slowly and watch the depth of field increase as the button is further pressed. Practice this at home to become proficient at setting your lens to the hyperfocal distance.

THE PHOTOGRAPHER'S DILEMMA
Now you have a better understanding of how shutter speed and aperture work together as managers of light. The problem you have to live with is that if you stop down to a small aperture for more depth of field, then the law of reciprocity makes it available only at the expense of using a slower shutter speed. And if you need a fast shutter speed, then you must

HOW FOCUSING ON HYPERFOCAL DISTANCE INCREASES DEPTH OF FIELD FOR WIDE-ANGLE LENSES

The table below compares the approximate depth of field achieved simply by focusing at infinity with that achieved by focusing at the hyperfocal distance. All three wide-angle lenses were set at *f*/22, the smallest aperture. Note that the wider the lens, the greater the depth of field. This is an important consideration in shooting scenic landscapes.

Lens	Depth of Field Focused at Infinity	Depth of Field Focused at Hyperfocal Distance
20mm	2 ft. to infinity	12 in. to infinity
24mm	3 ft. to infinity	18 in. to infinity
35mm	6 ft. to infintiy	36 in. to infinity

be willing to sacrifice depth of field by using a larger aperture.

When you visualize the results you want before shooting, you need to decide if your priority is depth of field or using a fast shutter speed. If it is depth of field, you must decide which *f*-stop to use and then find a corresponding shutter speed. You can do this in manual exposure mode or you can use the aperture-preferred autoexposure mode. If your priority is a fast shutter speed, choose the shutter speed first, and then find the *f*-stop. Use either manual exposure mode or switch to the shutter-preferred autoexposure mode.

Sometimes the problem is getting enough depth of field while using a fast-enough shutter speed to handhold the camera or freeze subject movement. Switching to a film with a faster ISO rating may be the only solution. With a faster film, you can use faster shutter speeds and still maintain a good depth of field with smaller apertures. But be careful—films as fast as ISO 200 can introduce image-quality problems. Their colors are not as vibrant, contrast increases, and the biggest problem is film grain. Perhaps the future will bring high-speed films that produce results only available from slow-speed films now. Until that day arrives, a good practice is to use the slowest film that works for the type of photography you do, and learn to balance your depth-of-field priorities with your shutter speed priorities.

THE CHROMA-ZONE CONCEPT

The Chroma-Zone Exposure System is unique in the way that it embraces color photography.

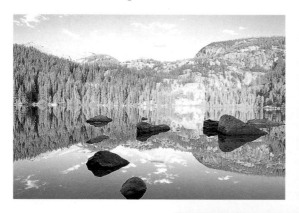

BEAR LAKE, Rocky Mountain National Park, Colorado. Nikon F4s camera, 24mm f/2.8 lens, Bogen 3021 Tripod with Foba Super Ball head, Tiffen ND grad .6 filter, Fujichrome Velvia.

Color slide film has a narrow exposure latitude, which means that exposure calculations must be close to perfect for good images. On the right, the scene is properly exposed. On the top left, the exposure is off by just one stop of overexposure. On the top right, the scene is underexposed by one stop.

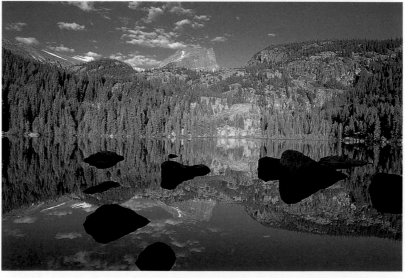

80

This system empowers you with its method for analyzing the different reflective values of colors in the natural environment, so that you can then assign an exposure value to each color. While it is easy to recognize that, in a given scene, a light tan-colored sandstone cliff is brighter in reflectance than a dark blue spruce tree, what would you normally do with this observation? With the Chroma-Zone Exposure System, you could analyze the reflectivity of these different-colored objects and areas in the scene, and then quickly adjust the shutter speed and aperture for the proper exposure.

Unlike a total reliance on autoexposure, using the Chroma-Zone Exposure System won't stifle your creativity because exposure decisions remain yours to make, not the camera's. And unlike bracketing, the system is accurate enough to get the exposure right with the first shot. This can be a lifesaver in outdoor photography when nature often doesn't provide us with a second chance.

The Chroma-Zone Exposure System specifically addresses the needs of those who use color-slide film. Color-transparency film, or slide film as it is commonly known, comes closer to accurately capturing what you see than color print film does. For this reason, slides are preferred by serious amateur and professional photographers and by publishers of books, magazines, and calendars. But as every outdoor photographer can attest, slides tend to be very unforgiving with respect to exposure. Almost perfect accuracy is required at the moment the photograph is taken, or the slides will be easily overexposed or underexposed.

Camera Requirements. If you own a 35mm SLR camera with TTL (through-the-lens) metering, you have all that you need to put the Chroma-Zone Exposure System to work right away. You don't need to invest in an expensive handheld exposure meter when you already have a perfectly good exposure meter in your camera. Plus, working with a camera's TTL meter is faster than using other camera equipment. A TTL meter automatically compensates for exposure changes as you do such ordinary things as add a filter, focus on closeup subjects, use an electronic flash, zoom to a different focal length, add a teleconverter to a telephoto lens,

or add extension tubes for macro photography. In other words, a TTL meter automatically reads into the equation anything that would alter the correct exposure.

And when the intensity of sunlight is changing from moment to moment—for example, when the sun ascends the early morning sky, or sinks at sunset, or dodges in and out of the clouds at midday—it is difficult to rely on slower exposure-calculation methods. A TTL meter instantly compensates for any change in the light's intensity. In addition to a TTL meter, you'll need a camera that allows you to manually adjust the shutter speed and f/stop, or offers exposure compensation in the auto-exposure mode (more on this later).

What if you use a medium-format or large-format camera without a TTL meter? The good news is that the Chroma-Zone Exposure System works perfectly with any quality camera system. In fact, I originally devised this system for my 4 x 5 photography. Unlike 35mm cameras, 4 x 5 cameras don't have built-in light meters, so I use a separate one-degree spotmeter for measuring reflected light. When you aren't using a TTL-metered camera, you do have to consider the effect that filters and extension have on exposure. If you already shoot with one of these cameras, you can easily adapt to this method.

UNDERSTANDING EXPOSURE METERS

A butterfly, a blue jay, a waterfall, and a sandy beach are examples of things that reflect different amounts of light. Everything about exposure comes down to the amount of light reflected by these objects. This is called subject reflectance, or *reflectivity*. Exposure meters measure this light and provide exposure recommendations.

The photography industry uses a universal standard for exposure meter calibration. This means that exposure meters made in Germany, Japan, and America all operate the same way. Exposure meters are calibrated to tell you what exposure to use for a medium-reflective subject. The key word here is "medium." The photography industry defines a medium subject as one that reflects 18 percent of the light reaching it.

How did they determine that medium reflectivity was 18 percent? Why not some other

number, such as 50 percent? Doesn't 50 percent seem closer to the middle? The answer lies in film's ability to record light. Eighteen percent happens to fall exactly midway between film's ability to record detailless white (pure white) and detailless black (pure black). It is also midway in film's 5-stop exposure latitude: 2-1/2 stops darker than pure white, and 2-1/2 stops lighter than pure black, which is why medium reflectivity is also known as medium gray. This explains why in a high-contrast scene, some objects are properly exposed, while those that are in light too bright or too dim for the film to record are overexposed or underexposed.

Exposure meters are designed to give photographers exposure readings for a tone always right between white and black, which means that something like the proper exposure will occur as long as the subjects in a photograph aren't either very light or very dark. However, if you're passionate about photography, you obviously must have a more accurate method for exposure calculation; something simple, yet bombproof!

The Photographic Gray Card. Photographers often refer to a very useful item called a "gray card" that can be purchased from most camera stores. The medium-gray shade of this card always reflects exactly 18-percent of the light, so it is a perfect mate for your exposure meter. If your exposure meter had its way, it would turn everything you photograph into a medium-tone just like the 18 percent gray card, which is why I've included the photographic gray scale in the Chroma-Zone Exposure System even though most nature subjects aren't gray in color.

However, keep in mind that there is no magic behind using the color gray to measure medium tones. This is so important, it bears repeating. There is no magic behind the use of the color gray. Exposure meters are color blind. An equally good substitute for a gray card could be medium blue, medium brown, medium red, and so on. The important factor in a gray card is its reflectivity of 18-percent of the light hitting it, not its color.

Adding and Subtracting Light. If your exposure meter is correctly calibrated, you can rely on it to give you an accurate reading of reflected light. But this doesn't mean that it is giving you the correct exposure. The correct exposure depends upon how you interpret the subject's reflectance; for example, you would probably want a white, sandy beach to be a lighter-than-medium tone in a photograph, but the exposure meter would tell you how to expose it as a medium tone.

All photographic subjects can be classified on the basis of the amount of light they reflect. Basically, they fall into three categories: medium subjects, lighter-than-medium subjects, and darker-than-medium subjects. To photograph medium subjects, no exposure compensation is necessary; the meter reading is correct. To photograph lighter-than-medium subjects, you must add light to the meter reading, which means the TTL meter will indicate that you're overexposing the photograph. For darker-than-medium subjects, you must subtract light from the meter reading, which means that TTL meter will indicate underexposure.

Modifying the exposure-meter reading is the same thing as adding or subtracting light. This is the essence of exposure compensation. A change in exposure that calls for adding light by adjusting the aperture or shutter speed is sometimes referred to as "opening up." Conversely, an exposure compensation that calls for subtracting light is interchangeable with the term "stopping down." Opening up and stopping down are common phrases, but they can be misleading, for they seem to indicate a change in *f*-stop, or aperture, only. I prefer to use the terms "adding light" and "subtracting light," which can mean any combination of changes in the *f*-stop or shutter speed that results in the desired exposure compensation.

Manual Exposure Compensation versus Autoexposure Compensation. Should you use the manual exposure mode or autoexposure mode of your camera? I prefer to shoot manually because it forces me to consider the implications of my *f*-stop and shutter-speed decisions. But if you prefer to use autoexposure, you can dial-in a plus or minus value by using your camera's "autoexposure compensation" feature, usually a dial or button somewhere on the camera.

ATAMASCO LILIES, North Carolina. Nikon F4s camera, 105mm f/2.8 macro lens, Bogen 3001 tripod with Linhof Profi II head, B-15 macro rail, UV filter, Fujichrome Velvia.

The lilies on the left were exposed using the exposure meter's recommendation, resulting in underexposure. The exposure meter can't read the different reflective values of light and dark subjects. On the right, I used the Chroma-Zone Exposure System to analyze the reflectivity of the flowers and placed them in zone +1$^{1}/_{2}$; then I adjusted the shutter speed and aperture for the proper exposure.

One advantage of using autoexposure compensation is that it yields accurate exposures even when light levels are changing from moment to moment, such as when clouds are passing overhead or a subject is moving in relation to the light source. Working in manual mode, you must meter the subject and take the shot before there is a change in the lighting. This doesn't mean that you have to rush your shooting, just that once you've taken a meter reading, you shouldn't waste any time because the light level might change.

With autoexposure you can elect to use either the aperture-priority exposure mode or the shutter-speed priority mode. If you are using aperture priority, the camera adjusts only the shutter speed as you dial-in the exposure compensation you want: for example, +1, to add one stop of light for a lighter-than-medium subject. Working in aperture-priority exposure lets you maintain a desired depth of field because the aperture isn't altered. And in shutter-speed priority metering, you set the shutter speed while the exposure compensation alters only the aperture. These are basic camera functions that every camera owner should understand. Be sure to reset the exposure-compensation setting immediately back to zero after you take the photograph. (All of the above applies to the operation of Nikon cameras. Other cameras operate similarly, but it is best to consult your camera manual if you use a different camera brand.)

Most of today's advanced 35mm SLR cameras additionally offer one or two program exposure modes in which the camera's microcomputer uses information from the exposure meter and computes the exposure without inviting any input from you regarding aperture or shutter speed. I would avoid using this feature on your camera except when you are in a fast-breaking situation and don't have time to think about the exposure (see "Metering Options" in this chapter).

THE CHROMA-ZONE EXPOSURE MATRIX

Now that you understand the fundamentals of exposure meter operation, you are ready to begin using the Chroma-Zone Exposure System to take pictures. At the very heart of the system is an important tool called the Chroma-Zone Exposure Matrix (see the chart on page 85). First, familiarize yourself with its layout. The matrix has four vertical columns. From left to right, these provide: Chroma-Zone Number, Exposure Compensation, Gray Tone Guide, and Color Guide. The matrix has 11 horizontal rows. Each represents a different zone. The zone 0 row represents any medium- or average-colored object with 18-percent reflectivity. Each row, or

zone, above and below zone 0 represents a 1/2-stop incremental difference in subject reflectance from zone 0. The five zones above zone 0 represent colors that are darker than average. The five zones below zone 0 are lighter than average.

Pick any zone, and all three descriptions directly to the right of it fit that zone. The second column gives you the Exposure Compensation for each zone, and the third and fourth columns provide important verbal descriptions that aid in identification.

While the Chroma-Zone Exposure System shares similarities with the Zone System created by Ansel Adams, Chroma-Zone numerical values and descriptions are different for color photography. The reason why is that color photographers don't have the luxury of making major alterations to their photographs. When a color slide is exposed, the image is final. This is quite different from black-and-white zone theory that incorporates major darkroom manipulation of how the negative is developed and extensive custom printing. For my color nature photography, I prefer using an exposure system that is easy to follow and understand, to trying to modify someone else's program to fit my model. Think of the Chroma-Zone Exposure System as a unified theory that brings together many established concepts into one cohesive model (the Chroma-Zone Exposure System is Trademark Registered Pending).

How To Use the Chroma-Zone Exposure Matrix.
The Exposure Matrix takes only a few seconds to consult. But photographing with it probably involves breaking old habits. Most individuals shoot a picture very rapidly and then rush to take the next shot. Changing an old habit, or starting a new one, is a matter of simple repetition. Here are the steps to take each time you shoot using information from the matrix:

Step 1. Start with the Color Guide or Gray Tone Guide (third or fourth columns). Find the best description of your subject. If your subject is a "medium color" or "medium gray," then it can be found in the middle row. If it is "darker than average," look for it in the upper half of the chart. If it is "lighter than average," look for it in the lower half.

Step 2. Assign a zone number to your subject (first column).

Step 3. Identify the Exposure Compensation that is directly to the right of the zone number (second column).

Step 4. Take a meter reading of the subject. Adjust the aperture and/or shutter speed for the desired exposure compensation. Take the photograph.

Step 5. If time permits, take two more exposures: 1/3 to 1/2 stop under, and 1/3 to 1/2 stop over the exposure you arrived at in step 4.

What To Meter. At this point, you know that you are supposed to use your exposure meter to interpret reflected light from somewhere within the composition that you have chosen. There are several ways to proceed.

Most compositions feature a specific subject or object that becomes the focal point of the composition. You might want to take a meter reading only of the primary subject, such as a moose wading in a shallow pond. Metering the subject is often a good idea because you want to be sure that it is rendered faithfully on film. But it isn't the only option. You can meter a specific area within a scene if that is easier to meter. In the example of the moose, this could be the broad surface of the pond, shoreline grasses, or an area in the background such as a hill or even a blue sky.

The best proceedure is to always look for a medium-toned, neutral area in zone 0 to meter first. Because no exposure compensation is necessary in this zone, you can work quickly. If the focal point of your composition isn't a suitable neutral subject, take a substitute reading from a neutral area illuminated by the same light as the subject. For example, the moose is clearly darker than zone 0, so metering a neutral area would mean choosing another object, such as the grass or the sky. The path of least resistance is to find areas that are in zone 0.

When you take a substitute reading, be sure it is from an area affected by the same light as the focal point of the photograph. If you don't, the meter reading will be unreliable. A fully overcast sky with soft, even lighting casts the same light everywhere and thus presents no

CHROMA-ZONE EXPOSURE MATRIX			
CHROMA-ZONE NUMBER	**EXPOSURE COMPENSATION**	**GRAY TONE GUIDE**	**COLOR GUIDE**
Darker than average subjects			
ZONE -2½	subtract -2½ stops	extreme black	extremely dark
ZONE -2	subtract -2 stops	black	very, very dark color
ZONE -1½	subtract -1½ stops	gray-black	very dark color
average subjects			
ZONE -1	subtract -1 stop	dark gray	significantly darker color
ZONE -½	subtract -½ stop	slightly darker gray	slightly darker color
ZONE 0	**neutral 0**	**medium 18% gray**	**medium color**
ZONE +½	add +½ stop	slightly lighter gray	slightly lighter color
ZONE +1	add +1 stop	light gray	significantly lighter color
Lighter than average subjects			
ZONE +1½	add +1½ stops	very light gray	bright or pale color
ZONE +2	add +2 stops	white	very bright or pale color
ZONE +2½	add +2½ stops	extreme white	extreme bright or pale color

problems. But in direct sunlight, there will be greater contrast between highlights and shadows and more opportunities for error. If the most important area of the image is in direct sunlight, be sure any substitute reading is taken in direct sunlight, too. Conversely, if the focal point is in the shade, take the substitute reading from a shaded area (see "Evaluating Exposure Latitude" below).

If you can't find a neutral area to meter, pick any object and evaluate its reflectance with the Exposure Matrix. That is what the matrix is for—it gives you the exposure compensation you need to take the picture. Returning to the example of the moose, if the season were late autumn, the grass at the edge of the pond would be light brown instead of summer's medium green. Even so, I would still prefer to take a substitute reading of the grass because the moose is a smaller, moving target and more difficult to meter. Here is how this would work using the matrix:

Step 1. Light brown is not a gray tone but a color, so let's use the Color Guide in the fourth column. Lighter tones appear in the five zones below zone 0. Light brown is "significantly lighter" than medium brown. It isn't "slightly lighter" and it isn't "bright or pale." Get the idea?

Step 2. Assign zone +1 to the light-brown grass.

Step 3. Identify "add +1 stop" as the proper exposure compensation.

Step 4. Take a meter reading of the light-brown grass. Don't include other areas in the scene

RED FOX IN WET GRASS, Katmai, Alaska. Nikon FM camera, 300mm f/4 ED-IF lens, handheld, Kodachrome 64.

When I couldn't directly meter this elusive fox, I took my meter reading from the medium green background and calculated accordingly.

that would influence the accuracy of the reading. Adjust the f-stop or shutter speed so that the viewfinder display indicates +1 overexposure of the grass. When the moose looks at you and smiles, take the photograph.

Step 5. Take two more exposures, subtracting 1/2 stop from the current camera setting, and adding an additional 1/2 stop.

If the lighting conditions should change, or if you decide to add something, such as a polarizing filter, that would alter your original reading, just take another quick TTL reading and you have the new exposure information to take the shot.

Metering Options. Your camera may offer several metering modes, including matrix metering, center-weighted metering, or spotmetering. I recommend using the spotmetering mode to obtain precise readings of small areas. The reason such accuracy is important is that peripheral objects close to the subject or in the background can influence a broader meter reading. Meters that provide averaged readings from all parts of a composition are heavily influenced by light and dark areas in a scene.

Spotmetering is still a relatively new feature on 35mm cameras. If you don't have it, use center-weighted metering (in which 60-75 percent of the reading is concentrated on the area in

the center of the viewfinder) and compensate by moving in close enough to read a specific area or switching to a telephoto lens' narrow angle of view for greater accuracy. Obviously, these tactics aren't as quick or convenient as spotmetering, but executed carefully, they will work just fine.

Matrix metering doesn't fit very well into this system. Although I have great respect for its capabilities, the problem is that matrix metering calculates the exposure from a multi-segmented analysis of the entire image area. Then the camera's microcomputer determines the exposure. Although this metering option is very effective in some situations, you lose control of the exposure calculation. And because you have no way of knowing how matrix metering will handle a situation, you are back to uncertain bracketing and wasting valuable film. Matrix metering is great for those who need to shoot very quickly. It is also great when you need an electronic flash. But it isn't as accurate as spotmetering or center-weighted metering when used in conjunction with the Chroma-Zone Exposure System.

Sometimes even a spotmeter's precise reading isn't enough to let you meter the subject directly. Perhaps your subject is an animal that won't hold still long enough for you to take a meter reading. Perhaps you are too distant from the animal to get a precise spot meter

reading of the fur or feathers. There is a solution. Usually when you can't meter the subject itself, you can meter the background. A small bird sitting in a tree can be metered by taking the reading from the tree or from a background of medium blue sky.

Bracketing Exposures. After all my emphasis on calculating the correct exposure, why do I still recommend bracketing in 1/3 to 1/2 stop increments? Because two factors beyond your control can affect exposure accuracy: film-manufacturing tolerances and film lab processing. When film is manufactured, the ISO assigned to it can vary as much as plus or minus 1/3 stop from its stated rating. Amateur films are supposed to be within 1/3 stop, and professional films have a closer tolerance of 1/8 stop. And film processing, even at the best professional labs, can be off by as much as 1/3 stop. A variance of 1/8 to 1/3 of a stop is barely discernible to most of us, so we're not talking about catastrophic variables. But these relatively minor factors can accumulate to a combined error of 1/2 to 2/3 stop, and then there is reason to be concerned. When the situation permits, bracketing by 1/2 stop over and under your calculated exposure will cover these possibilities as well as any error on your part.

Sometimes subtle differences in color saturation, hue, shade, and tint can make deciding in which zone a subject belongs quite challenging. For example, it might be difficult to decide if a subject is exactly medium reflective or whether it is slightly lighter or darker. Based on my experience, if the differences are that subtle, just treat it as medium. It will be close enough.

If you have the opportunity to bracket exposures by 1/3 to 1/2 stop, you will get a "slightly lighter" and "slightly darker" rendition, too. Bracketing a medium-blue flower by plus and minus 1/3 to 1/2 stop would yield a "slightly lighter" blue version, and a "slightly darker" blue version in addition to a medium blue. All three versions will probably be "keepers" and individually useful. This subtle use of bracketing is a far cry from blindly shooting over and under by several stops.

Much of the time, outdoor photography situations don't provide us with the luxury of bracketing. Then we simply have to hope that the film and developing won't adversely affect the results. Actually, it is rare when an exposure error results from something other than the photographer's miscalculation. But a couple of extra shots can save the day!

EVALUATING EXPOSURE LATITUDE

The Chroma-Zone Exposure System can vastly improve your exposure accuracy. In the interest of artistic expression you may sometimes deliberately break the rules in order to achieve a desired exposure effect. But knowing the rules, you are the master of your camera and your art. You make the exposure decisions based upon your subjective interpretations in each situation, and you remain in control of the desired effect.

Exposure calculation remains an art no matter how hard we try to apply rules or technology. Who is to say when something is properly exposed? It remains in the eye of the beholder.

It is important to evaluate the degree of contrast in your composition. Bear in mind that broad scenics can be very intolerant to exposure error, while closer-proximity compositions tend to be more forgiving. The challenge of scenery is that the sky is often much brighter in relation to a foreground scattered with such light-absorbing objects as green trees, grass, plants, and dark soil. Snow, rocks, and bodies of water, all highly reflective, are often interspersed in the darker areas and add to the confusion. In addition, scenes with strong backlighting can have different exposure values in the foreground and background. These extremes of light and dark reflectance are a problem for your film to record.

If all areas in a scene are not illuminated by the same kind of light, the scene's lighting ratio can extend several steps beyond the five-stop exposure-latitude range of film. This situation fools more inexperienced photographers than any other. The human brain has a sophisticated ability to absorb and interpret a scene containing great contrast (around ten stops or more). A camera is crude by comparison. It records what is there within the narrower confines of the film's five-stop capabilities.

Problems of exposure latitude are most commonly encountered at sunrise and sunset when the sky is brightly lit compared to the foreground, and at midday when the sunlight is

intense and shaded areas are very dark. In shaded areas where the human eye can still discern detail, film often records the shade as solid black. The lighting ratio between highlights and shadows must be kept within the exposure capabilities of color film emulsions.

In a high-contrast situation, the first step is to decide which part of the scene should get optimal exposure midway between highlights and shadows, which I will refer to here as the neutral area. The next step is to meter the brightest highlights and darkest shadows to determine how many stops away they are from neutral.

Although it is generally agreed that film has a 2-1/2 stop exposure latitude above and below

absence of any neutral area, find something else to meter and analyze its reflectance using the Chroma-Zone Exposure Matrix.

A good technique for evaluating midday light is to stretch out one arm directly in front of you. If it casts a clearly defined shadow, you have a potentially high-contrast lighting situation. If there is a faint or non-existent shadow, you have a safer low-contrast situation.

High-Contrast Lighting. When the lighting is beyond the recording capabilities of the film, you have several options. You can wait for cloud cover to diffuse and soften the light. You can shoot just as the sun sets and the intensity of the sun is reduced by haze on the horizon. You can use a ND grad filter to lower the lighting ratio. If you are photographing a small area instead of a broad landscape, you can use portable reflectors to bounce light into the shadowed areas or use a portable diffuser between the subject and the sun to even out the light. I use a couple of 21-inch collapsible discs for reflection and diffusion. Electronic flash can fill-in shadowed areas as long as the subject is within the distance range of the flash's output. This is called daylight-balanced "fill-flash," a highly useful

EXPOSURE LATITUDE IN HIGH-CONTRAST LIGHTING		
CONTRAST EVALUATION	COLORS	DETAILS
3 stops above neutral area	washed out	gone
2^1/$_2$ stops above neutral area	nearly gone	nearly gone
2 stops above neutral area	bleached out	poor
1 stop above neutral area	pale	still good
neutral area	excellent	excellent
1 stop below neutral area	rich	still good
2 stops below neutral area	dark	poor
2^1/$_2$ stops below neutral area	very dark	nearly gone
3 stops below neutral area	extremely dark	gone

neutral, this isn't written in stone. Personally, I aim for a maximum of plus or minus 1^1/$_2$-2 stops from neutral in my images (see the box above). I'm particularly concerned about retaining some color saturation in highlight areas, such as the sky. Proper exposure for the highlights is generally more critical to the success of an image than holding detail in the shadows. My major concern with shadows is that, through underexposure, they don't mask visual information crucial to the image and that they aren't so large as to be distracting.

When photographing scenery, as long as the lighting ratio in the scene is fairly even (for example, when the scene is predominately in the sun or in the shade), then all you have to do is meter a readily identifiable neutral area in zone 0 and adjust the shutter speed and aperture to the meter's recommendation. In the

technique outdoors. I often use a Nikon SB-24 flash unit for this purpose because the camera and flash automatically calculate a pleasantly balanced exposure between the ambient light and the flash. Here are some techniques for high-contrast lighting:

- Wait for the lighting ratio to lower in contrast.
- Use a ND grad filter to lower the lighting ratio between the sky and foreground.
- Bounce light with a portable reflector into shadowed areas.
- Employ a portable diffuser to soften direct sunlight.
- Fill-in shadows with an electronic flash.

When the lighting contrast in a scene is high, prudent photographers using the Chroma-Zone Exposure System will bracket two additional

CROSS COUNTRY SKIER,
Wasatch Range, Utah.
Nikon 8008 camera,
300mm f/4 ED-IF lens,
handheld at 1/500 sec.,
Fujichrome 100.

There was a great deal of contrast in this scene between the snow, the backlit skier, and the dark evergreens. I intentionally selected a dark background of trees to prevent overwhelming the image with too much bright snow, and I chose dramatic backlighting for the skier. I knew the reflection from the snow would reduce overall contrast in the image by acting as "fill light" on the skier.

exposures. Many animated subjects don't hold still long enough for bracketing, but scenics are perfect for 1/2-stop bracketing. When the contrast in a scene is low, bracketing exposures is far less critical. If you consistently find a need to bracket more than 1/2 stop, this is a clear indication that you aren't using the Chroma-Zone Exposure Matrix to its fullest potential.

THE CHROMA-ZONE COLOR REFERENCE CARDS

During my early experiments with the Chroma-Zone Exposure System my greatest concern was whether medium reflectance was recognizeable in different colors. I knew that if I could recognize the medium colors, then I could use the Chroma-Zone Matrix to determine the proper zone for the other colors, too. Medium gray was easy, because, like many photographers, I always carried a small gray card for reference. But trying to compare the infinite variety of colors in nature to a gray card was like trying to imagine how a black-and-white movie might look in color.

I wondered whether I could develop a set of reference cards in colors to work just like a gray card. With these color reference cards I could easily tell when a subject was medium reflec-

tive, lighter, or darker. When is a red flower actually medium red? When is green grass actually medium green? Is a slab of weathered wood a shade of medium brown, lighter brown, or darker brown? Color reference cards would help me to answer these questons.

For months, my attempts at developing a set of color reference cards met with disaster. At first, I tried to use the wide variety of colors in the Pantone system employed by printing presses. But I couldn't find colors that were realistic enough, and each paper sample I found was too shiny to use outdoors. I took meter readings from the papers, but they made no sense. I nearly give up the effort when an unlikely source turned up some very special non-reflective, clay-coated papers. These paper samples were available in a broad variety of colors and were perfect for making the reference cards I had in mind.

I metered the samples with a highly sensitive, Pentax Digital Spot Meter (I could have also used the camera's TTL meter) and recorded the exposure values of different colors as they compared to a gray card. Then I photographed the paper samples (with the film I use most often, Fujichrome Velvia) using my exposure-compensation values to see if they did indeed come out properly exposed. In a couple of instances I adjusted the values to reflect the actual results.

The data started to make sense. In fact, it was astoundingly accurate! For example, a meter reading of a light blue card, in comparison with an 18-percent gray card, indicated that +1 stop overexposure was necessary in order to record light blue correctly. If I didn't overexpose the light blue card by +1 stop, a straight meter reading of the card would yield a 1-stop under-exposed photograph.

The exposure values of some colors were quite easy to believe. I selected a yellow color, for example, that was a perfect match for a handy test subject: a common yellow dandelion flower. I could use the precise exposure value of the yellow reference card and apply it with confidence to capture a photograph of a dandelion. But a few colors were a total surprise, and I had to overcome my subjective biases to accept their exposure values; still, repeated testing confirmed the results.

The experiment was working, but I had no idea how many colors would be needed to create a useful set of field reference cards. At one point, I was convinced that it would take an unwieldy batch of at least 70 colors to do the job satisfactorily. I began to question the sanity of the entire enterprise. Then I returned to my original premise: If I could identify colors with medium reflectance, I could improve my accuracy in using the Exposure Matrix. With further refinements, I eventually settled on a concise group of 21 colors, shown on the right. I found that just 21 cards could do the job of hundreds of cards by making the subtle exposure adjustments I'm about to explain. The color accuracy of the Reference Cards is so critical that it was impossible to accurately recreate them with printer's inks and make them available in this book. However, custom-made sets are available (see the Resource Guide on page 142 for information on ordering them).

Armed with these color samples, I found that the human eye is an extremely accurate instrument in analyzing the relative brightness of colors when they are compared in close proximity with the Reference Cards. But without a side-by-side comparison, it is easy to be fooled by nature's presentation of so many colors as observed in different types of light.

If you've ever tried to shop for a tie to match a blazer, or a skirt to match a blouse, without taking it with you to the store, you know how difficult it is to match colors by memory alone. The primary reason for using these Reference Cards is to have a standard reference point, just like a gray card, in order to evaluate the correct exposure. Frequently, the Reference Cards will come so close to matching your subject, that they will provide an immediate analysis.

All you have to do is find the card that most closely matches the subject you want to meter. The card tells you what the proper zone is. Then you meter the subject directly, and adjust the exposure based on that zone. This is better than trying to take a meter reading from the card itself or from a gray card, since the subject may very well be in different light from where you are standing. The Chroma-Zone Exposure System works accurately without the cards, but the Reference Cards refine the process to the point where guesswork is virtually eliminated.

**LEAF GREEN
CHROMA-ZONE 0**

**MEDIUM RED
CHROMA-ZONE 0**

**REDWOOD
CHROMA-ZONE 0**

**MEDIUM BROWN
CHROMA-ZONE 0**

**RED-VIOLET
CHROMA-ZONE 0**

**MEDIUM BLUE
CHROMA-ZONE 0**

**LIGHT VIOLET
CHROMA-ZONE +1/2**

**LIGHT BLUE
CHROMA-ZONE +1**

**ORANGE
CHROMA-ZONE +1**

**FUSCHIA
CHROMA-ZONE +1**

**GOLD
CHROMA-ZONE +1**

**FLESH
CHROMA-ZONE +1**

**YELLOW
CHROMA-ZONE +1$\frac{1}{2}$**

**PINK
CHROMA-ZONE +1$\frac{1}{2}$**

**EVERGREEN
CHROMA-ZONE -2/3**

**DEEP VIOLET
CHROMA-ZONE -1**

**WHITE
CHROMA-ZONE +2 to +2$\frac{1}{2}$**

**LIGHT GRAY
CHROMA-ZONE +1**

**MEDIUM GRAY
CHROMA-ZONE 0**

**DARK GRAY
CHROMA-ZONE -1**

**BLACK
CHROMA-ZONE -2 to -2$\frac{1}{2}$**

*© 1993 PHOTOnaturalist. These colors are only close approximations, not actual representations, of the Chroma-Zone Reference cards.

Seven of the Chroma-Zone Reference Cards represent medium colors in zone 0, shown here. The remaining cards identify colors that aren't medium.

Get Acquainted With the Reference Cards.

There are 21 Chroma-Zone Color Reference Cards. Each card is 2.5 x 3.75 inches. They are heat laminated in clear plastic so that they are durable enough for outdoor use and resist the color-bleaching effects of ultraviolet light. They are compact enough to carry in a shirt or vest pocket. The colors were chosen on the basis of their resemblance to common objects in the natural environment: plants (*leaf green* card), sky (*medium blue* card), human skin (*flesh* card), trees (*evergreen* card), snow (*white* card).

The best way to familiarize yourself with the Chroma-Zone Color Reference Cards is to spread them out in front of you and take notice of the zone number on each card. The zone numbers are the same as the exposure compensation values. For example, the *light blue* card is zone +1, and its exposure compensation is also +1. So you simply take a TTL meter reading of a subject matching the *light blue* card and perform an exposure compensation of +1 stop. To see how this fits into the Chroma-Zone Exposure Matrix, take a quick glance at the fourth column of the matrix to find the matching Color Guide description. The Color Guide offers a verbal description for that zone. For *light blue* in zone +1, the description reads, "significantly lighter color" (meaning significantly lighter than 18-percent medium blue). Now do this for each of the 21 cards. In this way, you will see how the Reference Cards and color descriptions of the matrix work together to simplify the exposure evaluation process.

Pay special attention to the seven cards that are identified as zone 0. These cards represent colors that are similar to a gray card in that they all have 18% medium reflectivity. When I can, I prefer to take my meter reading from a readily identifiable medium-toned subject. That is the fastest way to make an exposure evaluation because these medium tones don't require exposure compensation. Just meter a medium-colored area, balance your shutter speed and aperture, and take the picture. Keep those seven cards handy, because you'll use them frequently. One of my workshop students asked me, "You mean that all I have to do is find something to meter that matches one of the reference cards, and then do what the card says?" That's exactly right!

I recommend practicing with a new set of Chroma-Zone Color Reference Cards in a friendly environment, such as a flower garden or city park. This is an ideal way to familiarize yourself with the system and become a Chroma-Zone expert in the shortest time. Then it is easy to transfer what you've learned to situations you encounter when you are hiking, backpacking, or exploring.

In your first practice session, don't attempt to take any photographs; first, hone your skill with the cards. Begin your practice session by trying to find objects with colors that are in zone 0. Check out the most basic elements in

the environment: the grass, trees, rocks, soil, and sky. Then study the colors of individual flowers. Hold the cards in front each subject. Which subjects are medium? Which ones are lighter or darker?

The cards let you compare the colors you find, which have unknown exposure values, to a Reference Card that has a known exposure value. Doing this for the first time could be the most euphoric and productive few minutes you'll ever experience in photography. Your fears and apprehensions about exposure will rapidly melt away as you suddenly realize the relationship between exposure values and colors in the natural world.

Once you feel comfortable with the cards, start using your camera. At first, pick examples that are easy to work with because they match your Reference Cards perfectly. Shoot some film. Study the results. Then graduate to more challenging situations. After you have practiced with the cards on a few field trips, you will find that you are referring to them less and less. Soon you won't rely on them for every situation, but only those instances when you are aren't sure of yourself.

Because the cards are in no particular order or sequence, you may want to rearrange them to suit your unique way of working. Similarly, you may decide to eliminate any cards that you don't seem to use much. I prefer to keep the entire set intact, as I can never predict what will come up next.

BECOMING A COLOR EXPERT

What should you do when a Reference Card doesn't *exactly* match the color of a particular subject? Scientists estimate that there are more that 16.7 million colors found in nature! Faced with this vast spectrum of color, how can you get by with just a handful of color reference cards?

The answer lies in the fact that, although we see the world in vivid colors, the exposure meter in your camera isn't concerned with color at all—only the amount of light reflected by different colors. Subtle differences in color are almost infinite, but fortunately, subject reflectance doesn't vary nearly as much. First find the Reference Card that most closely resembles the color of the subject. If the colors

Practice with the Reference Cards in a garden to help you learn how to use them. This geranium is a perfect match for the *medium red* card. The card indicates that red is in zone 0, which means you can take a closeup meter reading of the red flower and then take the picture without any exposure compensation.

aren't closely matched, ask yourself whether the subject is lighter or darker (does this sound familiar?). Then adjust the zone placement according to the following:

- When the subject is *lighter* than the Reference Card, if it is "slightly lighter," add 1/3 to 1/2 stop; if it is "significantly lighter," add 2/3 to 1 stop.
- When the subject is *darker* than the Reference Card, if it is "slightly darker," subtract 1/3 to 1/2 stop; if it is "significantly darker," subtract 2/3 to 1 stop.

For example, if your subject were a brown tree trunk and, in your judgment, "slightly darker" than the *medium brown* card, looking through the cards you would find that there are no Reference Cards showing a darker brown. The *medium brown* card is in zone 0, so being "slightly darker" would place your subject -1/3 to -1/2 zone from the Reference Card.

In another case, imagine that you were metering the sky and found it, in your judgment, "slightly lighter" than the *light blue* Reference Card. Looking through the cards, you don't find one showing a lighter blue. Because the *light blue* card is in zone +1, "slightly lighter" would place your subject +1/3 to +1/2 from it.

Based on my experience, when a subject isn't a perfect match with a Reference Card, it will

usually be within 1/3 to 1/2 stop of it. It is rare when a subject is a full stop from any of the cards. With this simple procedure, your Reference Cards can provide unlimited exposure information for the entire gamut of colors in the natural world! Here are a few pointers that will accelerate your color awareness:

Green. This is obviously the dominant color in nature, and therefore it is frequently the object of meter readings. Grass is a common background subject that is convenient to meter. I refer to my *leaf green* and *evergreen* Reference Cards more often than any of the other Reference Cards.

Tall green grass growing around the perimeters of ponds or along the road often makes a good medium-green subject; however, a word of caution about green is in order. Green foliage has a propensity for absorbing light and will trick your exposure meter into overexposing many scenes. For example, compare common lawn grass with the *leaf green* Reference Card, an ideal example of medium green. Lawn grass varies, but it is usually closer to zone -1/2 than to medium green.

Medium green is actually lighter in color than we tend to think it is. Many broad-leafed plants are good examples of medium green, but these too, can be deceiving. Aspen leaves are an interesting case; they can be medium green in the spring when they are somewhat translucent, and later in the summer, they become darker green and belong in zone -1/2. Most conifers are zone -2/3 to -1. Light-green leafy plants and shrubs with just a bit of yellow component mixed in are usually zone +1/2.

Red. Reds are easy to meter because they are often close to medium. A bright red tomato is zone 0 and a good object to use as a mental color reference. A typical red barn or a medium-red ski parka can also work. Red maple leaves are zone 0 when they are bright red at the peak of autumn splendor. If they are darker-than-medium, exposing them in zone -1/2 usually works. Pink is actually a shade of red overexposed by +1 to +2 stops. Bright fuchsia azalea blossoms are an example of zone +2/3 to +1.

Blue. A good example of medium blue is a clear blue sky about 45 degrees above the horizon. You can actually take a reliable meter reading from this giant 18-percent blue card in the sky. Directly overhead, the blue is a deeper zone -1. The light-blue sky right at the horizon is zone +1 to + $1^1/2$. Humidity, wind-blown dust, and industrial pollution can turn the sky into an

BEAVERTAIL CACTUS, Arizona. Nikon F4 camera, 55mm macro lens, Bogen 3001 tripod with Linhof Profi II head, Fujichrome Velvia.

When I have the Chroma-Zone Reference Cards with me in the field, I can readily identify subjects that are medium-tone colors. Guesswork is virtually eliminated! I can confidently shoot an entire 36-exposure roll of film, knowing every shot is perfectly exposed. This cactus is a perfect match with the *leaf green* reference card.

CACTI UNDER SNOW IN DEVILS GARDEN, Arches National Park, Utah. 4 x 5 Linhof Master Technika camera, 90mm lens (equivalent to 24mm in 35mm format), Bogen 3021 tripod with Foba Super Ball head, polarizer, Fujichrome 100.

Proper exposures for snow scenes are not difficult with the Chroma-Zone Exposure System. Just take a meter reading from an area of evenly lit snow and increase the exposure by adding 2 stops of light (snow is zone +2). It's that easy!

unsuitable area to meter directly for 18-percent reflectivity. But a clear blue sky, midway up, is a good reference for medium blue. The *medium blue* card is a perfect example of medium blue, but due to variations in elevation, ground reflection, and atmospheric pollutants, it doesn't always match the tonality in the sky.

Yellow. A good reference for yellow is a common yellow dandelion flower in zone +1$\frac{1}{2}$. A richer, golden yellow is zone +1. A brighter, lemon-yellow flower would be a little lighter than a dandelion, and therefore be zone +1$\frac{2}{3}$. In the mountains of Colorado, autumn aspen leaves vary between lemon-yellow, gold, and

even orange. On average, they are zone +1 to +1$\frac{1}{2}$ when they are at their glorious peak and shimmering in distilled autumn sunlight.

ADVANCED METERING WITH THE CHROMA-ZONE EXPOSURE SYSTEM

A few exceptional exposure situations require special consideration. For example, some nearly white subjects should be slightly underexposed to reveal their visual details. If your subject is very pale or brightly colored, it may benefit from slight underexposure. A very pale pink primrose flower is almost white, but not as bright as pure white. A pale flower most likely falls in zone +2. Underexposing it in zone 1$\frac{1}{2}$

will slightly deepen its color and reveal details and texture that would otherwise be lost.

The same can be said for a polar bear's fur. First of all, it isn't as white as the pure white snow in zone $+2^1/_2$. Technically, polar bears fall into zone $+2$. But if you want to retain greater details in the fur, treat it as zone $+1^1/_2$. If you expose it as zone $+2^1/_2$, all you will see is a pair of dark eyes and a black nose!

Every year, I see several magazine articles about how tricky it is to calculate exposures of snow. Not true-it is easy with the Chroma-Zone System! Pure white snow has a very high reflective value of $+2^1/_2$ (consult your *white* Reference Card). But most snow scenes look better when underexposed by 1/2 to 1 stop. Use zone $+1^1/_2$ for sidelit snow that is illuminated by a low-angle sun when you want to retain some detail and sparkle in the snow crystals. For bright white snow, use zone $+2$. A simple rule for properly exposed snow is to aim the camera at an area of evenly lit snow and add 2 stops to the meter reading.

On the other end of the spectrum, some nearly black subjects should be slightly overexposed to reveal their visual details. For example, the dark fur of a buffalo or a black bear is zone -2 (very, very dark). In order to record detail in such fur, overexpose it one stop by treating it as a zone -1 subject. Meter the dark fur only, and subtract 1 stop to expose it in zone -1. Such cases are quite rare, and they are tricky. I would prefer to take a substitute reading of an easier-to-meter area in the same light as the subject.

Caution: Don't treat all near-white and near-black subjects to the same slight exposure adjustments. Black lava and dark mud may be atypical photographic subjects, but photographs of these subjects should retain their dark qualities. There is no reason to intentionally overexpose such subjects for visual details.

Backlighting. Most photographers have at one time or another heard the old maxim that you should light your subject by placing the sun over your shoulder and orienting the subject toward the light source (usually the sun). This is classic frontlighting. This recommendation comes from the fact that frontlighted subjects are typically easy to photograph since they are evenly illuminated.

When the light source is behind the subject and facing the camera, the lighting is referred to as backlighting. This is a trickier situation than frontlighting. For example, with a low-angled sun directly behind a hiker who is walking toward you along a trail in a sunny green meadow, the hiker will be underexposed if you base your exposure upon the overall scene. The meadow would be properly exposed, but the shaded side of the hiker facing you would be underexposed.

There are two common backlighting situations: foreground dominant and background dominant. If a foreground subject, such as the hiker in the meadow, comprises roughly 60 percent or more of the area within the camera's viewfinder, then the scene is subject dominant. If the background comprises 60 percent or more of the composition, then the scene is background dominant (60 percent is just a rule-of-thumb, not a strict reality).

If the scene is foreground dominant, the exposure of the foreground subject takes priority over the background. In this instance, your hiker in the meadow would be framed fairly tight in the composition: from the waist up, for instance. Take a closeup reading of the subject, and disregard the background. Including less background will usually improve a foreground-dominant backlighting situation because the background will be overexposed in relation to the subject.

At the risk of sounding too complicated, an exception is when a backlit subject is against a very dark background. This is one the most desirable lighting situations you can encounter. The backlit hiker, rimmed with a brilliant fringe of sunlight, will standout from a shaded background with stunning visual impact! If the subject is opaque or somewhat translucent, such as a closeup of a backlit leaf against a dark background, the subject will almost glow, and details in design and color will jump out at you as if you were peering into a captivating old-fashioned kaleidoscope! Be careful of lens flare, as you will be pointing the camera in the direction of the sun.

When the background dominates the photograph, you must base the exposure primarily on the background instead of on the foreground subject. In our example, the hiker is now a

SUNFLOWER. Nikon F4s camera, 300mm f/4
ED-IF lens, 14mm extension tube, Bogen 3021
tripod with Foba Super Ball head, Fujichrome Velvia.

I took a spotmeter reading of the backlit yellow
petals, being careful not to include the darker
background in the reading. A quick consultation
with the *yellow* Reference Card told me to place
the flower in zone 1 1/2. But the sunflower's
yellow was slightly richer in tonality than the
Reference Card, so I placed it in zone +1 for
a more golden yellow.

smaller figure in the overall shot of the mead-
ow. But if you base your exposure entirely on
the background, the hiker will be silhouetted.
The solution is to take a meter reading of the
background and slightly overexpose it to bring
out more detail in the backlit subject. Do this by
giving the background +1/2 to +1 stop overex-
posure. This is high-contrast lighting, and brack-
eting exposures is the only sure way to cover
the situation. When you bracket, you will hope-
fully make at least one shot that strikes a pleas-

ing compromise between overexposing the
background and underexposing the backlit sub-
ject. Another technique is to add some sort of
"fill" light on the subject, using such natural
reflectors as a bright foreground of sand or
snow, or a nearby wall bathed in light. Another
way to add fill is with an electronic flash or a
portable reflector disk.

Silhouettes. Silhouetting a subject is an effec-
tive, dramatic way to portray it as a powerful,
graphic, two-dimensional shape. The technique
for making silhouettes is relatively straightfor-
ward. First, the subject should be in the shade
or in a deep shadow with a bright background.
You simply base your exposure on the brighter
background. If you don't want a total silhou-
ette, you can use an electronic flash or a
portable reflector disc to somewhat illuminate
the subject.

Sidelighting. Sidelit scenes often contain both
deep shadows and bright highlights. Sometimes
these differences balance each other out, but

the best tactic is to weight the exposure in favor of properly recording the highlights. Photographs with overexposed highlights are usually unacceptable. As long as the shaded areas of your composition don't become large, distracting black blobs, the photograph will be successful if the highlights look natural.

To expose for the highlights in a sidelit situation, you must outsmart your exposure meter once again. The darker, shaded areas may trick the exposure meter into slightly overexposing the subject to open up detail in the shaded areas. Try subtracting 1/2 stop from an overall reading of a subject that includes both shadows and highlights. For example, in strong sidelight, some of a small group of flowers will be highlighted by direct sunlight and other flowers will be shaded. To favor the highlights, subtract 1/2 stop from the overall reading and bracket 1/2 stop in both directions.

As an alternative, you can try moving in close to your subject and metering a clearly defined area in direct light. Imagine a sidelit scene with a small creek meandering through a scattered group of boulders. In this situation, I would begin by trying to find a medium-gray rock lit by sun, and then place it in zone 0. In the absence of a good medium-gray rock, identify a lighter or darker rock and use the Gray Tone Guide on the Chroma-Zone Exposure Matrix to determine the rock's reflectance. Once this rock is properly exposed, the overall scene will look acceptable in the final photograph.

When Not to Use a Gray Card. In some situations, you can't meter the subject directly. Small birds, mammals, reptiles, insects, and flowers are sometimes hard to meter because they are small or scurry around too fast. Transparent spider webs are another example of a difficult

subject to meter. In these situations, the best thing to do is meter a gray card or meter the background. The idea is to pick out some area of the image that is large enough for you to meter it reliably with your camera's spotmeter, not necessarily the subject itself.

But working with a gray card is not always the answer, and I hardly ever do. Many photographers have asked me why I don't use a gray card anymore. The fact is, I do use one for macro photography when the conditions are right and it is convenient to hold it next to the subject. Otherwise, here are a few reasons why I think gray cards are hard to use and you are better off taking reflected-light readings from the scene:

● Gray cards are intended primarily for indoor studio use. Outdoors, it is difficult to hold the card so that it doesn't reflect the sun or show a shadow. A slight change in the card's orientation can cause the exposure meter to fluctuate wildly.

● A gray card must be metered in the same light as the subject. If your subject is in the middle of a lake or 1,500 feet above you on a mountain top, you can't expect it to be in the same light as where you are standing. This is especially true at sunrise and sunset when high-

(Left) OAK TREES IN SPRING, Wisconsin. 4 x 5 Linhof Master Technika camera, 90mm lens (equivalent to 24mm in 35mm format), Bogen 3021 tripod with Foba Super Ball head, Fujichrome 100.

The hardest part of taking this silhouette of bare tree branches was looking through the camera while it was on the tripod and pointed straight up at the sky. The exposure calculation was easy: I simply based my meter reading on the blue sky.

(Right) MOSS GLEN FALLS, Green Mountains, Vermont. Linhof Master Technika camera, 180mm lens (equivalent to 50mm in 35mm format), Bogen 3021 tripod with Foba Super Ball head, polarizer, 81A filter, Fujichrome 100.

Waterfalls have a "cotton candy" appearance when exposed for 1 second or longer. Base the exposure on a spotmeter reading of whitewater (zone +2) or from elsewhere in the scene.

er elevations are bathed in warm light but you're still enveloped by shade.

● If you're using a lens longer than 100mm, you'll have a very hard time holding the card out far enough in front of the lens while still looking through the camera.

● If you're photographing a backlit landscape with a 20mm or 24mm wide-angle lens, and the light is shining toward you, you can't get a meaningful reading of the shadow side of a small card with such a lens.

● In sidelighting situations, obtaining an accurate reflected-light reading from a gray card is nearly impossible due to the difficulty in orienting the card to the light source.

● When I've framed a subject in the viewfinder, it is easier to do a quick exposure analysis of the subject's reflectance and then take the shot, than it is to stop what I'm doing and work with a gray card.

Some Special Subject Considerations. Like other stationary subjects, waterfalls and whitewater rapids can be exposed using the Chroma-Zone Exposure System. A few pointers may be helpful. First, be sure to meter only a foamy white area of the water. Place the whitewater in zone +2. Most mistakes are made when photographers fail to meter the whitewater only. If you have difficulty metering a white area, find a suitable substitute, such as a boulder or a grassy area along the river bank, and take a substitute meter reading.

Backlit rivers and lakes are very, very bright and are composed of specular highlights that will cause your camera to grossly underexpose the scene. Even a small specular highlight can trick an exposure meter into underexposure. Remember to open up 2 stops from a direct meter reading of sparkling water to compensate for the highlights' dominance.

If you meter fog and shoot it straight on, the scene will be underexposed as 18-percent medium gray. Place fog in zone +1 or zone +1 1/2. When you're shooting above timberline or across mountaintops, expose bright cloud banks in zone +2.

At sunrise and sunset, base your exposure of the sky on an area a little to the right or left of the sun. But don't include the sun itself in the meter reading, or the image will be drastically underexposed. Try taking several exposures, beginning with one of an area close to, but not including, the sun, which will somewhat underexpose the overall image. Then shoot additional images based on meter readings made from farther away from the sun. This will give you a variety of pleasing exposures. Sometimes a little underexposure of 1/2 to 1 stop will add drama to the sunrise or sunset.

Judging Your Exposure Results. Suppose you've now tried the Chroma-Zone Exposure System and you get your first few sets of slides back from the lab. How can you tell which frames are properly exposed?

To judge whether or not a slide has been properly exposed, don't use a slide projector or hold the slide up to a sunny window. The intensity of these light sources can vary too much. With daylight-balanced film (all outdoor color film is daylight balanced), it is important to use a light table that is color corrected to 5500 degrees Kelvin. Even a small, inexpensive light box will work fine. If you're viewing one slide at a time, try covering the bright, exposed areas of the light table with a few pieces of cardboard, or it will be difficult to judge the exposure. Use a high-quality magnifying loupe to check for proper exposure and sharp focus. Edit ruthlessly and learn from your mistakes.

Eloquent Light. It is a poet's challenge to be imaginative, expressive, and sensitive to life's experiences. My challenge as a nature photographer is to capture images that elicit an emotional response from the viewer. One of the ways I do this is by exposing the film's light-sensitive color emulsion so that I communicate my personal interpretation and previsualization of the scene. While a textbook-perfect photograph might be defined as having a pleasing range of color and visible detail in both highlights and shadows, my preference might be a special effect in which the lighting is dark and ominous or bright and airy. Sometimes I want the appearance of soft, caressing illumination that envelopes the subject in evenly diffused light. At other times, I want the high-contrast look of strong sidelighting to reveal intriguing shapes and textures. The Chroma-Zone System allows me to paint with light and create images that express my emotional bond with nature. My goal is to erase the normal delineation between technique and art so that the camera becomes an eloquent extension of my personal interaction with the natural world.

SUNSET OVER PACIFIC OCEAN, Tillamook Bay, Oregon. 4 x 5 Linhof Master Technika camera, 300mm lens (equivalent to 100mm in 35mm format), Bogen 3021 tripod with Foba Super Ball head, Fujichrome 100.

I based my meter reading of this spectacular sunset on the medium gray cloud just to the left of the tree. No extra filtration was used to enhance colors—this is how it really looked!

LIGHT AROUND-
THE-CLOCK

*"To me, every hour of the light
and dark is a miracle"*
—WALT WHITMAN

Light, wonderful light, is what makes photography possible. It comes in different colors, from different directions, and in varying intensity. Look at the world, and you see a constantly evolving scene. No two moments are the same. The key element, always changing, is the light. Your knowledge of light and your ability to use its elusive qualities are critical to your success as a photographer. The right light can bring vitality and meaning to your compositions. Disregarding light could condemn you to a lifetime of frustrating results. The character of light constantly changes throughout day, affecting every aspect of your work.

Sunrise and sunset are favorite times for photography. The light then has almost magical qualities that can turn even an average subject into an extraordinary image. But it is a misconception to think that good photographs are only taken early and late in the day. In truth, there is no such thing as bad light; you simply must learn how to use it. Even a foggy, rainy day presents opportunities to create unusual images filled with drama and visual impact.

SUNSET WITH CHOLLA AND SAGUARRO CACTI, Arizona. 4 x 5 Linhof Master Technika camera, 75mm lens (equivalent to 20mm in 35mm format), Bogen 3021 tripod with Foba Super Ball head, Tiffen .9 ND grad filter, Fujichrome 100.

As a photographer, your most important subject is always the light; other elements comprising the image are merely props

I typically scout around looking for a good subject and then decide how to photograph it with good light. Often, this means waiting, or coming back later or on another day. This fact surprises most people because they are accustomed to finding their photographs complete: the right subject in the right light. So the idea of matching the subject with the best light might require some effort before it can work for you. It might be hard to imagine how a subject will look in different types of light.

Once you've grasped how essential the right light is to any photograph, you can recognize good subjects even when they are in the wrong light. For example, I might come across a waterfall in bright midday sunlight but decide that it would look better in overcast light. So I simply return when afternoon clouds start to build up and create the light I need. If I've decided that I need golden light at sunrise or sunset, I might have to move on to other subjects and then return to my prescouted location for the light I want.

At other times, matching the light with the subject works in reverse. When a good sunset is developing, I often scramble around, trying to match it with a suitable subject. Something interesting almost always reveals itself, and I get another good shot. Sometimes the shot doesn't materialize on that visit, and it can take years of returning to a place, trying to get the shot that is indelibly imprinted on my imagination, before I succeed. When the shot I want finally comes together perfectly, there is a

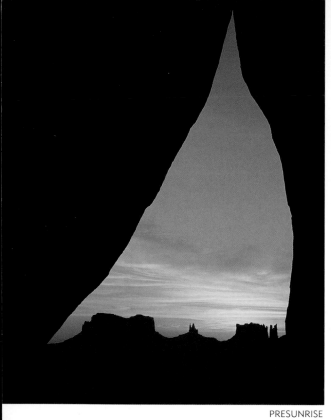

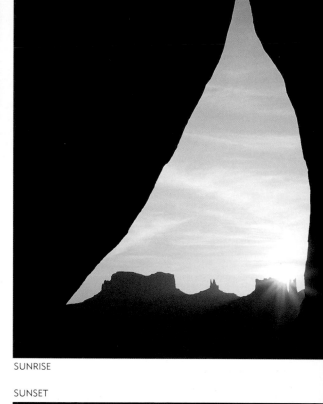

PRESUNRISE SUNRISE

LATE AFTERNOON SUNSET

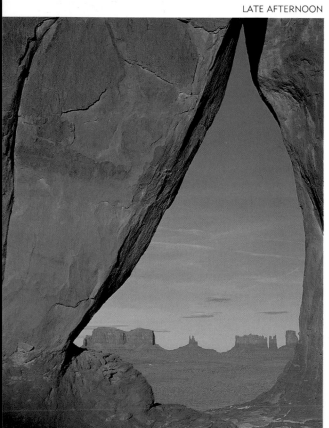

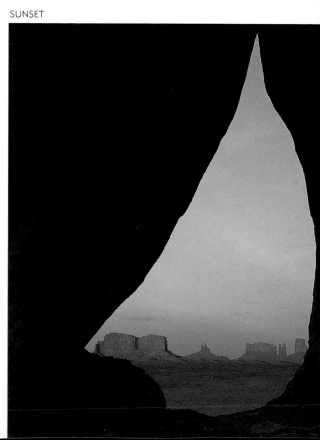

tremendous sense of accomplishment in completing the task.

Possibly the most rewarding type of shooting occurs when I have a specific image in mind but come across something entirely unexpected and wonderful. To capture these serendipitous events, it is essential for me to be receptive to what is really going on, even when I have a different goal in mind. Sometimes I have an almost overwhelming sense that the right image is about to reveal itself. That is my signal to relax and let the next picture just happen.

Throughout the day, I am constantly evaluating the light and how I can best utilize it in constructing effective compositions. This sensitivity to light is like radar, keeping me appraised of the lighting situation. Where is the light coming from? Is it direct light, reflected light, or light filtered by clouds and haze? What color is it? How strong is it? How does it affect what I see? Which subjects look more or less favorable in this light? Would this subject look better with different lighting conditions? How will the light's intensity affect shutter speed and depth of field?

Wanting to be a productive photographer throughout the entire day, I've become a student of light. I can't afford the luxury of shooting

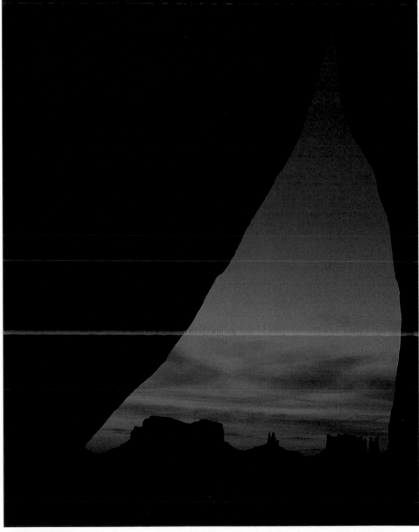

DESERT ROCK WINDOW, Monument Valley, Arizona. 1 n 5 Linhof Master Technika camera, 180mm lens (equivalent to 50mm in 35mm format), Bogen 3021 tripod with Foba Super Ball head, polarizer and 81B filter in all five, Fujichrome 100.

The same scene photographed at five different times of day gives dramatic testimony to the fact that light really is the critical factor in any picture.

POSTSUNSET

(Left) PRESUNRISE, Land O'Lakes, Wisconsin. 4 x 5 Linhof Master Technika camera, 120mm lens (equivalent to 35mm in 35mm format), Bogen 3021 tripod with Foba Super Ball head, Tiffen .3 ND grad filter, Fujichrome 100.

(Right) SUNRISE AT INTERFALLS LAKE, Pattison State Park, Wisconsin. 4 x 5 Linhof Master Technika camera, 180mm lens (equivalent to 50mm in 35mm format), Bogen 3021 tripod with Foba Super Ball head, polarizer, 81A filter, Fujichrome 100.

only at sunrise and sunset, so I've developed a system for working with all types of light. What follows is my guide to using *light around the clock*.

First, some definitions: by *presunrise light*, I mean up to half an hour before sunrise. The *sunrise golden hour* goes from sunrise to one hour after sunrise. *Midday* begins one hour after sunrise and lasts until one hour before sunset. The *sunset golden hour* is from one hour before sunset to sunset. *Postsunset light* lasts up to half an hour after sunset. Finally, *celestial light* fills the night sky one hour after sunset until one hour before sunrise.

PRESUNRISE AND POSTSUNSET

This is an exciting time of transformation, whether from night to day, or day to night. In the dim light before sunrise, and in the waning light after sunset, the sky itself is the light source for photography. The intensity of light is low but changing rapidly. High clouds may be illuminated with flaming colors as they catch either the first or last rays of the sun. Distant landscapes are painted in subtle pastel hues due to the scattering of short wave-lengths in the atmosphere.

The sky is several stops brighter than foreground subjects at this time of day. Contrast is

low, and subjects are evenly illuminated by the sky. Shadows are weak or non-existent. Exposure values are changing fast, but typically, exposures will range from 1/2 to 1/4 sec. at f/16 with ISO 100 film.

Photography Techniques. To take advantage of this beautiful light, you should be in camera position and set up for photography at least half an hour before sunrise and one hour before sunset. The most colorful areas of the sky will be in the direction of the sunrise or sunset, so position yourself accordingly. Use a cable release, and steady the camera with a tripod for long exposures in the faint light. Be prepared to use a ND grad filter if necessary to balance a brighter background with a darker foreground. As the sun nears or departs from the horizon, the light's intensity is changing rapidly, so take frequent exposure meter readings.

With this light, seek out such reflective foregrounds as water, snow, or sand that can pick up the colors in the sky. A placid lake, for example, is a perfect mirror for recording the sky. Look for interestingly shaped subjects that can be silhouetted against a colorful sky. For example, a person, animal, tree, or mountain makes a suitable subject for a silhouette against the luminescent heavens.

THE GOLDEN HOUR AT SUNRISE AND SUNSET

This hour after sunrise or before sunset is truly a treasure for photography. The first 30 minutes following sunrise are characterized by rich, golden light. During the last 30 minutes of sunrise, the light gradually turns into lighter tones of amber. Sunset's golden hour begins with warm, amber sunlight, closely resembling the effect rendered by an 81B amber filter. During the last 30 minutes of sunset, the landscape is bathed in precious golden light. Sunset tends to be warmer than sunrise due to extra atmospheric dust and pollution generated by the day's activity.

The first few minutes of sunrise and the last rays of sunset are particularly dramatic. This almost horizontal light is highly desirable for its warmth and ability to bring out magical, fiery qualities in the landscape. The low-angled light highlights shapes and textures and gives objects three-dimensional character.

Keep in mind that the light's intensity is weak and that exposure values change rapidly during the golden hour. Contrast and shadows are moderate to weak, compared with other times of day. Exposures normally range from approximately 1/8 to 1/15 sec. at f/16 with ISO 100 film.

Photography Techniques. This is an excellent time to photograph almost any subject. The ethereal qualities of the golden hour are highly desirable for scenic images painted with warm, directional light. Try beginning by using wide-angle lenses to capture the overall scene, then use longer focal lengths to isolate interesting pockets that come alive in the spectacular light. The light is changing from moment to moment,

and you must act quickly to catch the magic. Take frequent meter readings to gauge the intensity of light. Don't include the sun itself in the viewfinder when taking exposure readings because it will grossly underexpose the image. Instead, take a meter reading from a bright area in the sky with good color, then recompose to include the sun. Also meter the foreground to be sure the lighting ratio is within the 5-stop exposure range of color transparency film. If there is greater than a 2 stop difference between the background and foreground, consider using a .6 ND grad filter to reduce the contrast ratio.

When shooting right at the sun, wait until it is low on the horizon and the intensity of its light is diminished. You can reduce lens flare by removing any filters from your lenses and by using fixed-focal-length lenses instead of zoom lenses; they are more prone to lens flare. Shoot

straight into the sun, not at acute angles that reflect light off optical surfaces.

Use sidelighting and backlighting to emphasize the textures revealed in your subjects. The warm, directional, golden-hour light is ideal for separating distant mountain ridges and adding depth and definition to landscapes. This is the best light for creating a strong three-dimensional effect in your pictures. To emphasize rich colors and add drama, intentionally underexpose some of your shots by 1/2-1 stop. Try using a polarizer together with an 81B filter to boost the color saturation.

Sunset photography tends to be more productive than sunrise photography. The disadvantage of working at sunrise is that you must position yourself in the dark before the sun rises, and it is more difficult in the dark to anticipate how the scene will unfold in the early light. At sunset, it is much easier to see what

you're doing and to work with the lighting until it becomes too dark to continue.

MIDDAY LIGHT

Once the golden hour has passed, the color of direct sunlight essentially remains the same for the rest of the day. Only the light's intensity changes as the sun arcs its way across the sky, from one hour after sunrise to one hour before sunset.

There are three kinds of midday light: direct sun, overcast, and open shade. Direct sun isn't filtered through any cloud cover; overcast light is. Open shade is what happens when the sky is blue but something blocks the sun from reaching the subject, so it is illuminated by blue skylight, not direct sun.

Photography Techniques for Direct Sun. The intensity of direct sunlight is strong, making for high exposure values. Light levels can reach 85 percent of maximum intensity within an hour after sunrise. Contrast is correspondingly high, meaning that the difference between exposing for detail in the highlights versus in the shadows can be great. Color film is daylight balanced for good, accurate colors in direct sunlight. A normal range of exposures in direct sun

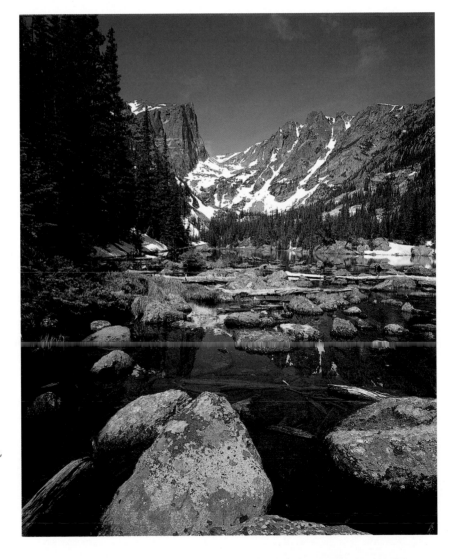

(Left) SUNSET OVER THE MISSISSIPPI, Upper Mississippi River National Wildlife & Fish Refuge, Grant County, Wisconsin. 4 x 5 Linhof Master Technika camera, 180mm lens (equivalent to 50mm in 35mm format), Bogen 3021 tripod with Foba Super Ball head, Fujichrome 100.

(Right) HALLET PEAK LOOMS ABOVE DREAM LAKE, Rocky Mountain National Park, Colorado. 4 x 5 Linhof Master Technika camera, 75mm lens (equivalent to 20mm in 35mm format), Bogen 3001 tripod with Linhof Profi II ball head, polarizer, Fujichrome 100.

I shot this picture in the strong, direct midday light illuminating Tyndall Gorge.

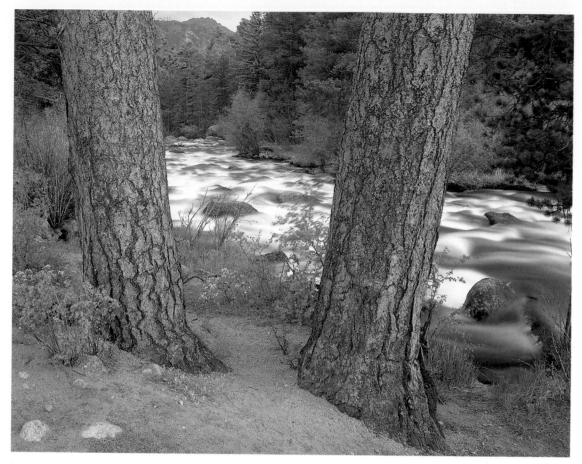

varies from approximately 1/30 to 1/125 sec. at *f*/16 with ISO 100 film.

The shadows cast by direct sun are dark and strong, and like open shade, the color of light in these shadows tends to be blue. Trying to minimize these shadows is a good idea. They are 4-5 stops darker than sunlit areas and will appear as distracting black areas in the final image.

Use a polarizing filter to increase the color saturation of such objects as water, rocks, and leaves that reflect daylight. The filter can also intensify blue skies and cut through haze to bring distant subjects into better focus.

Although your subject may be lit from any direction, sidelighting and backlighting will again help to emphasize the subject's texture and form. Using a lens hood will help prevent direct sunlight from striking your lens, which can degrade the image and create lens flare.

Photography Techniques for Overcast. Overcast light is bright white when the cloud cover is thin and evenly distributed. As the cloud cover becomes thicker and darker, overcast light may become slightly cool, or gray, in color. Light intensity and exposure values for overcast are moderate to weak. Contrast is low, and shadows are weak or nonexistent. Typical exposures are approximately 1/8 to 1/15 sec. at *f*/16 with ISO 100 film.

A solid, bright canopy of white clouds provides an evenly diffused, white light that eliminates distracting shadows and emphasizes accurate colors. The light is very neutral and natural. These are ideal conditions for closeups and forest interiors, subjects that on sunny days are too contrasty for slide film. Crop out gray, overcast skies altogether, or keep them to a minimum—they are too bright and nondistinct to be included in landcape images.

When you want to record rich, extremely accurate colors in nature, wait until the light is overcast. Human skin tones, animal fur, feathers, and flowers are just a few subjects that overcast renders in vibrant colors. Fall foliage colors are recorded in rich, saturated tones. Waterfalls, snow, and sand look more natural in overcast light. If your subject is wet, for example, from the rain, use a polarizing filter to reduce glare and improve its color saturation.

The low intensity of overcast light is useful for depicting subject motion. For example, a slow shutter speed of around 1 second will make moving water look like "cotton candy."

Panning and blurring motion is easier in soft light because both techniques encourage the use of slower shutter speeds.

If a bright, overcast sky becomes dark gray and ominous, the light will turn slightly cool. Using an 81A filter will counteract the cooler light and restore some warmth to your composition. With mist, rain, and fog scenes, try combining a polarizing and an 81A filter to give colors more "snap."

Photography Techniques for Open Shade.
When the sun is hidden behind something other than a sky of solid clouds, the blue sky

(Left) BIG THOMPSON RIVER, Moraine Park, Rocky Mountain National Park, Colorado. 4 x 5 Linhof Master Technika camera, 120mm lens (equivalent to 35mm in 35mm format), Bogen 3001 Tripod with Linhof Profi II ball head, polarizer, 81A filter, Fujichrome 100.

Bright midday overcast light brought out the details in these tree trunks and made the water seem to glow.

(Right) WATERFALL IN OPEN SHADE, Catskills Mountain Park, New York. 4 x 5 Linhof Master Technika camera, 180mm lens (equivalent to 50mm in 35mm format), Bogen 3001 tripod with Linhof Profi II ball head, polarizer, Fujichrome 100.

Low-contrast lighting provided by open shade was ideal for bringing out details and color around the cascading stream in Catskills Mountain Park.

itself becomes the source of light for photography. For example, open shade is the light in the shade of a large tree or a rock cliff; but it also occurs when a single puffy cloud passes overhead and momentarily blocks the sun in an otherwise clear blue sky.

Open shade is a combination of blue skylight and reflected sunlight, and provides soft blue light that can give objects a blue cast. But the color and intensity of light in the shade can also be affected by reflections from, for example,

canyon walls, cliffs, snowy slopes, or sand beaches. Some films, including the Kodak Ektachromes and Fuji Velvia, emphasize the blue cast of open shade's soft light more than others, as they are more sensitive to blue wavelengths.

Such subjects as blue petaled flowers and blue lakes look fantastic when their color is accentuated by the color of clear blue sky; however, this blue light gives an unnatural appearance to many subjects. For example, human skin

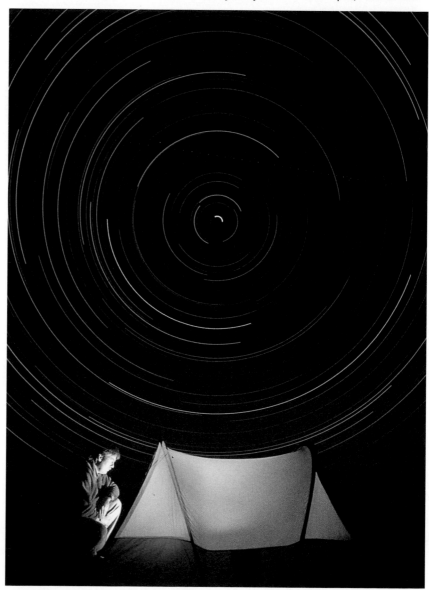

CELESTIAL STAR WHEEL. Nikon F4s camera on "T" setting for 6 hours at f/2.8, 20mm f/2.8 lens, SB-24 flash, Bogen 3001 tripod with Linhof Profi II ball head, Kodachrome 64.

On a moonless night, I centered the North Star in the middle of the frame and took a 6-hour exposure to record the star trails as they circled the North Star. The tent and I were illuminated by a burst from an electronic flash unit inside the tent.

112

looks pale and less healthy in bluish light. Waterfalls, snow, and sand take on a blue tint in open shade's soft light. Some people find this pleasing, others don't; it is a subjective matter of taste. If you don't want the look of blue light, you can neutralize it by using an 81A or a stronger 81B amber filter to warm up the image; or you can try using a "warmer" looking film to offset "cool" light.

CELESTIAL LIGHT

Once the sun's powerful presence is gone, the stars start to twinkle and it is time for night-owl photographers to go to work. After dark, the stars and the moon are your available light sources and make fascinating subjects themselves. (You can also use electronic flash to capture images of nocturnal animals that can't be seen during daylight hours.) Keep in mind that the night sky is brightest during a full moon and darkest during the new moon.

Photography Techniques after Dark. You'll want to be in camera position for photography about one hour after sunset, even though the sky won't be sufficiently dark for star photography until you can spot all the stars in the Big Dipper constellation. The Big Dipper contains the "pointer stars" that point to Polaris, or the North Star, around which the heavens wheel.

If you center Polaris in your camera viewfinder and expose your film with a time exposure, you can record "star trails" that spin in concentric circles around Polaris. You must put the camera on a tripod (unless you're steady

enough to handhold a six-hour exposure!), and use the "Time" (T) or "Bulb" (B) shutter-speed setting to lock the shutter open for long exposures. When you're making star-trail exposures, remember that longer focal lengths require shorter exposures than wide- angle lenses. For example, a 200mm lens can record complete star trails in two hours while a 20mm lens requires five-to-six hours.

Night landscape photographs are illuminated by the moon, a changing source of light. The proper time exposure for landscape subjects will depend upon the moon's phase: full moon, half moon, quarter moon, or new moon, and all the gradations in between. Moonlit exposures are highly experimental because the moon's intensity varies from night to night and can be affected by altitude and such atmospheric conditions as pollution and humidity. Here are some experimental exposures for night landscapes shooting with Kodachrome 64 (ISO 64): For a quarter moon, shoot at $f/2.8$ for approximately 4-6 hours. For a half moon, shoot at $f/2.8$ for approximately 2-3 hours. For a full moon, shoot at $f/2.8$ for approximately 1/2-1 hour.

If you want to freeze the position of stars in order to record them individually, limit the length of their exposure along the following guidelines: 24mm lens (maximum 25 seconds), 35mm (maximum 17 seconds), 50mm (12 seconds), 70mm (9 seconds), 200mm (3 seconds), 300mm (2 seconds). An exposure of the moon can be calculated as a shutter speed of 1/ISO at an aperture of $f/8$. For example: 1/125 second at $f/8$ for ISO 100; 1/60 second at $f/8$ for ISO 50.

FIELD GUIDE TO LIGHT AROUND-THE-CLOCK			
LIGHT AROUND-THE-CLOCK	COLORS	SHADOWS	APPROXIMATE EXPOSURE WITH ISO 100 FILM
Presunrise	Subdued	None	1/2-1/4 sec. at $f/16$
Golden Hour Sunrise	Golden	Weak	1/8-1/15 sec. at $f/16$
Midday Direct Sun	Good	Strong	1/30-1/125 sec. at $f/16$
Midday Overcast	Excellent	None	1/8-1/15 sec. at $f/16$
Midday Open Shade	Bluish	None	1/8-1/15 sec. at $f/16$
Postsunset	Subdued	None	1/2-1/4 sec. at $f/16$
Golden Hour Sunset	Golden	Weak	1/8-1/15 sec. at $f/16$
Celestial	None	None	Long "bulb" exposures

CAPTURING NATURE'S DESIGN

"God creates. People rearrange"
—JOSEPH CASEY

When I'm hiking a wilderness trail and photographing nature, I have a sense of what the world must have been like before humans came along and started changing everything. I want my images to communicate this feeling of timelessness. But it is becoming harder and harder to take wilderness photographs. Wilderness is shrinking. Air pollution drifts across the continent. Even the sky glows at night, reflecting artificial city light, which obscures our natural view of the celestial heavens.

When I'm ready to take a photograph, I try to concentrate exclusively on the moment. I think about where I am and how I feel. Basically, my goal is always to make a good picture technically and to give my subject a new, artistic interpretation on film.

The most valuable possession a photographer can have is a gifted eye that takes a fresh view of a landscape. That is why I think it is dangerous to take pictures primarily to satisfy a particular group of people, and I don't. My inspiration comes from my personal interaction with nature. If my photographs are any good, they will eventually find viewers who will appreciate them.

Anyone with a camera is, strictly speaking, a photographer. The ease with which people can take pictures has fostered a public opinion that somewhat undervalues photography as a serious art form. Pushing a button and taking a picture without any notion of what constitutes a thoughtful or well-composed image is an effortless act. I try to avoid debates about whether or not a person using a camera creates fine art. A more relevant question is: Are your images any good?

Like any creative pursuit, you can't expect perfection from your photography all the time. In fact, even the best photographers find that most of their images are just "okay"; a few are "pretty good"; even fewer are "quite good"; and only now and then they amaze themselves with a "masterpiece." Expect that you won't always succeed, because too many things can go wrong and too many things can't be translated onto film just the way you saw them.

WHAT IS A GOOD PHOTOGRAPH?

A good photograph depends on a combination of many things. It might be the photographer's use of color, composition, lighting, or peak moment, coming together in a unique way. Good photographs stand out from the thousands of images taken every day because they stir our imaginations and, simply put, it is a pleasure to look at them. Wilderness photographers are motivated to record the beauty they

AUTUMN TAPESTRY, Mink River Estuary, Wisconsin. 4 x 5 Linhof Master Technika camera, 300mm lens (equivalent to 100mm in 35mm format), Bogen 3021 tripod with Foba Super Ball head, 81A filter, Fujichrome 100.

The key characteristic of a good photograph is that it merits coming back to again and again for another look. If I can achieve that kind of intimacy between the photograph and the person viewing it, then I have done my job.

encounter because they have the opportunity to see things most people will never experience. A beautiful scene or moment in nature doesn't guarantee a great photograph; attention to technique and composition is still essential.

Four elements come together to make a great picture: technical prowess, imagination, a good subject, and the decisive moment. First, you must master the technical elements of photography in order to produce good results consistently. At the very least, you should read and re-read your camera manual until all aspects of your camera's operation are second nature to you. Next, it takes the power of imagination to interpret a scene artistically and create an image on film. The best photographs are seen in the mind before the picture is actually taken.

Of course, you need to choose a subject that is photogenic and that other people will find interesting. Related to this is your choosing *the decisive moment* to take the picture. Unlike a painter, you can't completely control the available lighting, and you can't control the subject, but you can choose the best moment for translating the scene onto a piece of film. The decisive moment is that perfect moment when the subject is ready for capture on film, not when you are ready to take the picture. Knowing when to press the shutter is one of the most critical decisions you can make.

Visual artists understand that certain compositional guidelines are helpful in composing successful images, and they use these guidelines to hold the viewer's attention. The photographer's use of design and composition—combined with viewpoint, lighting, camera-to-subject distance, lens, depth of field, and film choice—is what creates stimulating, original photography.

DECISIVE MOMENT IN MONUMENT VALLEY, Arizona. 4 x 5 Linhof Master Technika camera, 180mm lens (equivalent to 50mm in 35mm format), Bogen 3021 tripod with Foba Super Ball head, polarizer, Fujichrome 100.

Unlike a painter, outdoors you can't control the lighting, and you can rarely control the subject, but you always have to choose just the right moment to press the shutter and translate the scene onto a piece of film. The decisive moment is when the subject is ready to be captured on film, not when you are ready to take the picture.

The greatest creative challenge facing outdoor photographers is the need to simplify the visual chaos in nature. Your goal is to present a visually stimulating image, not a visually confusing one. Nature is like a giant, disorganized, jigsaw puzzle; the photographer's job is to assemble a small piece of it in a visually organized way to satisfy the human desire for good composition. Out of the existing conditions, you must create a strong statement that is visually arresting. The problem with outdoor photography is that you start with an almost overwhelming amount of input from Mother Nature. The solution is to simplify your composition until you get a good shot.

BASIC ELEMENTS OF PHOTOGRAPHIC DESIGN
Line, shape, pattern, texture, and color are classic elements of design that are familiar to every painter, illustrator, and graphic artist. These basic compositional tools are also what photographers use to build strong images. As mentioned above, an additional key element is unique to photography: the decisive moment when a photographer chooses to convey what he or she sees onto film.

When I first started identifying natural elements of design in the landscape and working with them, my images took a dramatic turn for the better. Suddenly I was making photographs instead of taking photographs. People started to notice my photographs! People started liking my photographs! And I started to sell my photographs! I firmly believe that good photography is more the practice of basic design rendered extremely well, rather than doing something extraordinary or unusual. This is the secret of taking good pictures. Here are some common elements of good photographic design for you to think about when you shoot:

Balance Versus Imbalance. Try using balance or imbalance to structure interesting images. In a balanced photograph, picture elements that are light and dark, or big and small, are evident in roughly the same amounts, creating a natural-looking image. But occasionally you might want to grab the viewers attention by deliberately upsetting the balance between elements, which is a very effective way of creating visual tension in a picture.

BEACH PEBBLES, Lake Superior, Wisconsin. 4 x 5 Linhof Master Technika camera, 180mm lens (equivalent to 50mm in 35mm format), Bogen 3021 tripod with Foba Super Ball head, polarizer, Fujichrome 100.

This intimate landscape eludes to the silent presence of the world's largest fresh water lake while depicting the timeless ebb and flow of the lakeshore that created these polished rocks. A 1/2 sec. exposure captured the movement of a wave withdrawing.

Lighting or Silhouetting the Subject. Another way to direct the viewer's attention to a particular object is to illuminate it, either with natural light or with electronic flash, and frame it against a darker background. You could also select a viewpoint that places a light-colored object in front of a darker one.

Conversely, one of the strongest compositional devices in photography is the silhouette. To create a silhouette, simply place the subject in shadow, and compose the image with a brighter background. Base your exposure reading on the brighter background, which will completely silhouette the subject by throwing it into underexposure.

Composing Abstract Designs. When you present a subject in a nonliteral, nonpictorial way, then you are creating an abstract image. I think that working in the abstract is possibly the most satisfying kind of photography you can do. An abstraction asks a question, rather than answers one; it stimulates, rather than satisfies, curiosity. An abstract image challenges the viewer to see with the same intensity you did when you envisioned the picture.

(Below left) SILHOUETTE AND AUTUMN COLORS, Pierce County, Wisconsin. 4 x 5 Linhof Master Technika camera, 180 mm lens (equivalent to 50mm in 35mm format), Bogen 3021 tripod with Foba Super Ball head, polarizer, Fujichrome 100.

Exposing for the background turned this foreground tree into a silhouette, throwing it into stark contrast with the autumn colors glowing in the background.

(Right)SANDSTONE, Lake Powell, Arizona. 4 x 5 Linhof Master Technika camera, 75mm lens (equivalent to 20mm in 35mm format), Bogen 3021 tripod with Foba Super Ball head, polarizer, 81A filter, Fujichrome 100.

An arduous hike in the heat led me to this rare microcosm of swirling Navajo sandstone. An abstract image challenges the viewer to see with the same intensity as the photographer did. Here, perspective is lost to the sheer power of line.

Freezing and Blurring Movement. A still photograph can easily freeze motion with a fast shutter speed. Even helicopter rotors and hummingbird wings can be stopped in midair. But is a frozen moment always the most effective way to convey motion? A slow shutter speed that blurs subject movement can sometimes describe action better than freezing it.

There are two ways to use slow shutter speeds to blur movement and show motion. The first is to hold the camera perfectly still, on a sturdy tripod, and let the subject—for example, a rushing stream—move past you. One of my favorite techniques for recording motion is to create a "cotton candy" effect in a waterfall or a turbulent, fast-moving river by shooting it with a slow shutter speed. Another is to photograph a skier, runner, or cyclist as slightly blurred against a stationary background.

The other way to convey movement is to pan the camera steadily along with the action while using a slow shutter speed. The resulting background turns into a blurred streak of action while the subject stays mostly in focus. Try panning with wildlife subjects as they run. The background and their legs will blur, while the animals' heads and torsos remain relatively sharp. You can also try panning with skiers, run-

(Left)HAVASU FALLS, Grand Canyon, Arizona. 4 x 5 Linhof Master Technika camera, 180mm lens (equivalent to 50mm lens), Bogen 3021 Tripod with Foba Super Ball head, polarizer, Fujichrome 100.

Simplify, simplify, simplify! Most photographers include too much in their photographs. Here the elegant line of this magical waterfall speaks for itself.

(Right) ISLAND IN THE SKY MESA ARCH, Canyonlands National Park, Utah. 4 x 5 Linhof Master Technika camera, 120mm lens (equivalent to 35mm in 35mm format), Bogen 3021 tripod with Foba Super Ball head, Fujichrome 100.

Here I used the rule of thirds to place the sun in the top right intersection of imaginary grid lines. This classic positioning of a picture's focal point is very pleasing to the viewer's eye.

ners, or cyclists by following their movement and using a slow shutter speed. (Bear in mind that longer focal lengths exaggerate the panning effect.) It is fun to experiment with this technique to see what effects you can create.

The Rule of Thirds. When a beginning photographer takes a picture of Fluffy the cat, the cat usually ends up dead center in the picture. Then there is Uncle Bob—again, dead center. Putting the subject at the center of the shot usually creates a boring photograph. Generally, it is more effective to compose the subject according to *the rule of thirds.* To use it, divide the image area into a grid of nine boxes by evenly spacing two horizontal and two vertical lines across it; then place the subject or main point of interest at any of the points of intersection between the lines. The division of space in the image thus becomes asymmetrical, which provide more visual tension and interest than symmetrical balance.

Although I dislike rigid rules, the rule of thirds is a very useful starting point for arrang-

ing interesting compositions. If your compositions are stuck in the center of the viewfinder, try following the rule of thirds closely for a while. Soon it will become second nature to compose the subject off center.

THE ILLUSION OF DEPTH
The goal of many landscape photographers is to capture all the realism offered in any given moment. But the camera is limited to a two-dimensional depiction of what we see accurately in three dimensions. One of the greatest challenges facing photographers is how to record a three-dimensional scene from the real world onto a flat, two-dimensional piece of film.

When I find an interesting subject to photograph, I study it from all angles. How does it look when I get down on my hands and knees. How does it change as I walk around it? I look for interesting camera angles and the way the light plays upon the subject.

As I view the subject, I cup my hand to form a tunnel and look through it with one eye. By eliminating my normal binocular view that

discerns depth, this one-eyed perspective helps me previsualize how the subject will appear on film. Because a camera cannot see depth, this exercise helps me "see" like a camera. I've practiced this a lot, so I can actually zoom from a wide-angle view to a telephoto view by varying the size of the peep hole in my hand. I developed this approach from necessity when I started shooting with a view camera. Moving it around for different perspectives was just too clumsy and time consuming.

Long before the invention of photography, artists discovered visual tricks that could create the illusion of depth in two-dimensional art.

Today photographers use the following compositional techniques to create the illusion of depth on film:

Linear Perspective. This is best demonstrated by the familiar illusion of railroad tracks seeming to converge at infinity. We know that the space between the tracks remains the same, regardless of distance, but the visual illusion is that the tracks merge closer together as distance increases. A wilderness photographer can use the same effect to highlight distance with winding rivers, hiking trails, and roads that lead the viewer's eye through the picture.

(Left) ASPEN GLADE, Kenosha Pass, Colorado. 4 x 5 Linhof Master Technika camera, 90mm lens (equivalent to 24mm in 35mm format), Bogen 3021 tripod with Foba Super Ball head, Fujichrome 100.

Here a three-dimensional effect is achieved by using linear perspective. The long shadows of a winter's day pull the viewer's attention into the scene.

(Right) FALL RIVER, Horseshoe Park, Rocky Mountain National Park, Colorado. 4 x 5 Linhof Master Technika camera, 180mm lens (equivalent to 50mm in 35mm format), Bogen 3021 tripod with Foba Super Ball head, polarizer, Fujichrome 100.

Rain and melting snow merge into Fall River, and wind their way down the mountainside, creating a compelling s-curve. The viewer's eye is nearly forced to scan up and down the path of the river, finally resting on the large boulder at the lower right.

Diminishing Size. A wide-angle lens emphasizes the size and importance of objects close to the camera, while objects in the background look much smaller and appear to be farther away. Vertical framing with wide angles increases the effect.

Objects Blocking Other Objects. The mind recognizes that, although objects visually seem to overlap on one plane, they actually exist separately in three dimensions. For example, as trees partially obscure each other in a forest, their spacial organization gives us a visual clue to the depth in the scene.

Directional Lighting. Low-angled light casts shadows between shapes and forms, which alludes to their spacial relationship. Sidelighting can emphasize textures and shapes to bring out their three-dimensional character.

Depth of Field. A composition that is in sharp focus from front to back encourages a viewer's eye to search forward and backward into the scene. Conversely, selectively focusing on just one part of the scene can also suggest depth, by directing the eye to a specific location and showing how it exists in spatial relationship to the out-of-focus areas in front of or behind it.

Atmospheric Haze. Wind-born dust, humidity, and pollution combine to make atmospheric haze. As distance increases, the haze thickens

STONES PEAK FROM TRAIL RIDGE, Rocky Mountain National Park, Colorado. 4 x 5 Linhof Master Technika camera, 90mm lens (equivalent to 24mm in 35mm format), Bogen 3021 tripod with Foba Super Ball head, polarizer, Fujichrome 100.

The most unique feature of Rocky Mountain National Park is its vast tundra zone above timberline. When a suitable foreground and background can be combined in the same photograph, they can convey a great deal of information about a place. This image looks three dimensional because the foreground rock and distant mountain are both in sharp focus. I also liked the way the rock and distant peak repeated the same shape; the top of the rock and the snow slope matched the same angle of tilt. These elements, combined with great depth of field, make an interesting composition.

and partially obscures objects. Those closer to the camera are seen more clearly, and as the background recedes in clarity, it is perceived as being farther away.

Scale. When an object of known size, such as a hiker, is included in a landscape image, it gives the viewer something recognizable against which to determine scale and distance. Scale is a visual clue to the size relationships between objects in a photograph.

TURNING IDEAS INTO IMAGES

Once you've mastered your equipment and fully understand the basic techniques of photographic composition, all your pictures will be postcard perfect, right? Actually, this is the point where your work as a photographer really begins. All the advanced camera technology and design sophistication in the world can't tell you what subjects to photograph. Nor will they lead you to the decisive moment to take a picture. Your imagination, the mind behind the camera, is always the most critical ingredient in your photographs.

The process involved in making a good photograph begins with an idea and leads to a successful photographic statement. Sometimes it happens with lightning speed out of necessity for a fast-breaking situation. But whenever possible, it is best to use a slower, more contemplative approach, in part because that process is simply more rewarding than banging away with a high-speed motor drive in hopes of capturing something interesting.

Although I don't believe in following rigid guidelines where creativity is concerned, I want you to understand that when you create images, you always follow a pathway of decision making. Consciously engaging in this process should help your development as a photographer. In my own work, I've had success most often when I allow my natural instincts to guide me down this pathway to the next photograph and then look objectively at the details that can make or break a successful image. My photography workshop students have found this imaging process very useful, so I'm happy to pass it along to you in this chapter. It consists of four steps: visualization, evaluation, execution, and review.

Step 1: Visualization. Before you pick up the camera, start the process by exploring. Let your natural curiosity guide you from one possiblility to another. Follow your intuition and instincts. Try to remain open to all the visual stimuli that surround you. Your way of seeing the world is unique. This is the most important phase of creating original photography.

If you already have a specific image in mind, be careful not to ignore other opportunities that may develop while you're concentrating on a specific idea. The most rewarding photographs sometimes occur when you are looking for one thing, and meanwhile, serendipity reveals an unexpected pleasure. Study the landscape with an eye for distant scenes, what is going on at medium distances, and the world close at your feet. With practice you can learn to previsualize how a scene would look through a wide-angle lens or a telephoto lens. Having this ability is like using zoom vision to scan through different focal lengths. When I'm concentrating on visualizing a scene, I see in horizontal and vertical rectangles that approximate the camera's view and help crop the image into a tightly woven composition.

Slow down, and really *see* what is around you. Take the time to see beyond the obvious.

(Left) RED MAPLE LEAVES, Chequamegon National Forest, Wisconsin. 4 x 5 Linhof Master Technika camera, 300mm lens (equivalent to 100mm in 35mm format), Bogen 3021 tripod with Foba Super Ball head, Fujichrome 100.

Color, especially red, can be a powerful tool in composing strong images.

(Right) REFLECTIONS IN POTATO RIVER, Iron County, Wisconsin. 4 x 5 Linhof Master Technika camera, 90mm lens (equivalent to 24mm in 35mm format), Bogen 3021 tripod with Foba Super Ball head, polarizer, Fujichrome 100.

While surveying a waterfall on the Potato River in Wisconsin, I spotted a brilliant red maple tree on the opposite bank. I left my camera equipment and walked toward the autumn spectacle. Suddenly, I spotted the reflection that became the subject of this photograph.

Scan your surroundings for things that you find interesting and believe would be worthwhile sharing with others. Also look for more abstract images filled with interesting shapes, patterns, textures, and colors. Something will eventually grab your attention and draw you in for closer scrutiny. This is the process of what I call "natural selection" at work.

Step 2: Evaluation. Continue looking around you without the camera. When you've spotted something that interests you, flip on what I call "tunnel vision." Tunnel vision is an exercise in eliminating the sounds and smells that enhance the present moment but won't be recorded by the camera. These nonvisual distractions can fool your judgement. As hard as it may seem, try to distance yourself from a scene's stimulating elements that elevate your excitement about it but can't be recorded by the camera.

Remember that your camera sees with total objectivity.

A craftsman relies on skill to convey his or her emotions. Now it is time to narrow down your intentions. What is the main point of interest in the image that is forming? Can it be photographed from your present position, or do you need to change your viewpoint?

It is finally time to refine your evaluation by looking through the camera, but continue working without the tripod—it would only limit your ability to move around freely and try different ideas. Again, it is essential to eliminate everything from your perspective except what you see within the camera viewfinder.

Experiment using various foregrounds, different framing elements, and various camera-to-subject distances. Try unusual viewpoints close to the ground; try tilting the lens to include lots of foreground; try aiming the camera

high to include more sky. Try longer lenses that compress the scene or bring the subject into closer view. Consider every lens in your arsenal. Don't limit yourself to a favorite lens or plant your feet in cement. Try different ideas, and move around!

By now, you have a fairly specific image in mind. Place the camera on the tripod. Return to a focal length that seemed to work best. Selectively crop the image in the viewfinder by moving forward and backward or from side to side. Change lenses again if necessary. Try vertical and horizontal framing. Some images just seem to shout "vertical," while others seem more suited to horizontal framing. Trying the shot both ways can stimulate ideas and free you from repeating the same composition again.

Pay very close attention to the area behind the subject in your image. Check for distracting elements that compete with the subject. Ask yourself if a simple change in camera position will improve the background. Don't forget to use the depth-of-field preview button when performing the background check. Remember that using smaller apertures brings the background into greater focus and reveals things that you'll overlook at full aperture.

If the horizon is included, decide if it should be placed high, medium, or low in the composition. Check that the horizon is perfectly level. A camera viewfinder fitted with an architectural grid is useful for checking that such vertical elements as trees or people aren't tilted at an unnatural angle.

Simplify the composition until you've included only what is necessary to communicate your intentions. Sometimes it is best to shoot the subject very tightly by moving in close or cropping the image with a telephoto lens' narrow angle of view. At other times, a tight shot doesn't reveal enough information about the place, and it is obviously better to include more space around the subject.

You should know what you want before you press the shutter button. Completing the following sentences will help you quickly ascertain if you've identified your intentions and defined the purpose of the photograph:

1) **What I like about this shot is** (complete this sentence)

2) **So I will** (complete this sentence)

For example: 1) **What I like about this shot is** the way the snow-capped mountains are reflected in this alpine lake. 2) **So I will** use a 24mm wide-angle lens in order to take in the entire scene. Depth of field is more critical to the image than shutter speed, **so I will** select an appropriate aperture first. Using f/22, I check the focus in the scene with the depth-of-field preview button. I want a good reflection, **so I will** wait for calm conditions and a perfectly smooth reflection. Now I will move the camera and tripod a few feet to my right where I can frame the mountain's reflection with those rocks jutting out of the lake. My exposure meter readings indicate that the background is far brighter than the foreground, **so I will** use an ND grad filter to balance the background with the darker foreground.

You should also ask yourself whether the available light is the best lighting for this subject. If not, when should you return for more favorable lighting? Your evaluation may help you decide that you don't like the image after all. This often occurs after a careful study of the composition through the camera reveals a scene that may look very different from your human

ASPEN GLADE IN AUTUMN, Rocky Mountain National Park, Colorado. 4 x 5 Linhof Master Technika camera, 90mm lens (equivalent to 24mm in 35mm format), Bogen 3021 tripod with Foba Super Ball head, 81A filter, Fujichrome 100.

Hiking among aspen trees during autumn is a multi-dimensional experience. I stopped to photograph a rich carpet of leaves on the forest floor. But after I set up the camera and studied the composition at greater length, I decided it didn't really convey the excitement of the moment. A few feet to my right were several dark gray boulders covered with leaves. I completed a quick mental evaluation: "WHAT I LIKE ABOUT THIS SCENE IS the manner in which the leaves from an overhead canopy of aspen trees are spilling over the boulders like gold coins. SO I WILL find a vantage point that combines all the important elements in the scene: leaves, dark gray boulders, and aspen trees." Then I moved my tripod and camera around in the boulders until I found the right composition.

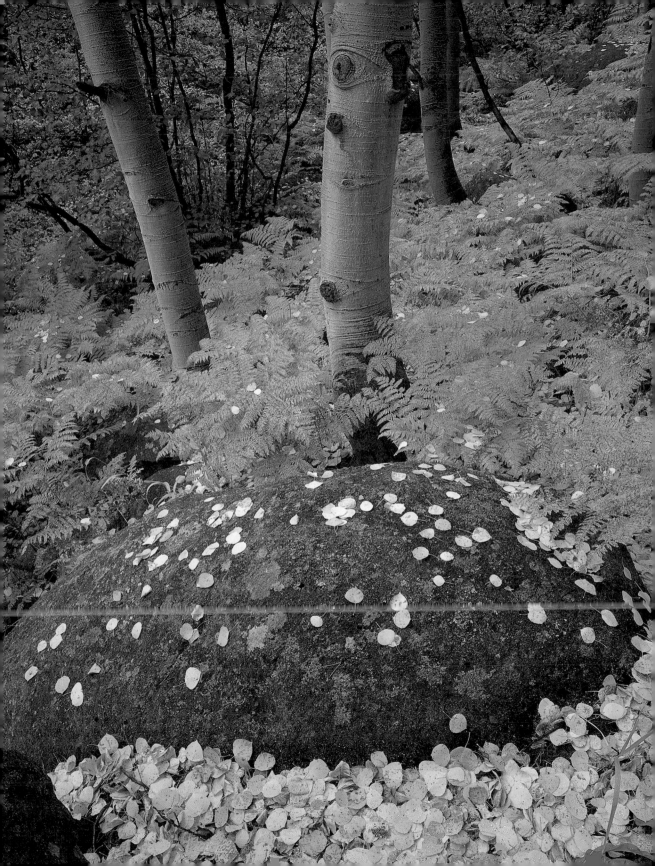

binocular vision of the scene. Sometimes you'll run into a road block and decide that what you've imagined isn't as good as you first thought.

Step 3: Execution. You've made the decision to go ahead and take the photograph. Now is the time to determine if a filter is merited, add it to the lens, and meter for the correct exposure. Is your priority depth of field or a fast shutter speed to stop subject movement? If the main consideration is depth of field, select the aperture first, then determine the shutter speed. If the shutter speed is the priority, select the shutter speed first, then the lens aperture.

Perform a last check around the viewfinder's edges for distracting elements or objects that don't contribute anything to your composition. Add a cable release if you're using a slow shutter speed, doing closeup magnifications, or using a long telephoto lens. Wait for the decisive moment when the subject is rendered in the best light or the wind doesn't interfere. Take the shot.

Step 4: Review. Are you certain that you've selected the correct exposure, or should you bracket over and under by 1/2 stop for insurance? Do you need to make additional in-camera duplicate pictures for your files, or for distribution to stock photo agencies and publishers? If the answers are yes, go ahead and shoot some more frames.

Can you improve upon the shot? Usually there is more than one way to photograph a subject. The first shot is frequently not the best interpretation. Keep honing down the composition until you feel you've exhausted the best alternative shots. If you are photographing wildlife or sports, it is wise to load a fresh roll of film when you have only a few shots left in the camera in order to be ready for fast-breaking situations, especially if you're working with a motor drive.

THE PASS/FAIL TEST

When I'm hiking or exploring, I often spot something that makes me stop and look a little harder. Would this make a good shot? Should I stop and work on this? Sometimes I like what I see, but I'm not quite sure of myself. If my

hunch is strong enough, I may set up the camera and tripod, and try to find a shot that will work. But after all that work, how do I know if it is a shot really worth taking?

I've developed a 15-second test to help me determine how far I should go in setting up a shot. Knowing what constitutes a good picture-taking opportunity is just as important as recognizing one that won't cut the mustard. The test either gives me the green light to proceed, or saves me from wasting more time and film on the situation. Here is my quick Pass/Fail Test to help you determine whether you should go ahead and take a picture, or whether you should keep on exploring:

- 5 SECONDS: Is it a good subject?
- 5 SECONDS: Is it a good composition?
- 5 SECONDS: Is it good light?

A potentially sucessful image must pass all three questions. If you answer yes to two out of three, then chances are you can turn it into a good shot just by looking for a more interesting composition or waiting for better lighting for that subject.

Most photographers start shooting without thinking first, as I've witnessed time and time again. They don't see that the flower is tattered and brown, the composition is carelessly structured, or the scene is half shaded/half sunlight. Believe me, doing this simple 15-second evaluation can make you a better photographer.

In my wildflower photography workshops, my students work outdoors in groups of two that we call "dynamic duos" for fun. I ask the duos to work together to find interesting flower photographs; then they have to convince each other that all three questions can be answered satisfactorily before they are supposed to take a picture. Eavesdropping on their discussions is revealing. When I hear something akin to "it's a good subject and good composition, but we don't like the lighting," then I know they are on the right track to more rewarding photography.

Students tell me that this test is one of the most valuable ways to apply what they've learned in the classroom sessions. One experienced workshop veteran told me that she had been exposed to all the photography theory in

the world, but she just didn't know where to begin when she got out in the field. The Pass/Fail Test gave her a place to start. At least she could say that she evaluated the quality of the subject, the composition, and the lighting before she took the picture. She later sent me a post card from the Galapagos Islands where she treated the entire photo safari as a series of Pass/Fail Tests. And the good news was that she was finally passing more than failing!

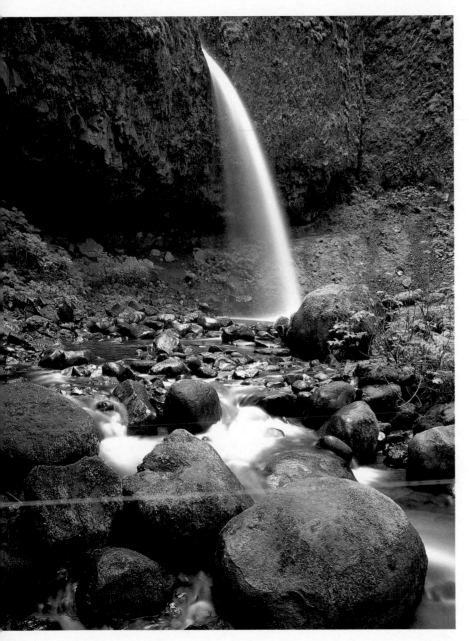

UPPER HORSETAIL FALLS, Columbia River Gorge, Oregon. 4 x 5 Linhof Master Technika camera, 90mm lens (equivalent to 24mm in 35mm format), Bogen 3021 tripod with Foba Super Ball head, polarizer, 81A filter, Fujichrome 100.

From the moment I first saw Upper Horsetail Falls, I knew that a great photograph was possible. A trail actually goes behind the falls to overlooks on the left and the right. Looking down upon the falls from the right, I centered it on my view camera's ground-glass. The image lacked vitality, just fell flat.

Then I slid down the muddy slope below the falls to study it from a lower perspective. Bingo! This vantage point emphasized the fall's eloquent form. I performed the 15-second pass/fail test to see where I stood: I had a good subject, I had good light, all I needed now was a good composition.

Several boulders situated together grabbed my attention. I established a camera position to align the falls with the largest boulders. Try holding your hand over the photograph to obscure the boulders from the composition, and you will see how important balance is to the overall success of this image.

WEATHERING THE STORM

*"There are only two kinds of people
who try to predict the weather around here:
fools and out-of-staters!"*

—THOMAS "ROWDY" ROUDEBUSH
(a cowboy from Telluride, Colorado)

Shooting in bad weather can present unique opportunities to capture the melancholy moods of nature. Although a lot of photographers pack up and head for home at the first sign of bad weather, with the right attitude, foul weather can be an asset. For example, one of the best conditions for nature photography is immediately after a rain storm. A good soaking cleanses the air and, along with overcast lighting, saturates the colors of wildflowers, trees, and rocks.

A vulnerable moment in bad weather is changing film. Don't let any water reach the inside of the camera, as moisture can be very damaging to delicate electronic parts. I protect the inside of the camera by using an umbrella, or I shield the camera with my body. In high-humidity situations, don't reseal exposed 35mm film cassettes in their plastic canisters. Put them in a ziplock bag and squeeze out the air. Later, air them out at room temperature before you send them to the photography lab in their plastic canisters. Otherwise, you could lock damag-

ing moisture inside the canisters with film, which completely defeats the purpose behind using film canisters for protection.

A lens hood and a UV filter on your lens helps protect it during inclement weather. Raindrops and snowflakes are easier to wipe off a filter than a delicate optical surface. Also, shooting with a polarizing filter will remove reflections from subjects with wet surfaces and improve their color rendition. If the sky is dark, then using an amber 81A or 81B warming filter will slightly warm up the steel-gray light.

Lenses and camera viewfinders tend to fog up in conditions of high humidity. You can use an antifog treatment on the viewfinder and filters (not on the lenses) to reduce nagging condensation. Large format photographers can use antifog on their groundglass viewers. A good antifog product is Fog Gone, used by NASA astronauts. Wipe moisture off all of your camera equipment before you put it way for any length of time.

RAIN AND LIGHTNING
A cloudy day diffuses sunlight, creating a soft, caressing light that is ideal for photographing autumn foliage or wildflowers. Colors really come alive in the soft overcast light! But a friendly overcast sky can turn into a torrential downpour quite suddenly. What does a photographer do during periods of rain?

In a nasty, wind-driven rain storm, the best thing to do is keep the camera tucked away,

YUCCA CACTUS IN SNOW, Colorado. 4 x 5 Linhof Master Technika camera, 180mm lens (equivalent to 50mm in 35mm format), Bogen 3021 tripod with Foba Super Ball head, 3 Frisbees supporting the tripod on the snow, Fujichrome 100.

A common Yucca cactus becomes the subject of a study in interesting form as it melts out from the snow.

completely protected, in a pack or camera bag. But it is tempting to continue working in an intermittent or light drizzle. If you are set up with the camera on a tripod and it begins to rain, the best remedy is to pull out a large, plastic, garbage bag and drape it over your valuable equipment until the rain ends. The best ones are tough trash-compactor bags that are 2.5 mils thick instead of flimsy 1 mil garbage bags that tear with one use. These garbage bags are large enough to fit over a 35mm SLR mounted with the longest telephoto lenses. The bags are great for protecting the fragile bellows of a 4 x 5 camera, too. Bring a second plastic bag to protect your camera bag or backpack. When it starts raining, pull out the bags, put on your Gore-Tex parka, and wait out the storm. As soon as there is a break in the rain, you can resume shooting.

Sometimes a pesky rain will follow you through an entire outing, which may force you to shoot under difficult conditions. Some photographers try shooting through a hole in a plastic bag. They cut out holes for their lenses and fasten the bags to the lenses with rubber bands. This sounds good in theory, but some lenses need to rotate as they focus back and forth, in which case the plastic bag fights you

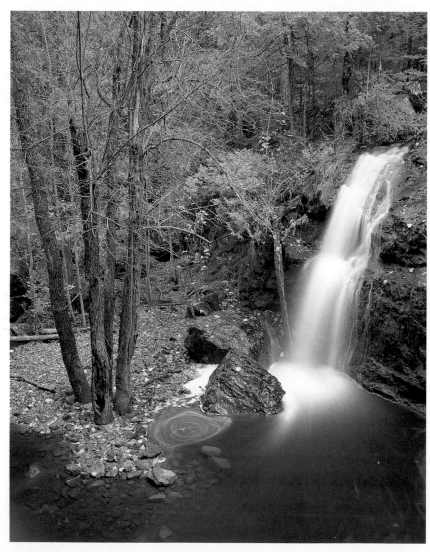

WATERFALL IN THE RAIN, Douglas County, Wisconsin. 4 x 5 Linhof Master Technika camera, 75mm lens (equivalent to 20mm in 35mm format), Bogen 3021 tripod with Foba Super Ball head, polarizer, 81A filter, Fujichrome 100.

This secret spot of mine is normally an uninteresting stagnant pool, but during a rainstorm the waterfall is reincarnated. I photographed this image at f/32 for 30 seconds in a light drizzle after a heavy downpour.

every step of the way. Working inside a bag, the aperture ring is very difficult to see or turn, and the camera fogs up as soon as you put your eye to the viewfinder. Plus you still have the problem of keeping the front element of the lens free of raindrops. And changing lenses or filters with this setup is an exercise in futility. Frankly, working with an umbrella is far simpler and more practical.

With an umbrella, you and your camera both stay dry, and you have a fighting chance to take some pictures when the rain just won't let up. I bring a small umbrella with me practically everywhere. I sometimes ask an underpaid assistant (my wife) to hold the umbrella while I continue shooting.

Protect Yourself from Lightning. Several years ago on a pleasant summer day, a friend and I climbed the Exum Ridge of the Grand Teton in Wyoming. We reached the 13,766-foot summit just as a frightening thunderstorm reached it, too. With no time for summit celebrations, we hastily started down the Owen-Spalding descent route. Suddenly a blinding flash and explosion forced us to fall to the ground in terror. Lightning had struck the summit where we had stood moments earlier. What we had felt

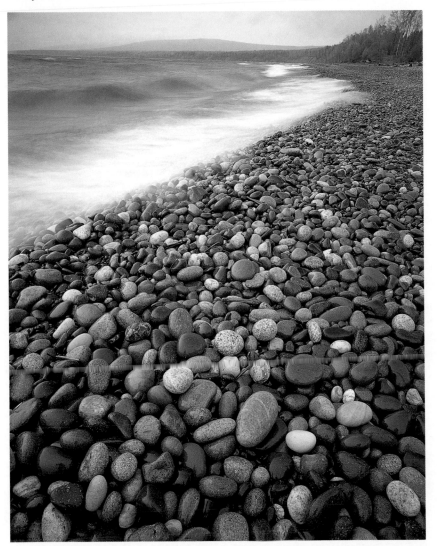

SHINY WET STONES AFTER RAIN, Oronto Bay, Lake Superior, Iron County, Wisconisn. 4 x 5 Linhof Master Technika, 75mm lens (equivalent to 20mm in 35mm format), Bogen 3021 tripod with Foba Super Ball head, polarizer, 81A filter, Fujichrome 100.

I've returned many times to this spot along Lake Superior to photograph these smooth pebbles. I took my favorite shot right after a storm when the rocks were glistening with moisture. The surf was still turbulent, and several waves soaked my boots and splashed onto the camera bellows. But it was worth it to record these almost translucent stones. I like the way they look smaller and smaller and smaller as their distance from the camera increases.

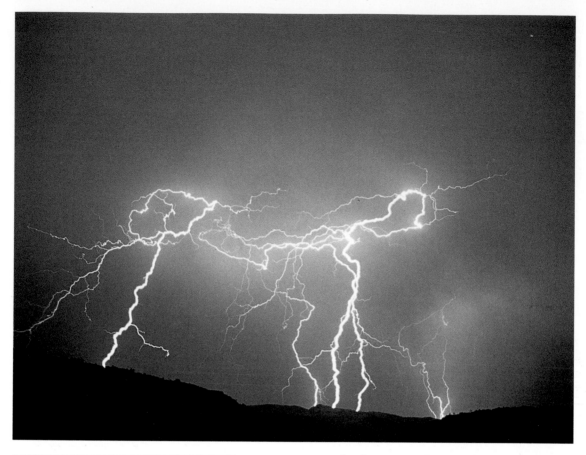

LIGHTNING AT THUNDER LAKE, Rocky Mountain National Park, Colorado. Nikon N8008 camera, 35-70mm f/3.3-4.5 zoom lens, Bogen 3001 tripod with Linhof Profi II head, Kodachrome 64.

After hiking 7 miles alone to a wilderness campsite, I hurriedly set up my tent in the wake of an impending storm. The storm seemed to intensify by the minute, and the wind became fierce as the sky turned dark as night. Before too long, Thunder Lake was living up to its name. I set up the tripod low to the ground just outside the tent entrance and attempted to photograph the lightning. I set the aperture to f/11 and added a polarizer, lengthening the exposures to 15 seconds each. Out of 12 frames, this was the best shot.

was a shock wave, and we could still smell the lingering ozone. We knew the next strike could occur at any moment, and then it might be fatal!

The worst thing to do around lightning is to be near the highest object around. Darn it, the Grand Teton was the highest object around! (In fact, it is the highest mountain in the Tetons.) We crawled down the steep slope a little farther and decided the safest thing to do was to make ourselves poor targets by crouching down low and sitting out the worst of the storm.

We removed our packs and piled our climbing gear in a heap before us. We were greatly relieved to be rid of aluminum carabiners and assorted metal climbing paraphernalia that could conduct electricity. Then I lost count of the bolts of lightning flying in all directions. At such a high elevation, some of the lighting originated directly in front of us and then struck somewhere lower on the mountain. It was as

dramatic a moment as I have ever experienced in the mountains.

We suddenly realized we were still wearing wrist watches with metal components. These quickly flew in the direction of the climbing gear. We knew that a direct strike from an upward stroke or a down stroke would kill us. We also knew that nearby strikes would dissipate their voltage along paths of least resistance—that would be down the side of the mountain to where we were. Not good. But it was safer to stay put than increase our vulnerability by standing up.

As we crouched down low, my right elbow occasionally brushed against a large boulder while I struggled to maintain my balance on the balls of my feet. Suddenly a surge of ground electricity shot through my arm and momentarily numbed my elbow. This was a serious situation. We remained there for 20 terrifying minutes. When it seemed that the worst of the lightning had passed to the east, we decided it was safe enough to resume our descent.

Now it started to rain and snow, and we still had thousands of feet to descend, including two rappels down our wet climbing ropes—one of them in midair. We nervously descended until we finally reached safer terrain. I'll never forget how close we came to being fried by that electrifying, all-natural fireworks display!

Thunderstorms are common in many parts of North America. It is impossible to avoid them entirely if you spend a lot of time in the mountains. The safest strategy is to start your hiking and climbing trips early in the day, and depart from high-risk areas before afternoon storms develop.

In the event that you do get caught in a thunderstorm, a few simple precautions can increase your odds of survival. If you're above timberline, crouch low (don't lie down because then dissipating electricity could pass through your entire body), avoid high points that make obvious targets, and stay away from cliffs. Balance on the balls of your feet to minimize contact with the ground. Below timberline, you are relatively safe in a forest as long as you're not sitting under a solitary tree. Avoid depressions or shallow ditches filled with water. And, most of all, avoid the summit of Grand Teton during a thunderstorm.

SNOW AND COLD WEATHER

Cold temperatures are less of a problem for camera equipment than you might think. I've used cameras at well below 0°F without any special modifications to the cameras. But there are certain do's and don't that should be heeded in winter conditions.

The biggest misconception is that the camera should be carried next to your body for warmth. This is bad advice. If you're using your camera in the cold and then stick it inside your coat, you immediately set up conditions for condensation to form inside the lens and camera—especially if you're hot and perspiring from skiing or snowshoeing. Always keep the camera at the outside temperature!

The rule of thumb is: You can go from warm to cold, but not cold to warm. Never take a cold camera into a warmer environment without insulating it. It must warm gradually to prevent condensation. If I'm skiing and head inside a ski lodge, I put the camera in the padded fanny pack and I even wrap my coat around it so that it remains cold as long as I am indoors. If you need to change film, do it outside.

Maintaining sufficient battery power is the biggest problem in cold weather. Even factory-fresh alkaline batteries lose their voltage around 0°F. In subzero weather, you will get significantly better cold-weather performance from rechargeable Ni-Cad batteries. If you're shooting a lot of film, a simple solution is to carry an extra camera-battery clip deep inside your clothing. When the camera's performance starts to become sluggish, just pop in a warm set of batteries and put the cold batteries into your inside pocket. When the batteries are warm again, their power is restored.

If you're headed for the North Pole or Antarctica, Nikon offers some solutions for working in extreme cold. Nikon camera owners can use the Anti-Cold DB-6 power pack. It uses 6 "D" cells that are kept warm inside the photographer's parka. A neoprene umbilical cord connects the DB-6 to the camera. This way the camera stays outside in the cold and still has plenty of power. A Nikon technical representative jokingly remarked to me that the DB-6 would jump-start a snowmobile. The DB-6 works with the N90 and F4 cameras, but I wouldn't recommend the N90 for sustained

subzero performance because it has a LED-exposure-display panel that could freeze.

Another alternative for F4 camera owners is the F4-E power pack. It uses a rechargeable Ni-Cad module and substitutes for the standard MB-23 power pack that uses 6 AA batteries. When the Ni-Cad module becomes too cold to operate, a second module, stored inside your parka, can be slipped into the power pack in just a few seconds.

The Nikon FM2 is another reliable camera for extremely cold weather. Its power source is a single 3V lithium cell. The camera is lightweight and uses a manual film advance that doesn't use battery power as the newer cameras do. In fact, the FM2 only requires a small amount of battery power to fuel its exposure meter. The FM2 can also be used with a DB-2 Anti-Cold Battery Pack. The DB-2 operates with 2 AA batteries and can be worn in an inside pocket to keep it warm. I used the Nikon FM2 on Mt. McKinley, the highest mountain in North America, and on Mt. Logan, the highest point in Canada, and it performed flawlessly down to -40°F.

On winter camping trips, you can bring your camera inside a tent or snow cave where it will be somewhat warmer than outside. But keep it in a camera case to avoid condensation. Sleep with one set of batteries inside your sleeping bag in case you need them the next day.

In winter, changing lenses can freeze the hands. So I use zoom lenses instead of fixed focal lengths as the zoom also simplifies shooting. I've found one lens that comes close to perfection on climbing and skiing trips. I almost hate to give this secret away! But here it is:

The Nikkor 35-135mm f/3.5-4.5 zoom is the closest to being the best overall lens for moving through scenic country. I use this zoom when I want to carry only one compact lens that covers a useful range from moderate wide-angle to short telephoto. I first used it on a mountaineering trip to Mt. Hunter in Alaska when I was concerned about carrying the weight of several lenses on a technical climbing route. Using this lens let me replace my standard three-lens assortment with just this 35-135mm zoom. It is small enough to carry in a padded case on a backpack's hip belt where it remains out of the way, yet handy. It was the only lens I took on that expedition, and with it, I found

that I could quickly compose and shoot everything from climbing action to scenery.

Shooting with ISO 100 film, I can handhold this 35-135mm zoom lens in average daylight, or brace it with ski poles or a climbing ice axe when the light levels are low. As you might imagine, climbing trips are quite abusive to camera equipment. But I'm still using that lens ten years later for backpacking and skiing trips. I recently used it on a week-long hut-to-hut ski trip in the Colorado mountains, and once again it confirmed my loyalty.

A word to the wise: Never ski or climb with an SLR camera inside your jacket. You could harm yourself in a fall or in a collision with another skier. And it would be foolish to wear a camera dangling loosely around your neck. During the day, I carry my camera in a padded chest pouch worn outside my clothing or in a fanny pack, worn to the front, that is very handy and probably less restricting than a chest pouch. The fanny pack can also carry an extra lens or two and serves as a "ledge support" to hold the camera when I change film.

Protect Your Equipment from Snow and Cold.
When snow accumulates on your camera or if you drop a piece of equipment in the snow, you can't blow the snow off without the camera looking as if it has been in a steam room. I use an old-fashioned shaving brush made of coarse bristles to brush away snow from its surfaces and crevices. (A soft lens brush is too flimsy for brushing off outside surfaces.) I also wrap the camera in a chamois cloth to absorb moisture and use the cloth to wipe snow off filters.

Be careful about exhaling close to your camera. It will fog up immediately. Sunglass defogger can be used on the viewfinder eyepiece and on UV filters to reduce fogging. I also use defogger on the groundglass viewer of my 4 x 5 camera.

Another enemy of cold-weather shooting is static discharge electricity. As the film advances, it may create static electricity that looks like small lighting bolts on the film. In the cold it is a good idea to avoid shooting multiple frames with a high-speed motor drive. If you have an F4 camera, you can use the "silent" film-advance mode for advancing the film slowly. Then use the old-fashioned manual film rewind

lever instead of the power rewind button.

Ski photographers have an unorthodox way of dissipating static charge inside their cameras. They make a soapy mixture of six drops of liquid dishwashing detergent in eight ounces of water, then sparingly apply the solution to the pressure plate, film rollers, and guide rails inside the camera. This is no joke, it really works. The film of soap left behind when the mixture dries seems to dissipate static electricity.

Extreme cold doesn't really have any adverse affects on a film's ability to record the scene. But film leaders become brittle enough to break off during loading. I like to carry a spare roll of film in a warm, inside-the-coat pocket so that the film doesn't become too brittle.

If you're a true fanatic, you may have tried to use your tripod in the snow. Usually it sinks down to knee level or falls over when you touch it. I carry three frisbees with me on winter landscape-photography trips. With a frisbee under each tripod leg, the tripod will support even a 4 x 5 field camera in deep snow.

Protect Your Hands from Extreme Cold. Avoid touching cold metal surfaces with your bare hands. I like to use a layering system of warmth

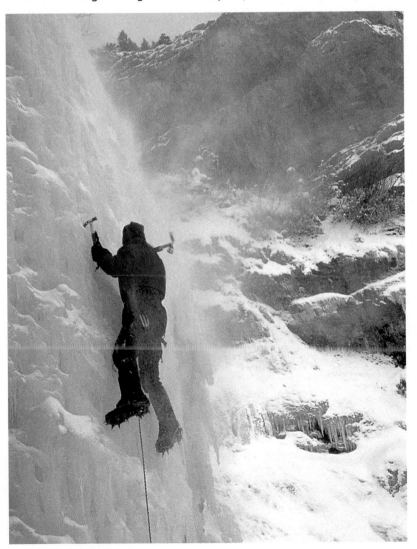

ASCENDING "WHITE NIGHTMARE," Provo Canyon, Utah. Nikon F4s camera, 35-135mm f/3.5-4.5 zoom lens, handheld, Fujichrome 50.

Environmental conditions made this a challenging shot. It was lightly snowing, and our climbing route was next to Bridal Veil Falls which persistently sprayed us despite the frigid winter cold. This was the supreme test for our Gore-Tex apparel. More important, the swirling mist instantly glazed-over my camera's optics. Fortunately, the light level was steady, so I didn't have to change the exposure settings constantly. For each picture of that ascent, I whipped the camera out of my fanny pack and shot as fast as Marshall Dillon. I was lucky to catch Mugs Stump hanging on during a small spindrift avalanche. He tragically perished in an avalanche on a later climb up Mt. McKinley in 1992. I'm glad to have this picture of him as a memory of better climbing days together.

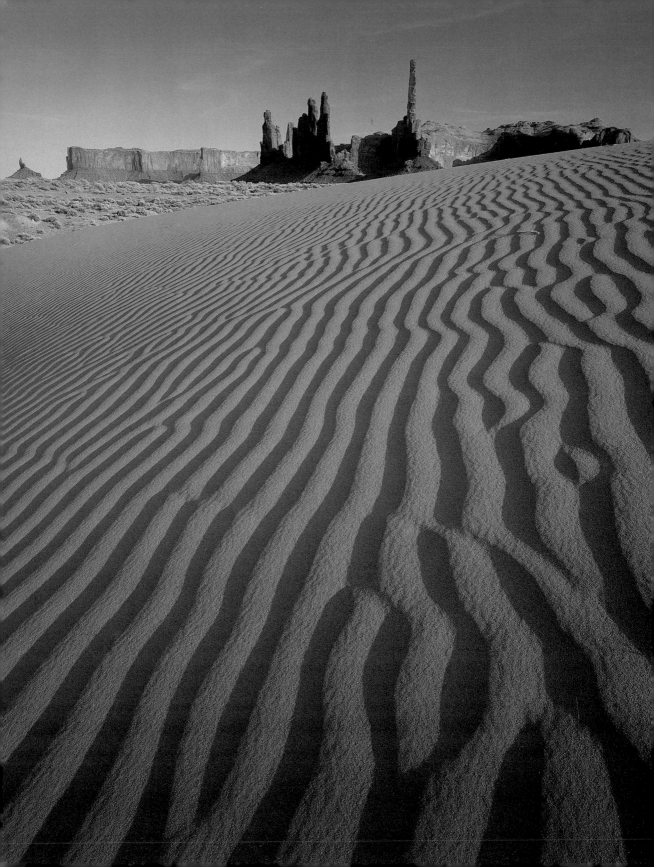

for my hands. I start with a thin pair of smooth silk gloves. Wearing them, I can accomplish the most dexterous jobs, such as changing film and setting f-stops. It is important to wear a smooth silk or nylon glove that won't leave little fuzzies inside the camera. For extra warmth I like to wear a fingerless glove over the silk liners. Both gloves and liners are sold by skiing and mountaineering shops.

If it is too cold for fingerless gloves, then I wear an insulated ski glove over the silkies. The best one I've found is Black Diamond's curved-finger glove; it includes a thick, removable glove liner inside a shell that is held in place by a strip of Velcro. The glove's long wrist gauntlet adds warmth and protects your wrists from snow. Focusing tip: When you're wearing gloves, a lens is easier to focus if you stretch a wide rubber band over its focusing ring.

In the most severe conditions, a heavy expedition mitten is warmer than a glove but it makes handling equipment very difficult. My favorite mountaineering mitten is the Helly-Hansen Polar Mitt. For skiing and winter climbing, I carry handwarmer packets (available at ski shops and sports stores) to reheat my hands.

Some photographers wear wool hunter's mittens that pull back to expose the fingers. The idea behind them is good, but they aren't as warm as I thought they would be. And the wool collects snow like a magnet and leaves fuzzies all over the camera.

DESERT ENVIRONMENTS

Other than dropping your camera in a lake or off a cliff, shooting in the desert is probably the most damaging experience for your equipment and film. In the desert, dust and sand can infiltrate every crevice of photography equipment. There is nothing worse than the gritty, grinding

TOTEM POLE AND YEBECHI ROCKS, Navajo Tribal Park, Monument Valley, Arizona. 4 x 5 Linhof Master Technika camera, 75mm lens (equivalent to 20mm in 35mm format), Bogen 3021 tripod with Foba Super Ball head, polarizer, Fujichrome 100.

There are many famous photographs of the Totem Pole rock formation. I like how the sand ripples in this shot lead the eye toward the subject in the background.

sensation of sand inside a lens barrel or camera motor drive.

Having had several bad experiences with sand, I now place each camera body and lens in a small, nylon stuff sack that is just large enough to hold each item. This habit has helped tremendously to keep loose sand in my backpack from penetrating every item. It also helps protect equipment from the sudden, unexpected gusts of desert wind that seem to come from nowhere and fill up the pack with sand as fine as talcum powder.

If any sand or dust gets inside your camera, it will find its way to the film and ruin a few shots. When you reload your camera with film, always check the inside of the camera for sand and dust, and remove it. Compressed air is very effective at blowing out fine-grained sand and dust that a brush can't reach. Q-tips and alcohol are handy for wiping clean the exterior components of cameras and lenses.

Protect Film from Heat. High temperatures are detrimental to film emulsions. In the car you should keep film in an ice cooler or use a portable, 6-volt refrigerator that can plug into the cigarette lighter. In the hot interior of a car, a refrigerator won't keep film actually cold, but it will keep it from baking.

If you're going to leave film in the car for a few days while you're backpacking, the best strategy is to use a well-insulated cooler and a block of ice because a refrigerator can run down a car battery in only two or three hours. Wrap the cooler in a couple of sleeping bags or blankets for extra insulation. Then put it in the trunk where it is marginally cooler than the car's interior. Park in the shade if you can find any.

In the field, follow a similar procedure by keeping spare film wrapped in a sleeping bag or in spare clothing. Fortunately, desert nights are cool, and insulating the film during the day will maintain some of the overnight cooling effect. I constantly worry about heat damage, but I've never actually had any film ruined by heat. I tend to believe that film is more tolerant of brief episodes of high temperatures than we might think. But prolonged exposure to heat will unquestionably damage the film. Process exposed film as soon as possible because it is less stable than unexposed film.

RESOURCE GUIDE

Here is how to contact the manufacturers and outfitters who provide the equipment and services described in this book:

Basic Designs
PO Box 2507
Santa Rosa, CA 95405
(707) 575-1220

Black Diamond
2084 East 3900 South
Salt Lake City, UT 84124
(801) 278-5552

Bogen
PO Box 506
Ramsey, NJ 07446
(201) 934-8500

Charles Campbell/
PHOTOnaturalist
PO Box 621454
Littleton, CO 80162
(303) 933-0732
Chroma-Zone Reference Cards, nature photography workshops, and videos. Catalog available.

The Coleman Company, Inc.
(Peak 1)
PO Box 1762
Wichita, KS 67201
(316) 832-2653

DeLorme Mapping
PO Box 298
Freeport, ME 04032
(207) 865-4171

Eastern Mountain Sports, Inc.
1 Vose Farm Road
Peterborough, NH 03458
(603) 924-9571

Eastman Kodak
Consumer information:
(800) 645-6687

Foba/Sinar Bron
17 Progress Street
Edison, NJ 08820
(908) 754-5800

Fuji Films
Technical information:
(800) 788-3854

Kelty Pack
1224 Fern Ridge Parkway
St. Louis, MO 63141
(800) 423-2320

Kirk Enterprises
4370 East US Highway 20
Angola, IN 46703
(219) 837-7134

Laird Photo Accessories
PO Box 5726
Santa Rosa, CA 95402
(707) 525-1787

LL Bean
Freeport, ME 04033
(207) 865-4761

Linhof/HP Marketing
16 Chapin Road
Pine Brook, NJ 07058
(201) 808-9010

Marmot Mountain Works
2321 Circadian Way
Santa Rosa, CA 95407
(707) 544-4590

Merrell Footwear
PO Box 4249
South Burlington, VT 05406
(802) 863-5519

Mountainsmith
18301 West Colfax
Heritage Square, Building P
Golden, CO 80401
(303) 279-5930

The Nature Conservancy
1815 North Lynn Street
Arlington, VA 22209
(703) 841-5300

Nikon, Inc.
1300 Walt Whitman Road
Melville, NY 11747
(516) 547-4200

The North Face
999 Harrison Street
Berkeley, CA 94710
(510) 526-3530

Really Right Stuff
PO Box 6531
Los Osos, CA 93412

REI (Recreational Equipment, Inc.)
1700 45 Street East
Sumner, WA 98352
(206) 863-5550

Sierra Club
730 Polk Street
San Francisco, CA 94109
(415) 776-2211

Sierra Designs
2039 4th Street
Berkeley, CA 94710
(510) 843-0923

Tenba
503 Broadway
New York, NY 10012
(212) 966-1013

Thermarest/Cascade Designs
4000 1st Avenue South
Seattle, WA 98134
(206) 583-0583

Tiffen
90 Oser Avenue
Hauppauge, NY 11788
(516) 273-2500

Tundra
PO Box 7234
Denver, CO 80207
(303) 440-4142

Vasque Boot Company
314 Main Street
Red Wing, MN 55066
(800) 328-9453

INDEX